Preface

Addressing the Century: 100 Years of Art & Fashion assembles over 250 works of art, fashion, photography, theatre design, video and film in celebration of the close and vivid relationship between art and fashion in the twentieth century. From the 1910s to the 1990s, the exhibition traces a history of ideas through a sequence of historical and contemporary moments when the overlap of art and fashion signals the advancement of a common set of visual discoveries.

Art and fashion have been the subject of several exhibitions in recent years, notably the Florence Biennale of 1996, the core of which was shown at the Solomon R. Guggenheim Museum in New York in 1997. These exhibitions mapped out a terrain within which this present project has developed, not as a historical survey, nor as an attempt to make a case either for fashion as art or art as fashion, but as an exploration of parallels between the two worlds which have been crucial to the advancement of twentieth-century visual culture.

Addressing the Century has been curated by Peter Wollen, Professor of Film Studies at UCLA in California, author of *Raiding the Icebox: Reflections on Twentieth-Century Culture* and curator of several major international exhibitions, including *Frida Kahlo and Tina Modotti*, which opened at the Whitechapel Art Gallery, London in 1982, and *The Situationist International*, which opened at the Centre Georges Pompidou, Paris in 1989. We are enormously grateful to him for bringing the eyes and insights of a cultural commentator to the selection of this exciting and stimulating exhibition.

Following its presentation at the Hayward Gallery, *Addressing the Century* will travel to the Kunstmuseum Wolfsburg in Germany, and we thank Gijs van Tuyl, Margarete Heck and Annelie Lütgens for their collaboration. The exhibition has benefited from the expertise of a great many people, and we are grateful in particular to Sally Brampton, Lynne Cooke, Mark Holborn, Janice Jeffries, Richard Martin and David Mellor for their advice. We also thank Judith Clark, Joanne Entwistle, Caroline Evans, Ulrich Lehmann, Robin Muir and Elizabeth Wilson for contributing articles to this publication, and the team at Esterson Lackersteen for designing it with flair and panache.

The tremendous visual ambition of *Addressing the Century* has been enhanced by the dynamic architectural approach of the exhibition's designer, Zaha Hadid. We are honoured to present this major public project, and we extend our wholehearted thanks to her, and to Oliver Domeisen and Woody Yao in her office. Our thanks also go to John Johnson and his crew at Lightworks, to Jane Lewis of the Museum of London, to the Textile Conservation Centre, and to Suzanne Lee and Danny Froggart for their work in dressing the exhibition.

We are grateful to media sponsors Harpers and Queen, retail partners Selfridges & Co., and ICI PERSPEX™ for their support.

As ever, my thanks go to my colleagues at the Hayward Gallery and SBC, and particularly to Fiona Bradley, the Hayward Exhibition Organiser responsible for this project, for bringing such an exciting and ambitious exhibition so successfully to fruition.

Finally, we thank all the lenders to the exhibition, both public institutions and private individuals, who have agreed temporarily to part with works from their collections and without whose collaboration this project would not have been possible. Above all, we are indebted to the many artists and designers who, as well as lending to the exhibition, have given freely of their time, interest and enthusiasm.

Susan Ferleger Brades
Director, Hayward Gallery

Acknowledgements

Addressing the Century **has benefited from the expertise of a great many individuals and organisations. Our especial thanks go to the following:**

Parveen Adams, Dawn Ades, Isabelle Anscombe, Nick Barley, Ray Barrie, Nicole Bellamy, Tosh Berman, Janice Blackburn, Dr Christian Brandstätter, Whitney Chadwick, Caroline Coates, Jean-Louis Delaunay, Leslie Dick, Liz Farrelly, Edmund and Natalia Fawcett, Briony Fer, Marcus Field, Alfeu Franca, Anna Galucci-Collins, Simon Glendinning, John Golding, Christopher Green, Carol Greene, Margot Heller, Marina Henderson, Mark Holborn, Sarah Hyde, Martin Kamer, Sean Kelly, Josy Kraft, Anna Kustera, Michael Leaman, Jem Legh, Adam Lowe, Camilla Lowther, Tiggy Maconochie, Colin McDowell, Christiane Meyer-Thoss, Simon Munro, Nicole Parrot, Dora Perez-Tibi, Jill Ritblat, Marianne Ryan, Doris Saatchi, Richard Shone, Matthew Solomon, Jörg Stürzebecher, Erika Tasini, Assunta Trotta, Robert Violette, Nick Wadley, Judith Watt, Sarah Whitfield.

Mark Francis at the Andy Warhol Museum, Pittsburg; Christopher Menz at the Art Gallery of South Australia; Rosemary Harden at the Bath Museum of Costume; Emma Young at Brighton Museum and Art Gallery; Bowles & Linares; Patricia Mears at Brooklyn Museum of Art; Peter Miall at The Charleston Trust, Lewes; Gelka Music at Comme des Garçons, Paris; Eric Näslund at the Dance Museum, Stockholm; Jane Pritchard at English National Ballet, London; Zbigniew Kotowicz and the Forum for European Philosophy; Chrysanthi Kotrouzinis at the Galerie Gmurzynska, Cologne; Kimio Jinno at Gallery HAM, Nagoya; Fredric Woodbridge Wilson and Annette Fern at the Harvard Theatre Collection, Cambridge; Ross van Horn at Hamilton's Gallery, London; Erika Patka at the Hochschule für Angewandte Kunst, Vienna; Stephanie Rachum and Eva Sznajderman at the Israel Museum, Jerusalem; Piera Beradi at Issey Miyake, London; Conor Maklin at Julian Barran Ltd, London; Jean Michel Massing, Jackie Cox and Shirley Hunt at Kings College Cambridge; Christian Beaufort-Spontin at the Kunsthistorisches Museum, Vienna; Dale Gluckman at the Los Angeles County Museum of Art; Eckhard Fürlus at the Künstlerarchiv der Berlinischen Galerie, Berlin; Angela Völker and Blanda Winter at the MAK, Vienna; Geraldine Aramunda at the Menil Foundation, Houston; James Peachey at the Michael Parkin Gallery; Pierre Vidal at the Musée Bibliothèque de L'Opéra, Paris; Lydia Kamitsis, Paméla Golbin and Jérome Recours at the Musée de la mode et du textil, Paris; Guy Blazy at the Musée des tissus et des arts décoratifs de Lyon; Valérie Guillaume at the Musée Galliera, Paris; Didier Schulmann and Natalie Leleu at the Musée national d'art moderne Centre Georges Pompidou, Paris; Valerie Steele and Irving Solero at the Museum at F.I.T., New York; Thimo Te Duits at the Museum Boijmans Van Beuningen, Rotterdam; Christine Byron at the National Portrait Gallery, London; Jonathan Herring and Patricia Acres at New Hall, Cambridge; Stephan Koja at the Osterreichische Galerie Belvedere, Vienna; Pfizer; Dilys Blum at the Philadelphia Museum of Art; Enrico Minio at Roberto Capucci; Adel Rootstein; Marshall Rousseau and Joan Kropf at the Salvador Dalí Museum, St Petersburg, Florida; Kerry Taylor at Sotheby's; Karin von Maur at the Staatsgalerie Stuttgart; Brixton at Steinberg & Tolkein; Bryan Bale, Gavin Hippard and Sue Muller at Stockman London Ltd.; Judith Collins and Richard Humphreys at the Tate Gallery; Pierre-Yves Butzbach and Frank Muñoz at Telimage, Paris; Myra Walker at the Texas Fashion Collection, Denton; Amber Rowe at the Textile Conservation Centre, London; Kathy Holbreich at the Walker Arts Centre, Minneapolis; Brad Barnes at White Cube, London; Bartomeu Mari at the Witte de With Centre for Contemporary Art, Rotterdam; Clare Lilley at the Yorkshire Sculpture Park.

Addressing
100 Years of A

Hayward Gallery

sbc

Published on the occasion of the exhibition *Addressing the Century: 100 Years of Art & Fashion*, organised by the Hayward Gallery, London, in collaboration with the Kunstmuseum, Wolfsburg.

**Hayward Gallery, London
8 October 1998 – 11 January 1999**

**Kunstmuseum Wolfsburg
26 February – 23 May 1999**

Exhibition curated by Peter Wollen with Fiona Bradley
Exhibition organised by Fiona Bradley with Julia Coates
Associate curator: Ulrich Lehmann

Catalogue designed by Esterson Lackersteen with Harmen Hoogland

Printed in England by The White Dove Press

Front cover: Oskar Schlemmer,
Spiral – Figurine with Spiral Hat and Cuffs from 'The Triadic Ballet', Black Series, 1922, reconstruction 1994 (cat. 226)

Published by Hayward Gallery Publishing,
London SE1 8XX
© The South Bank Centre 1998
Texts © the authors 1998

ISBN 1 85332 183 4

Hayward Gallery, National Touring Exhibitions and Arts Council Collection publications are distributed by Cornerhouse Publications, 70 Oxford Street, Manchester M1 5NH (telephone 0161 200 1503; fax 0161 200 1504).

In association with

and

With support from

Contents

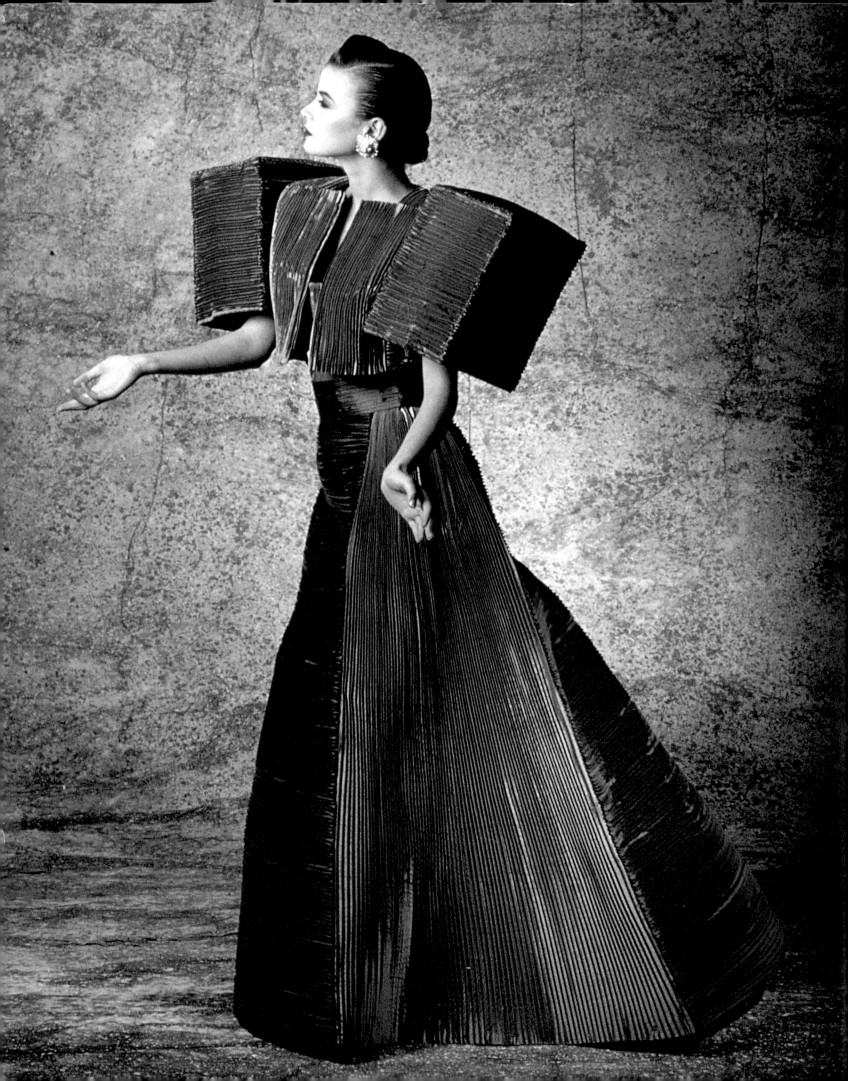

Addressing the Century
Peter Wollen

The line between artist and artisan has always been an indistinct one, ceaselessly renegotiated. On the one hand, it is the job of the artisan to make objects designed for use and convenience, whereas the work of the artist is regarded as non-instrumental – you can't do anything with a painting except look at it – and, when it is successful, it is valued, not simply for the opulence of its materials or its decorative appeal or its technical expertise, although it may share all these qualities with artisanal work, but for its adherence to a set of higher values which have been elaborated by experts in art history and aesthetics. These values, certainly since the time of Kant, have been explicitly defined as non-instrumental, as values of disinterested design, sensibility, style and imagination, removed from the practical concerns of everyday life. Individual works of art are situated and judged in the context of art history and, for their full

appreciation, the connoisseur is expected to be able to place them historically, to understand the artistic context in which just such a specific and singular work could be produced, one which should be both original and appropriate to its time.

As a result, a great deal depends on the way in which the history of art is written and its context defined at any specific point. For instance, the boundaries of art were significantly re-defined when posters by Toulouse-Lautrec, collages by Picasso, found objects by Duchamp, assemblages by Johns or Rauschenberg, machines by Tinguely, video installations by Nam June Paik, the props of performances by Beuys or the wrapping of the Pont Neuf by Christo were defined as falling legitimately within the context of art. All these artefacts, however, with the significant exception of Toulouse-Lautrec's posters, respected the

criterion of non-utility. They simply pushed the boundaries of art into a number of new areas, far beyond its traditional heartland of drawing, painting and sculpture. The utility of a urinal or a bicycle wheel was drained from it by Duchamp and the machines exhibited by Tinguely served no purpose beyond display. The case of photography, however, was more complex, because it plainly threatened the defensive wall which had separated drawing and painting as art from that of drawing and painting as commercial illustration – the line which Lautrec crossed at the end of the last century. Photography of many different kinds has become acceptable within the art museum. Moreover, the boundaries of the artistic context have been broadened retroactively, to include work that was neither regarded nor presented as art at the time when it was first made, a sure sign that our working definition of art is again being

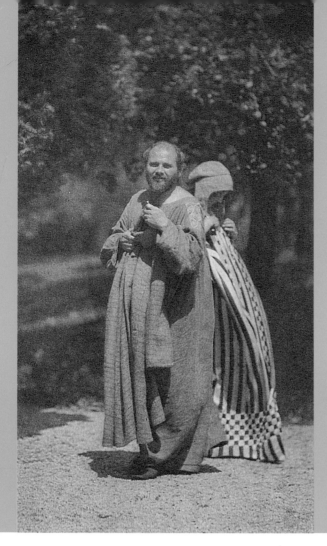

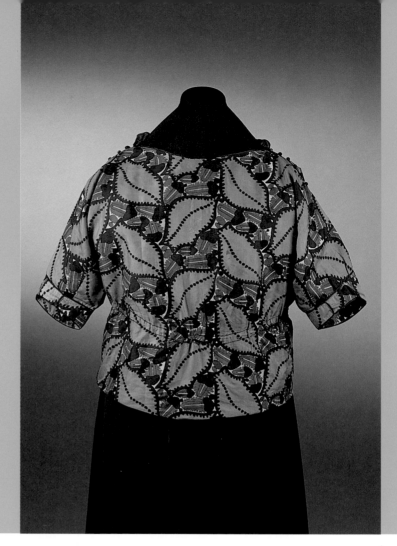

290 Wiener Werkstätte
Gustav Klimt with Emilie Flöge, 1909

291 Wiener Werkstätte
Blouse (for Johanna Staude), 1910-15

re-configured, even more radically than before.

The design and making of garments has traditionally been viewed as artisanal rather than artistic, like the design and making of ceramics or furniture. Its status, however, has continued to rise during the last two hundred years. The single trait which most significantly distinguishes garments from other useful things is, plainly enough, the intimate nature of the relationship between the garment and its wearer. Paradoxically, it was because of this intimacy that even the most skilled and talented tailors and dressmakers were always regarded as servants in the court circles that determined social prestige, placed much lower on the social ladder than painters or architects. Their status did not begin to change until the mid-nineteenth century, when Charles Worth, the 'father of haute couture', re-defined the nature of that relationship. To begin with, Worth was a man,

a couturier, successfully imposing himself within the hitherto female, and therefore low-prestige, world of the dressmaker. Second, Worth was able to get his clients to come to his house, rather than the other way round, just as a patron might visit an artist's studio. Third, Worth proved himself a master not only of formal court clothing, but also of the more witty, fanciful and often historically based show costumes, modelled on famous paintings, commissioned for masquerade balls. The princess Pauline von Metternich went to a ball dressed by Worth as the devil, in a black costume embroidered with silver and crowned with two horns of diamonds. As Diana de Marly put it, 'he was catering for those who liked to be conspicuous'.[1]

Under Worth's leadership, in fact, haute couture became not only a luxury business, the interface between the silk and brocade manufacturers of Lyons and the world of the

aristocracy and the Court, but also a vehicle for publicity which favoured both the client and the couturier. Costumes for masquerade balls became the showcase for the designer clothes which, significantly enough, had no everyday use but were one-offs worn to give substance to a fantasy and to create a theatrical effect. Moreover, unlike paintings or other domestic objects, these clothes had no lasting market value beyond the original transaction between designer and client, although discarded court dresses would be sold off to American clothes-for-hire outlets. They were viewed by their original wearers as ephemeral. In fact, rich clients rarely wore the same dress more than once, however much they had paid for them. In contrast to fashion, however, the prestige of painting was closely bound up with its durability and the historically transcendent values it embodied. In fine art, too, display and fantasy

193 Paul Poiret
La Perse, 1911

had the upper hand over use and practicality, but fashion could never hope to achieve the status of an art until it overcame its ephemerality, which was closely associated with its theatricality.

At the same time, however, couture entered into a complex two-way relationship with painting, as dress designers thought in terms of visual tableaux and looked to art for inspiration, while artists painted portraits of clients who wore the clothes they had acquired from the couturier. The predominance of the clothed figure as a subject for the artist meant that an ability to paint the texture of fabrics and drapery was a necessary skill both for the historical painter and the portraitist. The couturier, like the painter, needed a particular awareness of human anatomy and a visual flair for images which would flatter the client. Portrait painter and dress designer necessarily inhabited the same visual domain. A society portrait was, in a sense,

a collaborative project, on which the painter worked at one remove from the designer. Painters like Degas and Whistler behaved like stylists, choosing exactly what their client ought to wear, fretting over a hat or a fold. Worth's dresses were recorded by a whole spectrum of painters, from Winterhalter and Carolus Duran through to Renoir and Manet. Painters as great as Cézanne and Monet drew on fashion magazines for their imagery. Whistler himself designed the Japonesque dress worn by Mrs Leyland in his 1873 portrait. Conversely, Worth was only the first of a string of couturiers to pride themselves on their achievement as Sunday painters and to seek out the company of artists.

Inevitably, the worlds of art and fashion began to converge. The crucial turning-point came with the Arts and Crafts revival that swept across Europe towards the end of the nineteenth century, a movement that overlapped with the

rise of Aestheticism and the Rational or Reform Dress movement, which aimed to create and popularize clothing for women which would be hygienic, aesthetic and practical. The right conditions were thus created for a radical change in the nature of clothes design, combined with a further blurring of the line between art and fashion. We can see this clearly in the work of E.W. Godwin, who was put in charge of the fashion department at Liberty's in London at the end of the century, and, especially, in the work of the Wiener Werkstätte in Vienna, with its flourishing department of dress design and its programmatic policy of fostering interchange between the arts. The Hellenic style favoured by Godwin was reflected at the same time in the paintings of Moore, Leighton and Alma-Tadema, who found, so to speak, an expressive precursor of Rational Dress in classical revivalism. Given further impetus by the success of Isadora

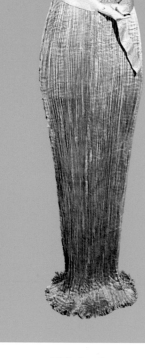

87 Mariano Fortuny
Delphos dress, c. 1910

161 Henri Matisse
Mandarin's Costume for 'Le Chant du Rossignol', 1920

Duncan's tours of modern dance, for which she wore neo-Greek costume, Hellenism had a crucial impact on fashion soon after the turn of the century. Its mark can be seen directly in Mariano Fortuny's Knossos scarves and the Delphos dress which made its first appearance in 1907, the same year that Paul Poiret launched his Neo-Classical line known as 'Directoire', inspired by the fashions of the period between the fall of Robespierre and the coronation of Bonaparte.

The Arts and Crafts Movement, in its closing years, consciously embarked on a programme of expansion into dress design. The Dutch architect and designer, Henry van de Velde, described clothing as the movement's 'last conquest', following architecture, furnishing, articles for daily use and 'decorative items'. In Austria, the greatest of Viennese *fin de siècle* painters, Gustav Klimt, was directly linked both to the Arts and Crafts Movement through his ties to the Wiener

Werkstätte, founded in 1903, and to the fashion world through his wife, Emilie Flöge, who was herself a dress designer. Not only did Flöge draw on Klimt's work as a painter, but Klimt himself began to design 'Art Dresses' at around the same time that Poiret made his own decisive break with traditional couture. As Kirk Varnedoe has pointed out, Flöge was quick to understand, with the help of Poiret's innovations, that Reform dress 'could be made appealing on other than just orthopaedic grounds'.[2] Reform dress, in effect, was re-packaged as Neo-Classical. In 1905 the Wiener Werkstätte established its own textile workshop, whose director, Eduard Wimmer-Wisgrill, consciously entered into dialogue with Poiret through his own dress designs. Both Flöge and the Wiener Werkstätte combined the influences of Poiret and Liberty to create designs which reflected the impact of Klimt's painting, the new Paris couture, Reform

Dress and elements from folk culture, typical of the Arts and Crafts Movement.

The Wiener Werkstätte group's admiration for Poiret was publicly reciprocated by the couturier himself. Poiret visited Vienna in 1911 to show his own collection and to lecture, but, subsequently, enthusiastic about what he had seen, he bought large quantities of fabric from the textile workshop, and then went on to visit Brussels in order to admire the Palais Stoclet, designed by the Viennese architect and Wiener Werkstätte designer, Josef Hoffmann. Hoffmann is notorious for designing not simply the palatial home of his client, a wealthy industrialist, but also the clothes which he should wear within it. As a result of these contacts, Poiret eventually set up his own interior design business with a supporting fabric workshop, *L'Ecole Martine*, where he employed uneducated teenage girls to create designs based solely on their own

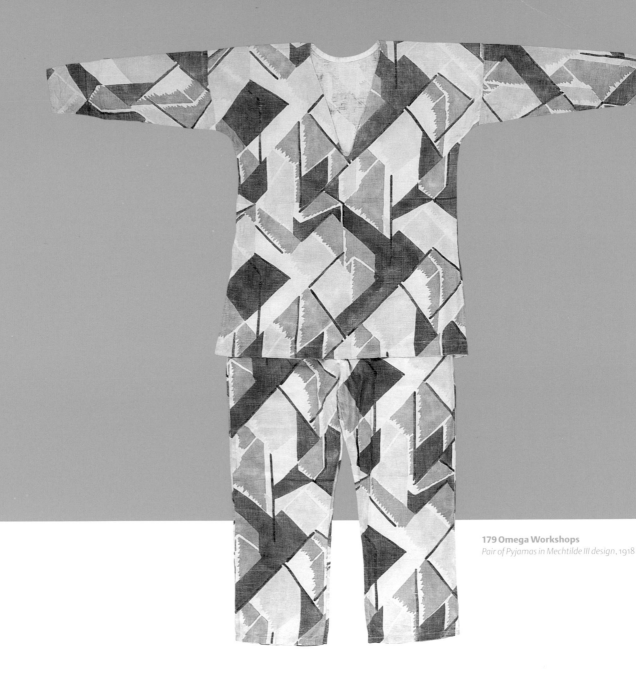

imagination, without any formal design training beyond exposure to existing work that Poiret admired. At the same time, Poiret commissioned early modernist artists, such as Dufy and Derain, to make fabric designs for his couture collections. Throughout his early career, we can detect the competing influences of Hellenism and Fauvism in his work, as he sought to combine his preference for flowing, unconstricted lines with the highly saturated colour palette of the Fauve painters.

The other decisive influence on Poiret was Orientalism – in this respect his work ran in parallel with Bakst's costume designs for Diaghilev's Ballets Russes, especially *Schéhérazade*, which premiered in Paris in 1910, just after Poiret had returned from a trip to North Africa. 1910 was also the year in which Henri Matisse visited the Islamic art exhibition in Munich, an experience which persuaded him to

embark on a series of painting trips to Morocco, which Poiret had also visited. Just as Matisse used the colour and ornamentalism of Moroccan costume as a decorative device in his paintings, so Poiret used the same elements in his couture. By this time the Liberty and Arts and Crafts Movement had effectively broken up, to be replaced by the much more amorphous tendency now known as Art Deco. Poiret stood on the divide between the two periods, but his influence made itself felt in a number of subsequent attempts to bring art together with fashion. Prominent among his followers were the Bloomsbury-led Omega Workshop group in London, who were directly influenced both by the Ballets Russes and by the example of *L'Ecole Martine*. Roger Fry, the main force behind Omega, had been to Paris in 1912 to organise a show of English art at the Galerie Barbazange, an art gallery sponsored by Poiret and located in the

same building as his fashion house. Poiret's work fitted closely with the Bloomsbury mixture of Post-Impressionist influences with a modernized Arts and Crafts aesthetic.

The Bloomsbury group – Vanessa Bell, Duncan Grant, Roger Fry – were defenders of the radical modernism which developed out of cubism, but never fully absorbed it, broadly remaining within a less ambitious, more decorative tradition. The mainstream of modernism, in contrast, developed in the direction of a rationalist and functionalist aesthetic, obsessed with a geometry of lines, angles and volumes, envisaging the future in terms of a new kind of technological society. Italian Futurism, the most extreme of the new avant-garde movements, saw itself as leading the struggle to create a dynamic new culture which would revolutionize clothing as well as painting, poetry, architecture, music, film and even cuisine. Beginning as early

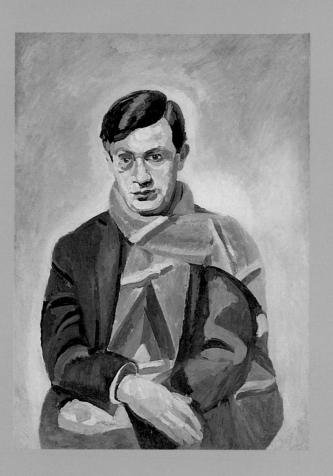

48 Robert Delaunay
Portrait of Tristan Tzara, 1923

66 Sonia Delaunay
The Window of the 'Boutique Simultanée', 1925

as 1913, Giacomo Balla designed brightly coloured, geometrically patterned clothes for both men and women, continuing until the 1930s. In the post-revolutionary Soviet Union, the Russian Constructivists – Stepanova, Rodchenko and others – followed a similar course, but with an emphasis on design for mass production, for workers rather than for an élite. In retrospect, these avant-garde artist-designers look wildly utopian in their revolutionary aspirations, but their work makes the Parisian couture of Chanel or Patou seem tame by comparison. Other avant-garde artists of the time, such as Léger and Schlemmer, restricted themselves to designing for the modern ballet, where a visionary approach was acceptable and even desirable.

Haute couture simplified itself radically during the 1920s, broadly in line with the new modernist aesthetic, addressing itself at the same time to a new and wider market extending beyond the traditional élites of a society discredited by the First World War. Artists such as Sonia Delaunay and Natalia Goncharova, who had played an important role in avant-garde movements during the war years, eventually found their way into the world of Parisian couture, where they began to work as designers for the fashion houses of Heim and Myrbor respectively. An artistic approach which had been startlingly innovative in earlier years was now transposed into a more decorative register, while still maintaining elements of the Simultaneist and Rayonnist past. In some respects, the triumph of modernism in the 1920s threatened to drive a wedge between fine art and the decorative arts, which came under increasing pressure from the move towards purist abstraction and a rationalist anti-ornamental aesthetic. The project of fusing the arts and crafts was only possible if both were seen as essentially decorative in nature. The shift towards functionalism encouraged a trend towards more practical sports-oriented clothes in fashion, garments suited to a range of active bodily movements. Rationalism meant a move away from the taste for conspicuous luxury and ornament, which had long been basic values of haute couture.

As Anne Hollander has noted, the 1920s brought with them a trend towards a more masculine, tailored look, which celebrated the ideal of a fit and healthy body produced by diet, exercise and athleticism.[3] For Hollander, Worth inaugurated a process of long overdue modernization in the world of high fashion, directly attributable to his typically masculine background in tailoring. This process was carried inexorably onward by the Rational Dress movement, leading, first to Poiret's abolition of

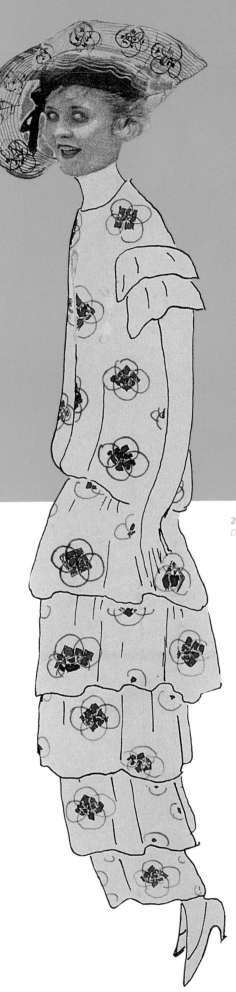

211 Alexander Rodchenko
Design for a dress, 1924

99 Natalia Goncharova
Dress design ('Borromées'), c. 1922-25

the corset and finally, between 1925 and 1935, to the establishment of a new school of couture, which displaced ornament into the realm of accessories, such as the costume jewellery favoured by Chanel. As a consequence, Hollander proposes, 'men and women had visual equality because female dress for the first time was following the masculine example in basic conception', so that women were able 'to look as real as men', rather than appearing as figures of fantasy. In other words, modernization meant the abolition of extravagant flights of fancy and the rhetorical misrepresentation of the body by clothes which distorted its underlying shape. Clothes became rationalized as the modernist aesthetic had demanded. Under the leadership of female designers, such as Chanel, Grès and Vionnet, haute couture could now be celebrated by Hollander in functionalist terms, for 'the working beauty of the garment in wear'.

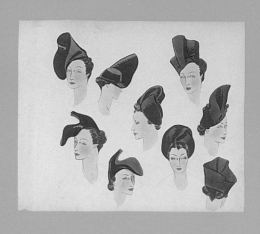

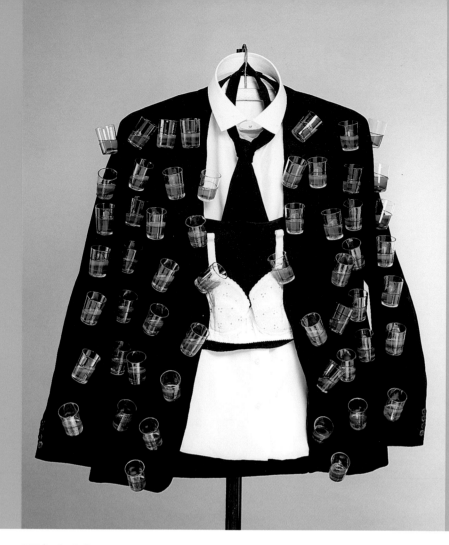

217 Elsa Schiaparelli
Drawing for Shoe Hat, Winter 1937

46 Salvador Dalí
Aphrodisiac Dinner Jacket, 1936, reconstruction

Male designers, in contrast, Hollander argued, 'generally continued, as most still do, to emphasize the total visual effect', in the tradition of Worth and Poiret – a contrast, as Hollander puts it, between 'optical' and 'tactile' values. Significantly, there is only one female designer whom Hollander specifically exempts from her general rule that, in the world of fashion, female is to male as tactile is to optical – Elsa Schiaparelli, whom she describes as 'staying always with purely optical excitement'. Schiaparelli rejected the 1920s modernism of Chanel, turning instead to the pictorial counter-tendency of surrealism. She paid homage to Poiret and, like him, surrounded herself with artists – Man Ray, whose career as a fashion photographer had begun working for Poiret, alongside Salvador Dalí and Meret Oppenheim, who was introduced to her by Man Ray. Schiaparelli also experimented with new materials – cellophane, glass, plastic, parachute silk – and deliberately gave exaggerated prominence to accessories. Fantasy in design always gravitates towards the bodily extremes, towards hats, gloves and shoes, which can be extravagantly shaped without affecting the basic form. Schiaparelli never allowed her penchant for optical excitement to detract from an architectural approach to dress. 'The body', she noted, 'must never be forgotten and it must be used as a frame is used in a building. The vagaries of lines and details or any asymmetric effect must have a close connection with this frame'.[4]

The onset of the Second World War created a deep crisis in the world of couture and the post-war recovery did little to close the gap which had emerged between art and fashion, partly for institutional reasons as New York now replaced Paris as the centre of the art world. Although Jackson Pollock paintings were used as backgrounds for fashion shoots in *Harper's Bazaar*, Abstract Expressionism as an art movement was far removed, culturally and geographically, from the world of couture. The new painting was resolutely American, distancing itself consciously from Paris, where couture was still struggling to re-establish itself. Signs of a new *rapprochement* between art and fashion began to re-surface only in the 1950s. The most important new development was the appearance of Performance Art, a genre which inevitably brought artists back to a preoccupation with clothes. Performance involved the creation of costumes, as designing for dance or theatre had done in the past, but intended now specifically for the artists themselves, worn as a form of self-expression or as an element in a quasi-ritual context. Performance art was a global phenomenon and, during this period, we find self-designed clothes

258 Atsuko Tanaka
Untitled (Study for Electric Dress), 1956

71 Jim Dine
All in one lycra, 1965

in artists' performances in Japan and Brazil as well as in Europe and North America. Right through into the 1970s, artists involved in performance, such as Jim Dine or Vito Acconci, incorporated clothes in assemblages or, as with Acconci, designed them as art-objects.

The 1960s brought another wave of enormous change in both the art and fashion worlds. In London, New York and Paris, designers responded to the new youth culture and to parallel developments in the art world – especially Pop and Op art. There was an overdue rejuvenation of Paris couture, as designers like Paco Rabanne and André Courrèges created simple and striking 'Space Age' clothes, angular and geometrical, with contrasting colours or, in Rabanne's case, innovative materials, such as metals and new types of plastic. As Georgina O'Hara put it, 'Rabanne made dresses using pliers instead of needle and thread'.

He described himself as a provocateur and titled his first collection '12 Unwearable Dresses'. In New York, designers illuminated dresses with electric lights, as the performance artist, Atsuko Tanaka, had done in Japan in 1956. Others, such as Rabanne and the artist, Harry Gordon, used paper as a material for garments, crinkled or printed in Pop style. In some respects, particularly through the use of new technologies and the emphasis on strong visual impact, the 1960s carried echoes of Schiaparelli, but in other ways, everything was completely transformed. Pop, Op and Colour Field painting replaced surrealism as the main points of reference in the fashion world, taking us back to the 1920s and the ready-to-wear designs of Rodchenko and Stepanova. There was a similar revival of interest in Constructivism within the art world too, as artists looked for new ways of bridging the gap between avant-garde art and popular culture.

The *rapprochement* between art and couture reached a decisive point in March 1982, when the New York magazine *Artforum* featured on its cover a collaborative work by the Japanese designer, Issey Miyake, and the bamboo artist, Koshige Shochikudo, a fusion of fashion, craft-work and sculpture. The *Artforum* feature on Miyake signalled the beginning of a new relationship between art and couture. Traditional forms of painting and sculpture had lost their automatic hegemony within the art world, giving way to installation work, conceptual art and other non-traditional genres, which gradually began to include the use of clothes. Eventually a new genre in its own right began to emerge – sometimes loosely referred to as 'clothes art'. At the same time couturiers began, not simply to surround themselves with artists, as Poiret and Schiaparelli had done, but to consider themselves as artists in their own

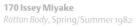

170 Issey Miyake
Rattan Body, Spring/Summer 1982

right. The 1960s and 1970s had created the foundation for a thorough-going intersection of the two worlds which would lead eventually to clothes being exhibited as artworks and artists beginning to invade areas, including the world of clothes, previously reserved for designers.

Conversely, in recent years, designers such as Lun*na Menoh and Helen Storey, have moved out of fashion into the art world, exhibiting their work directly in galleries and museums – Lun*na Menoh even carries the runway show into an art world setting as an event in her annual Los Angeles shows. In the 1980s, new movements such as 'Wearable Art' and 'Conceptual Clothing' began to take shape alongside the (by now) traditional use of clothing in performance and installation contexts. Artists in these new fields come from both art and craft backgrounds and, in effect, a new type of crossover Arts and Crafts aesthetic has begun to develop, looping back to

the beginning of the century, without there being any discernible direct influence. The Japanese designers, in particular – Issey Miyake, Rei Kawakubo at Comme des Garçons, Yohji Yamamoto – come from a tradition in which there is no clear-cut distinction between arts and crafts. Indeed, it is for this very reason that *Japonisme* was such a major influence on the development of the original Arts and Crafts Movement in Europe. Rei Kawakubo, in particular, tends to see her clothes as elements in a total environment, reminiscent of those created by the Wiener Werkstätte – meticulously designing her shops as if they were art installations, while looking back to modernist designers such as Eileen Gray for inspiration. As she herself put it, 'I try to reflect my approach not just in the clothes, but in the accessories, the shows, the shops, even in my office. You have to see it as a total impression and

not just look at the exposed seams and black'.

The Japanese designers also experiment with new materials – Miyake employs technical experts in his Miyake Design Studio to explore the possibilities of new fabrics and new manufacturing technologies. The experimental use of strange and eccentric materials is one of the features now linking art and couture. Ceramic, for instance, has been used by both Tiziana Bendall-Brunello, an artist, and Martin Margiela, a Paris couturier. Other artists and designers are experimenting with woven stainless steel, rubber bands, newspaper, thistledown, wood and glass. A number of artists and designers are also concerned with the re-configuration of the outline shape of the body through provocatively 'sculptured' clothes. Both Georgina Godley and Rei Kawakubo have designed clothes which distribute concave and convex forms in contradiction to basic body

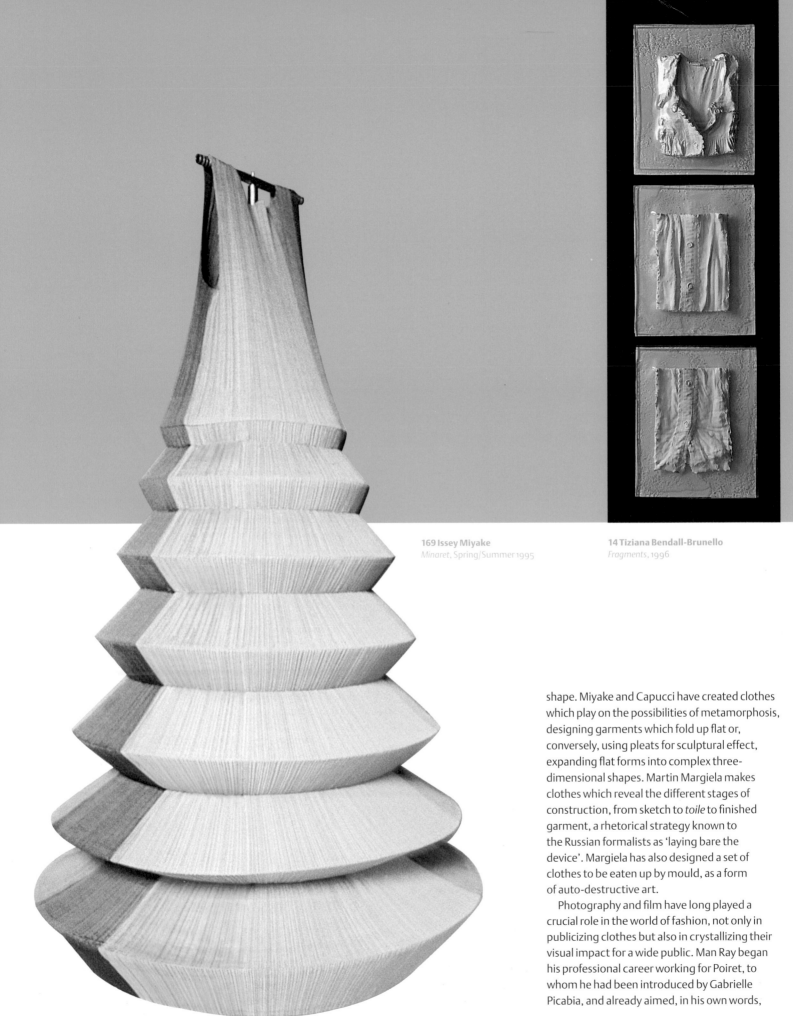

169 **Issey Miyake**
Minaret, Spring/Summer 1995

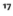

14 **Tiziana Bendall-Brunello**
Fragments, 1996

shape. Miyake and Capucci have created clothes which play on the possibilities of metamorphosis, designing garments which fold up flat or, conversely, using pleats for sculptural effect, expanding flat forms into complex three-dimensional shapes. Martin Margiela makes clothes which reveal the different stages of construction, from sketch to *toile* to finished garment, a rhetorical strategy known to the Russian formalists as 'laying bare the device'. Margiela has also designed a set of clothes to be eaten up by mould, as a form of auto-destructive art.

Photography and film have long played a crucial role in the world of fashion, not only in publicizing clothes but also in crystallizing their visual impact for a wide public. Man Ray began his professional career working for Poiret, to whom he had been introduced by Gabrielle Picabia, and already aimed, in his own words,

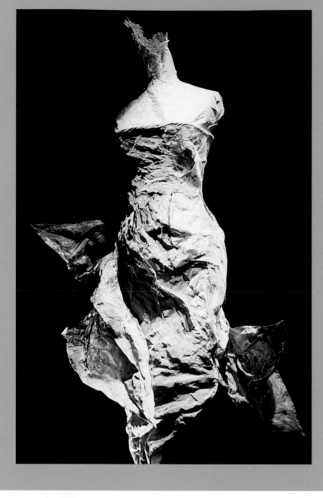

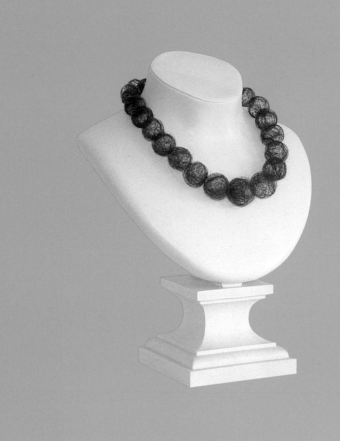

166 Deborah Milner
Stainless Steel Dress, February 1998

113 Mona Hatoum
Hair Necklace, 1995

to 'combine art and fashion'. The relationship between couture and photography has remained a close but complex one, establishing a common visual domain between the forms, just as couture had previously established a parallel relationship with society portraiture. Much of today's couture is designed for the camera as well as for the wearer, for visual impact as well as for tactile wearability, and artists are increasingly involved in fashion photography – Cindy Sherman for Comme des Garçons, Nan Goldin for Matsuda. Indeed, in the fashion world, runway shows have become much more performance oriented, at times overlapping with performance art, and this, in turn, encourages the use of video, not simply as a recording medium, but as a creative medium in its own right. At the same time artists use clothes-related performances as a source for their own video art. The aesthetic divide between the two

worlds will become increasingly permeable, as the aesthetics of mixed and new media continue to develop.

In her book, *Sex and Suits*, Anne Hollander suggests that fashion is art because of its ability to create 'complete figural images', bodily shapes both psychologically and physiologically 'real' and 'modern'.[5] Fashion, she proposes, has always had a close relationship with visuality and yet, at the same time, we have a tactile awareness of the clothes we wear or imagine ourselves wearing. Couture, she argues, seeks, at its best, to reconcile these two aesthetics, the optical with the tactile. In the avant-garde of fashion, I would argue, the optical and the tactile are often placed in dynamic tension, rather than reconciled. Moreover, these terms, drawn from the discourse of art history, run in parallel with the distinction conventionally made between the arts and the crafts. This rigorously

maintained distinction began to unravel in the 1960s, and its breakdown (often noted under the rubric of 'post-modernism') led to the emergence of a 'third area' in a field previously dominated by painting and sculpture, to be supplemented and indeed challenged by performance, video, and installation. The craft dimension of fine art has been disavowed for most of the century, and now the pendulum is swinging back, in a disturbing return of the repressed. The Kantian doctrine of the disinterestedness of the optical begins to disintegrate. Artists turn to fashion, just as clothes designers turn to the fine arts, in order to explore the dynamic and often conflicting relationship between optical and tactile, fine and applied art, a sense of pure form and a sense of design for use. The dialogue between them is still at an early stage, but its productivity can no longer be denied.

129 Komar and Melamid
Sears Jacket, 1991

Notes
1 Diana de Marly, *Worth: Father of Haute Couture*, Holmes and Meier, New York, 1990 (first edition, Holmes and Meier, 1980).
2 Kirk Varnedoe, *Vienna 1900: Art, Architecture & Design*, The Museum of Modern Art, New York, 1986 (exhibition catalogue).
3 Anne Hollander, *Sex and Suits*, Alfred A. Knopf, New York, 1994.
4 Elsa Schiaparelli, *Shocking Life*, E.P. Dutton & Co., New York, 1954.
5 Hollander, op. cit.

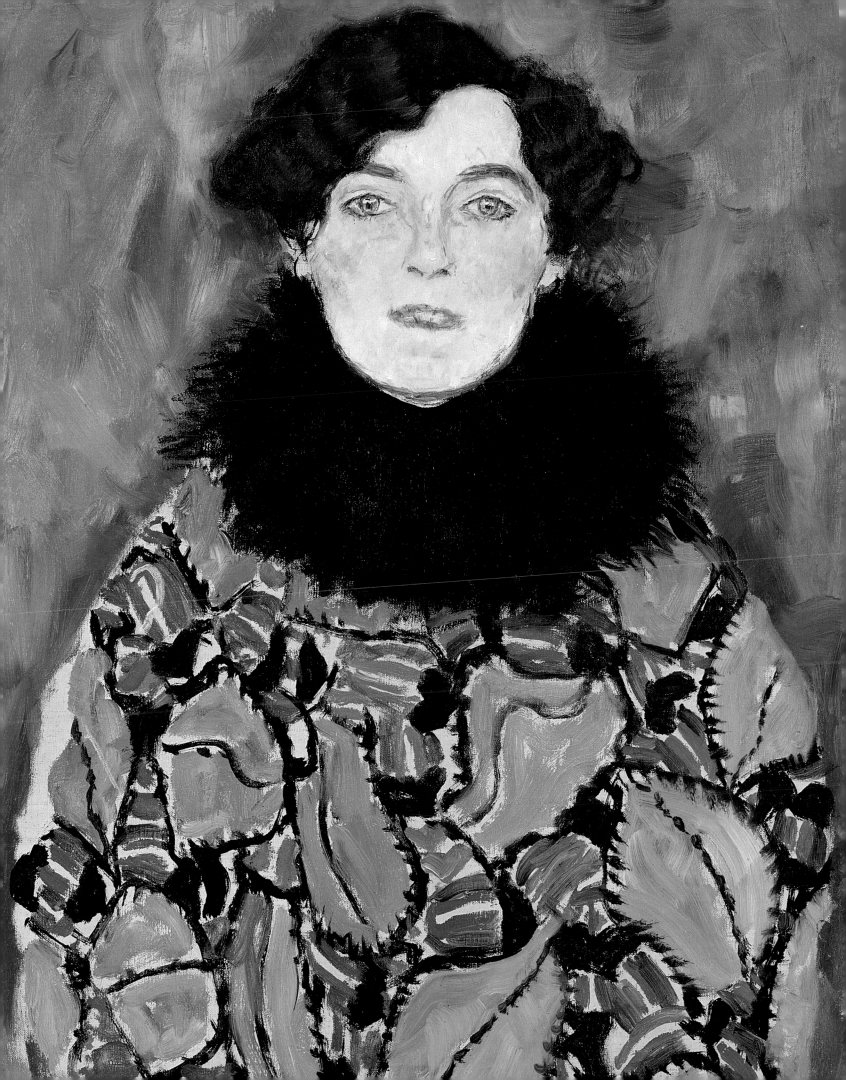

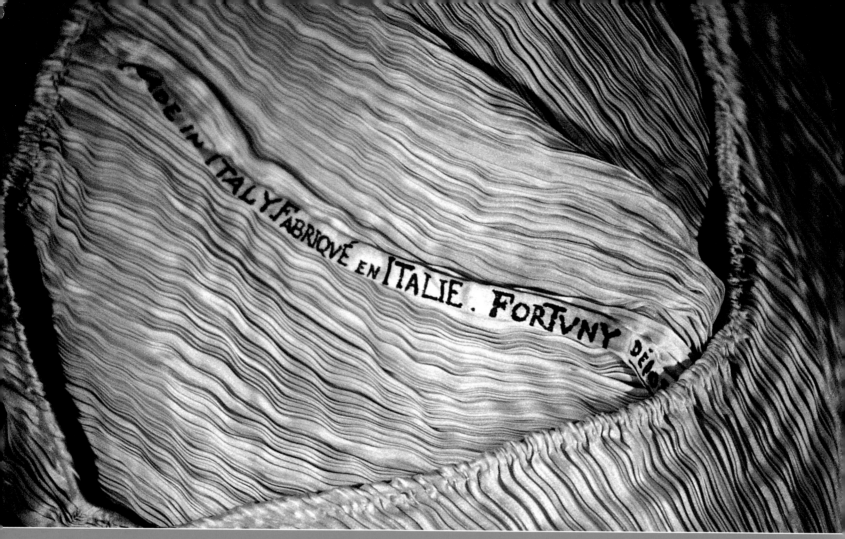

125 Gustav Klimt
Portrait of Johanna Staude, 1917-18, detail
(previous page)

Klimt, a Viennese artist, was married to the
fashion designer Emilie Flöge. Both were
involved in the Wiener Werkstätte workshops
and shared an interest in the integration
of art and design. Klimt paid particular
attention to the clothes worn by his sitters:
the fabric of the blouse worn in this portrait
was called *Blätter* (leaves) and was designed
for the Wiener Werkstätte by Martha Alber.

85 Mariano Fortuny
Delphos dress, c. 1910, detail of label
(above)

87 Mariano Fortuny
Delphos dress, c. 1910, detail
(right)

Fortuny began his career as a painter in Paris.
In 1899 his family moved to Venice where he
stayed, becoming interested in stage lighting
and costume and working with D'Annunzio
and Duse. His couture designs were inspired
by the iconography of Classical Greece and
were intended to be beautiful and theatrical,
but also practical. His pleated dresses were
sold rolled, in a small, signature bag.

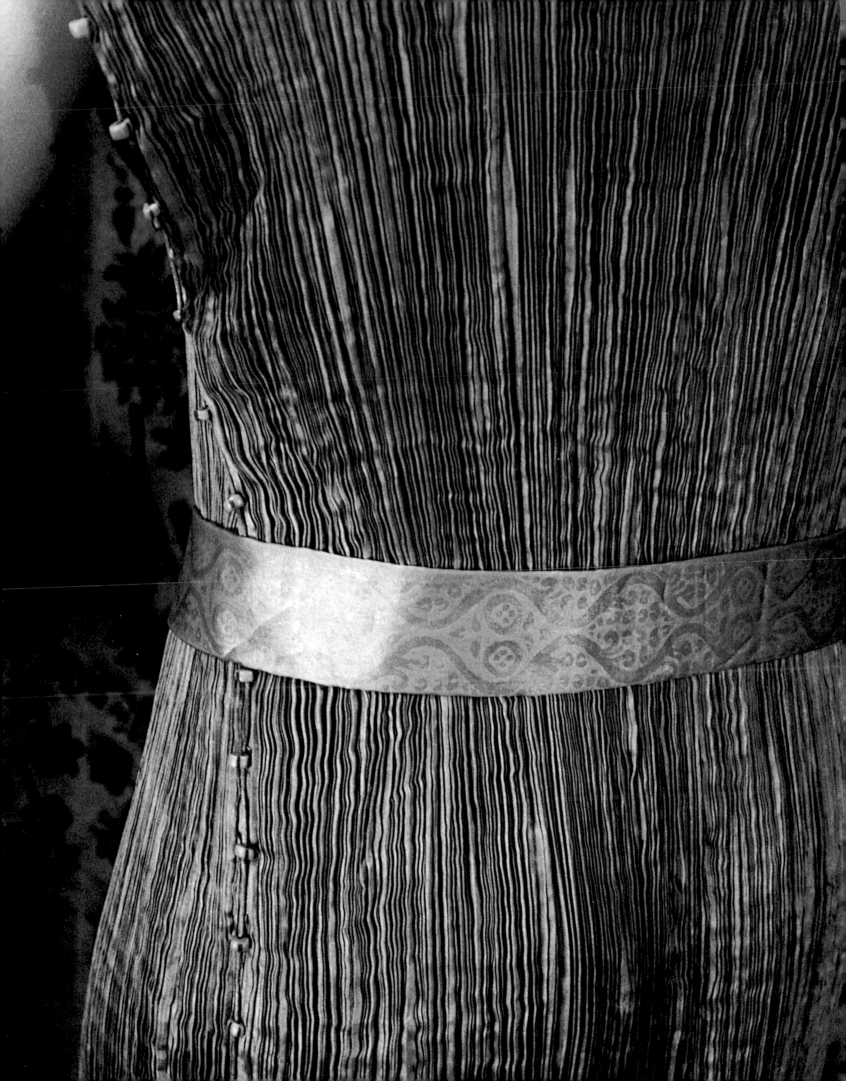

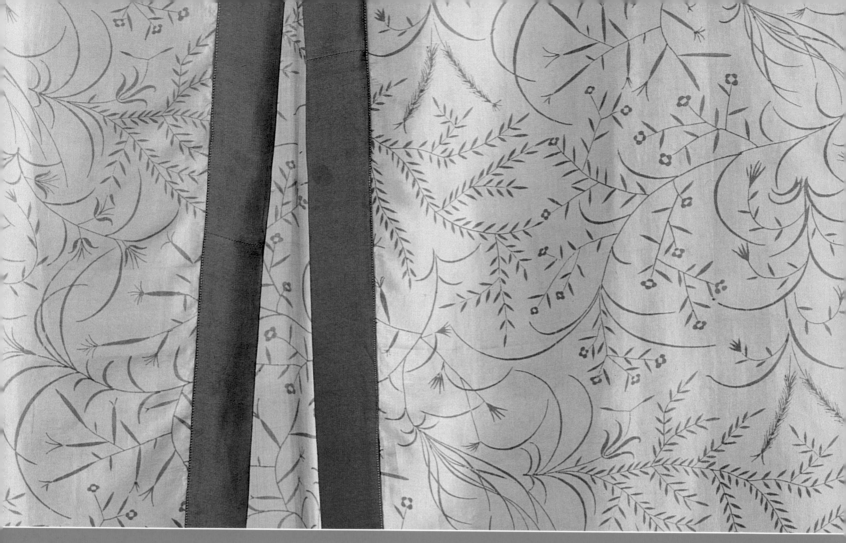

24 **188 Dagobert Peche**
Dress in 'Wicken' Fabric, detail
(above)

Peche, a textile and fashion designer, played
an active part in the Wiener Werkstätte,
the Vienna-based association of artists and
designers which was founded in 1903 and
which opened a textile workshop in 1905.
The designs produced in the workshop
were similar to those of Poiret in Paris,
the designers sharing an interest in luxury,
colour and decoration.

280 Madeleine Vionnet
Afternoon Dress, 1922, detail
(right)

Vionnet was a fashion designer and patron
of artists in Paris. She is known for the rigour,
subtlety and almost architectural precision
of her pattern cutting. Skilled in the handling
of fabric, she was the mistress of the bias cut.

56 Sonia Delaunay
Costumes for Cleopatra, 1918
(overleaf)

The French painter Sonia Delaunay, together
with her husband Robert, developed a style
known as 'simultaneism', which used
contrasting colour and shape to express
the speed and contradictions of modern
urban life. She began designing clothes and
theatre costumes to extend the range of
her formal vocabulary and to publicise her
theories of painting, and eventually became
a professional couturier, designing for the
house of Heim in Paris.

M-548

S. Delaunay

M-549

S. Delaunay

M-550

M-551

67 Fortunato Depero
Template for Découpage
(above)

Depero was an Italian Futurist who, together
with Balla, designed clothes for a 'Futurist'
way of life, concentrating especially on
clothes for men while criticising women for
their vanity and 'toilettitus'. This template
demonstrates a stage in Depero's method
of creating collaged textiles.

69 Fortunato Depero
Hat, 1929
(right)

According to the Italian Futurists, fashion,
one of the most immediate expressions of
modernity, 'has always been more or less
Futurist'. Futurist dress was to be 'aggressive,
agile, dynamic, simple, comfortable,
hygienic, joyous, asymmetrical, transigent
and variable', an event as much as an object.

**210 After a design by Alexander
Rodchenko**
Man's working suit and boots, 1922,
reconstruction c. 1979
(overleaf, left and right)

Rodchenko was part of the group of Russian
Constructivist artists in Moscow who
developed a style of art based on communist
beliefs and the rejection of purely decorative
elements in favour of a marriage of labour,
technique and organisation. For them art
was integrated with life, and this suit was
designed according to Constructivist
principles, to clothe the workers of the future.

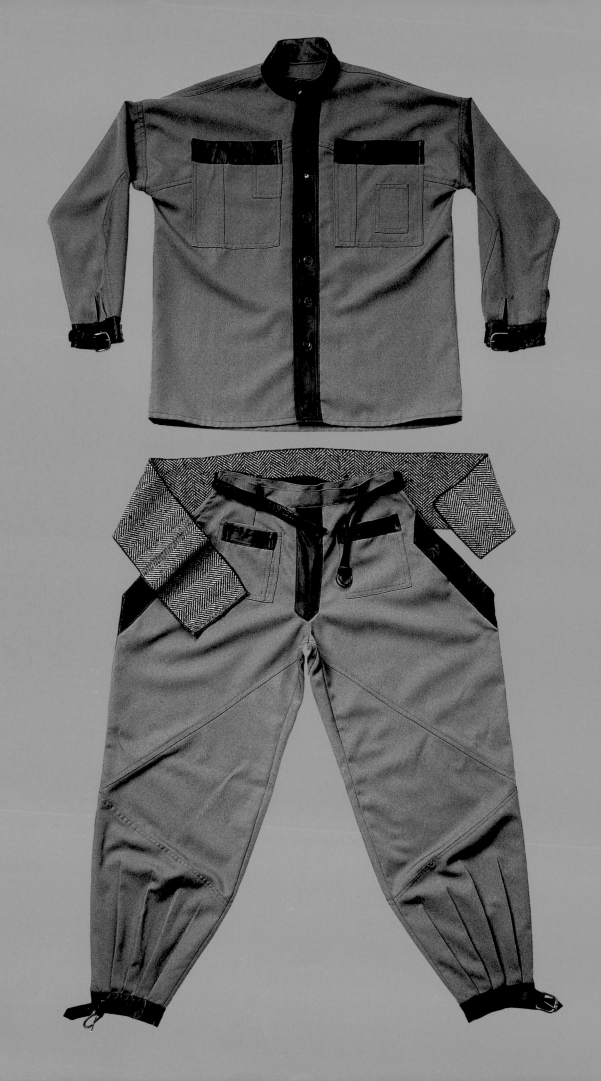

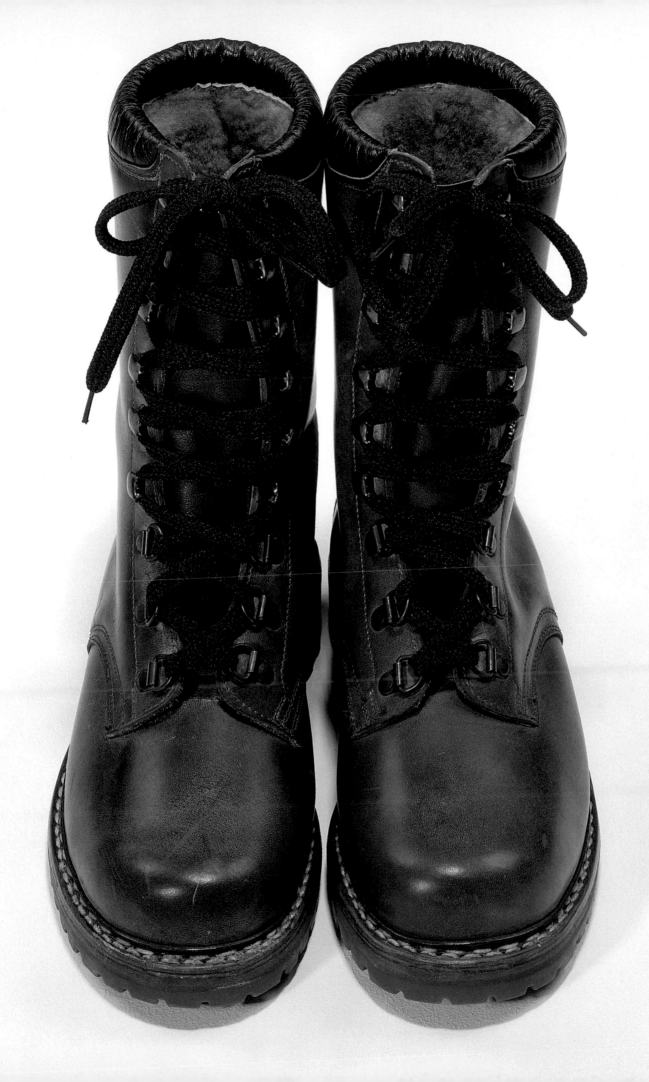

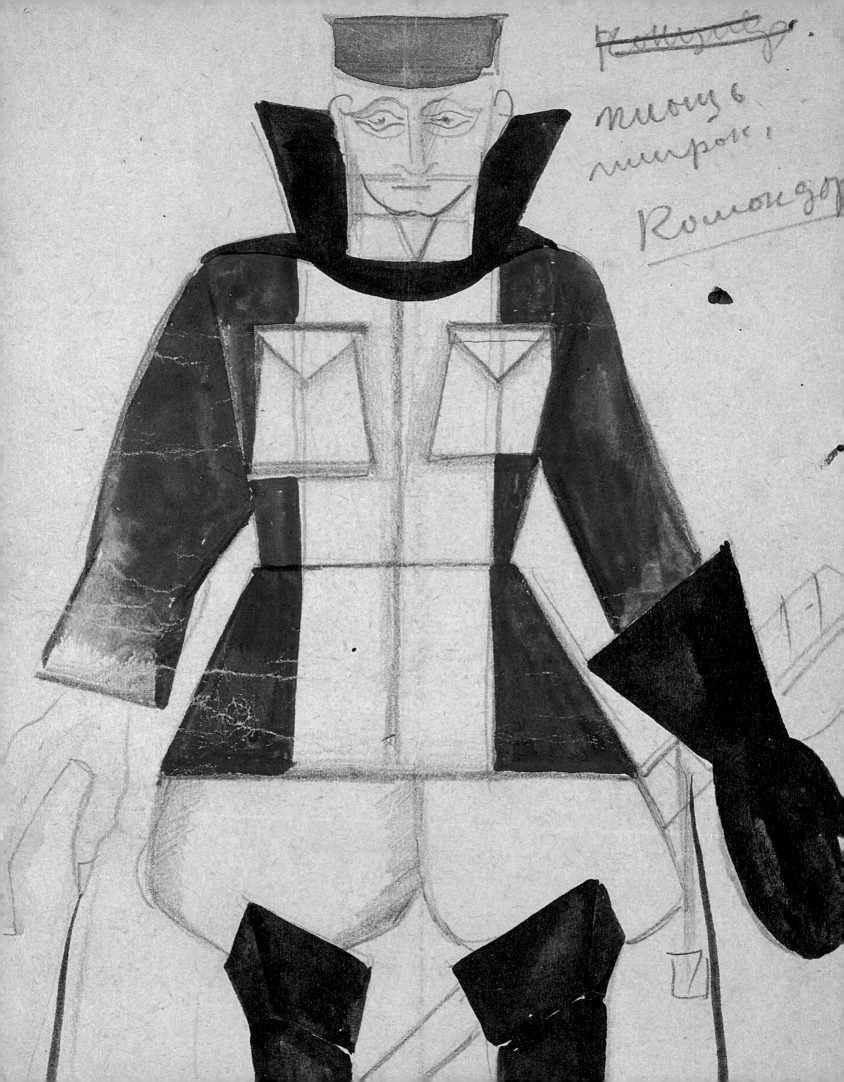

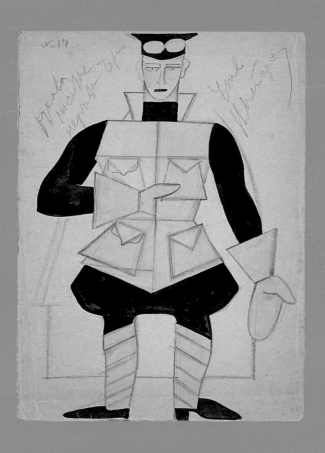

197 Ljubov Popova
Costume design for 'The World in Turmoil', 1923
(left)

198 Ljubov Popova
Costume design for 'The World in Turmoil'
(The Army Commander), 1923
(above)

Popova, like her fellow Russian Constructivist artists, used the theatre as a place to test out her radical ideas. She designed these two costumes for one of Vsevolod Meyerhold's avant-garde productions, which he saw as an opportunity to rethink traditional, illusionistic theatrical décor. Popova shared Meyerhold's anti-aesthetic approach, designing her costumes as prototypes for worker's uniforms.

199 Ljubov Popova
Clothes Design (Leto), 1924
(right)

Popova extended her work in many directions in her search for a new art for the socialist revolution, focused around the worker and the industrial production of useful, necessary things. This collage was made as a design for the cover of the magazine *Leto*.

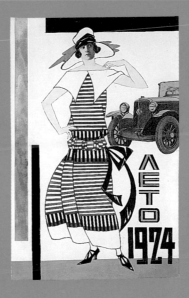

283 Constantin Vjalov
Costume design for Sten'ka Razin (Popi),
1923-24
(far left)

284 Constantin Vjalov
Costume design for Sten'ka Razin (Voivoda),
1923-24
(left)

282 Constantin Vjalov
Costume design for Sten'ka Razin (Harem),
1923-24
(above)

Designing for the theatre allowed Russian
artist Vjalov to pursue an integrated
approach to art and design, and to
experiment with actual as well as
represented movement in his geometric,
boldly coloured designs.

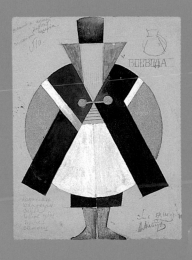

259 Ilja Tchaschnik
Design for a Dress, 1924
(left)

260 Ilja Tchaschnik
Design for a Dress, 1924
(above)

Tschaschnik, a Russian artist, experimented with dress design as an extension of painting, transferring pure colour and geometric shapes on to dress fabric to make avant-garde clothing for the masses.

246 Varvara Stepanova
Costume Design for 'The Death of Tarelkin'
(Doctor), 1922
(right)

The Russian Constructivist artist Stepanova designed costumes which would facilitate movement. Simple shapes reflected the form of the body and made strong linear patterns when viewed together on stage.

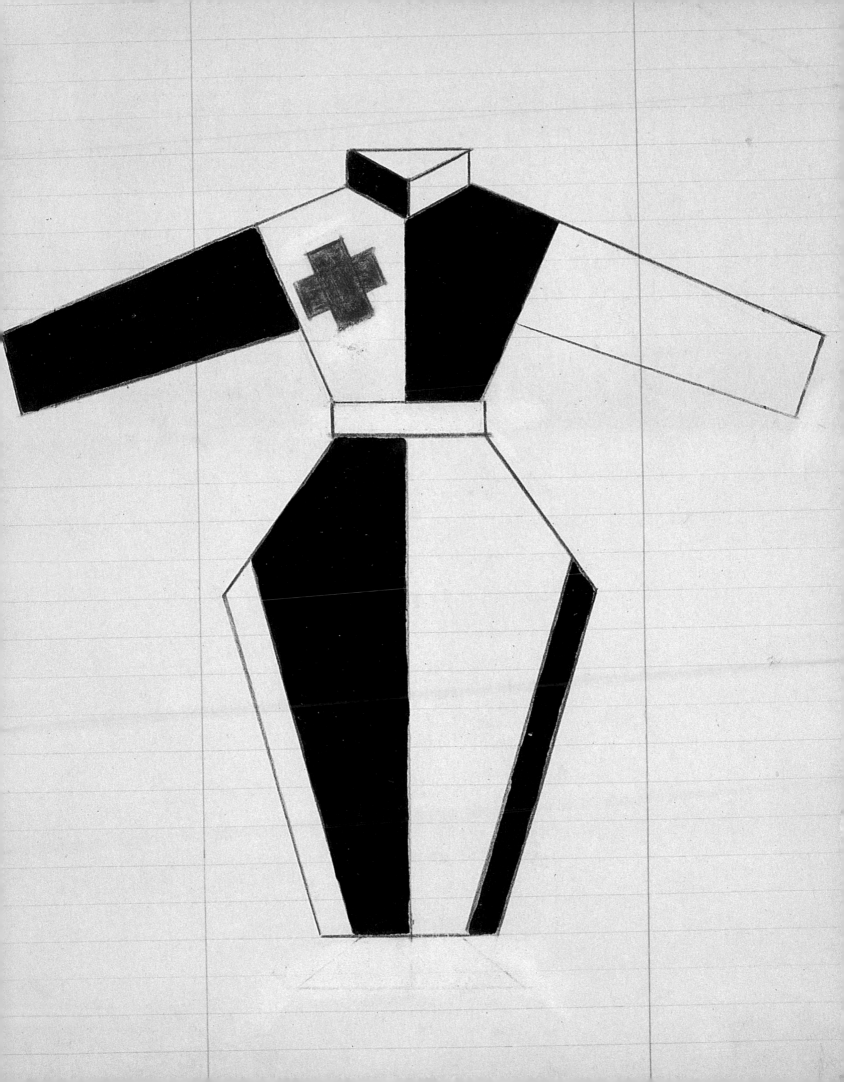

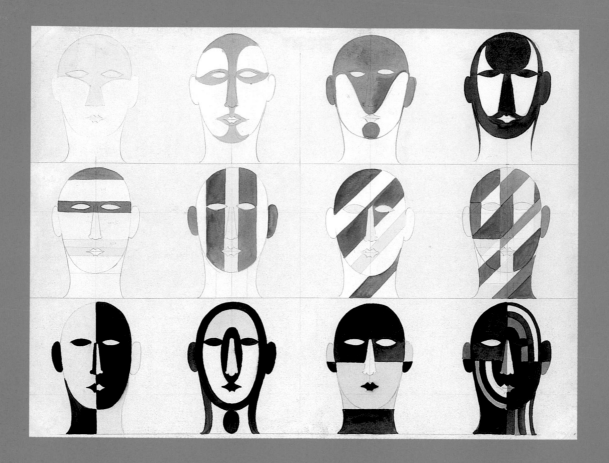

234 Oskar Schlemmer
Mask Variations, 1926
(above)

234 Oskar Schlemmer
Mask Variations, 1926, detail
(right)

Schlemmer was an artist and choreographer
who ran the Stage Workshop at the Bauhaus
School for the Arts in Germany from 1923
to 1929. He used masks to conceal the
expressions of his actors, transforming
them into groups of moving shapes in space.

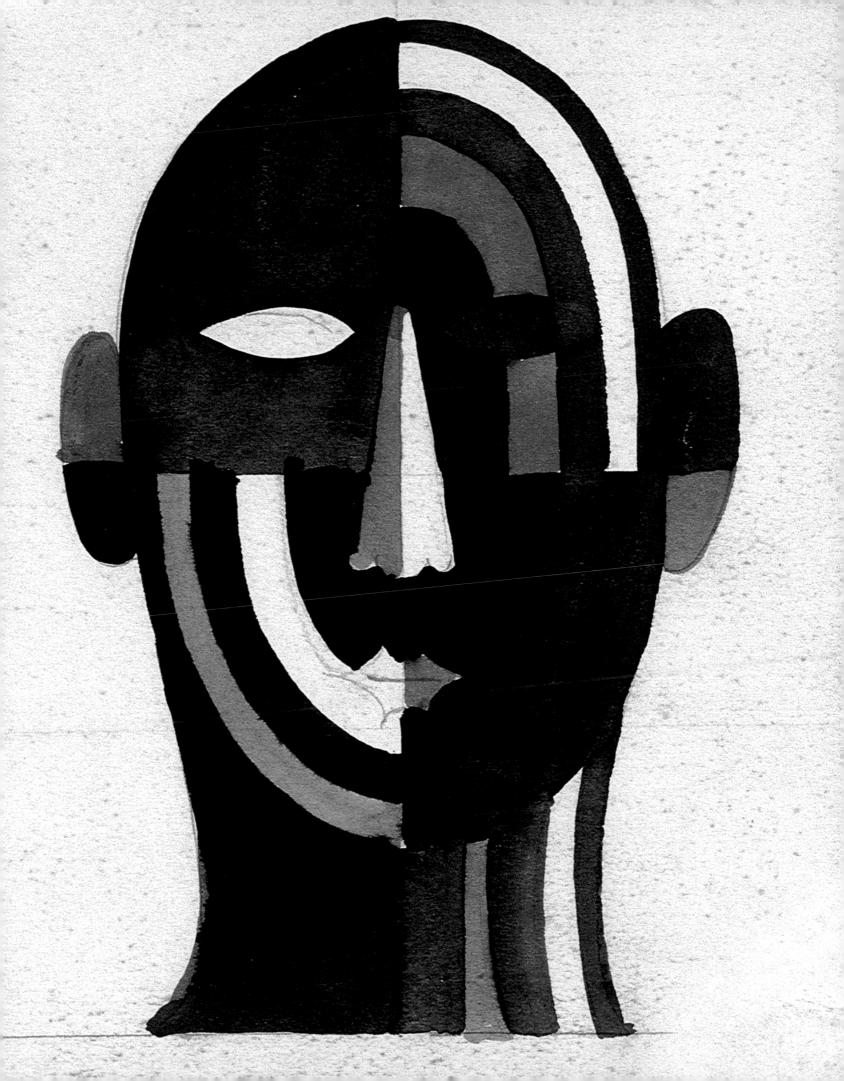

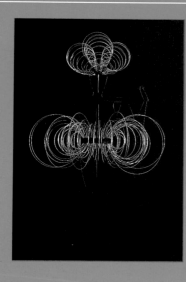

228 Oskar Schlemmer
*Wire Figure – Figurine from 'The Triadic Ballet',
Black Series*, 1922, reconstruction 1985
(left)

225 Oskar Schlemmer
*Golden Sphere – Figurine from 'The Triadic Ballet',
Black Series*, 1922, reconstruction 1967/93
(above)

227 Oskar Schlemmer
*The Abstract – Figurine from 'The Triadic Ballet',
Black Series*, 1922, reconstruction 1967/85
(right)

Schlemmer's *The Triadic Ballet* was the
most successful realisation of his theories
of performance. A fusion of three arts:
dance, costume and music; it used actors
as abstracted figures executing complex
geometric gestures within a predetermined
spatial web. The costumes extended the
contours of the actors' bodies into space,
their individuality obscured by the use of
heavy padding and metal shapes.

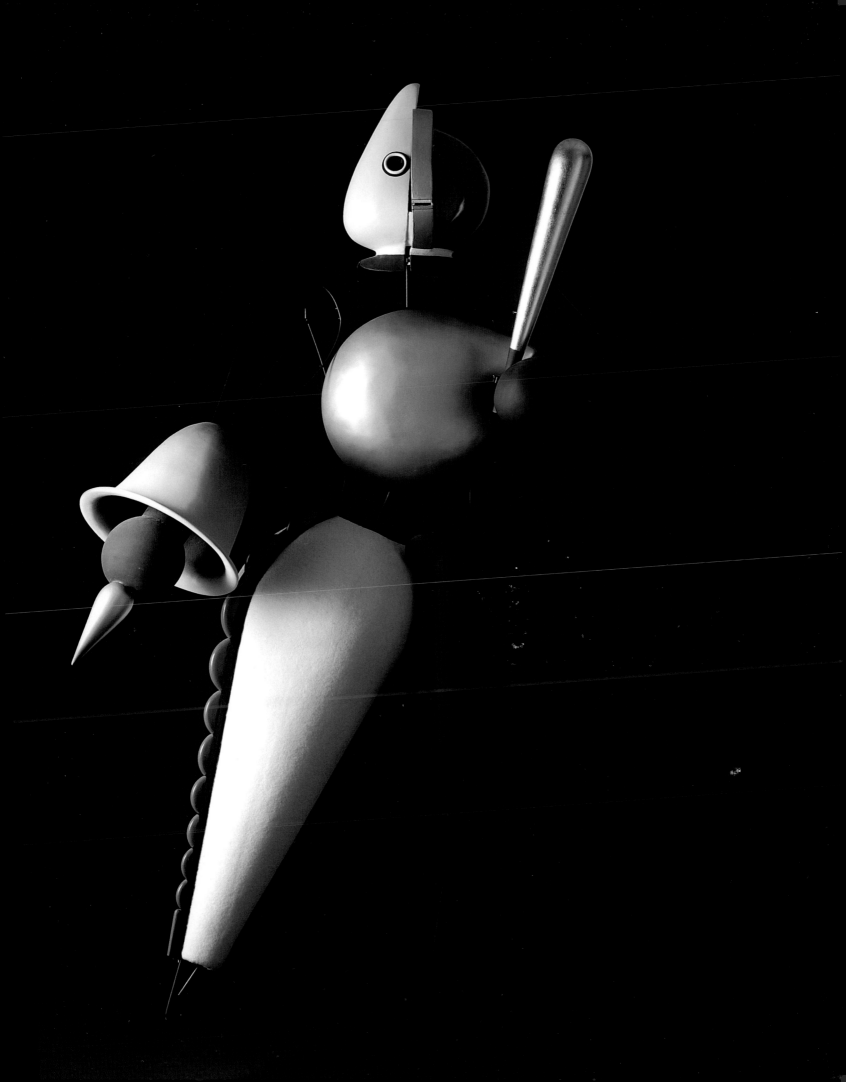

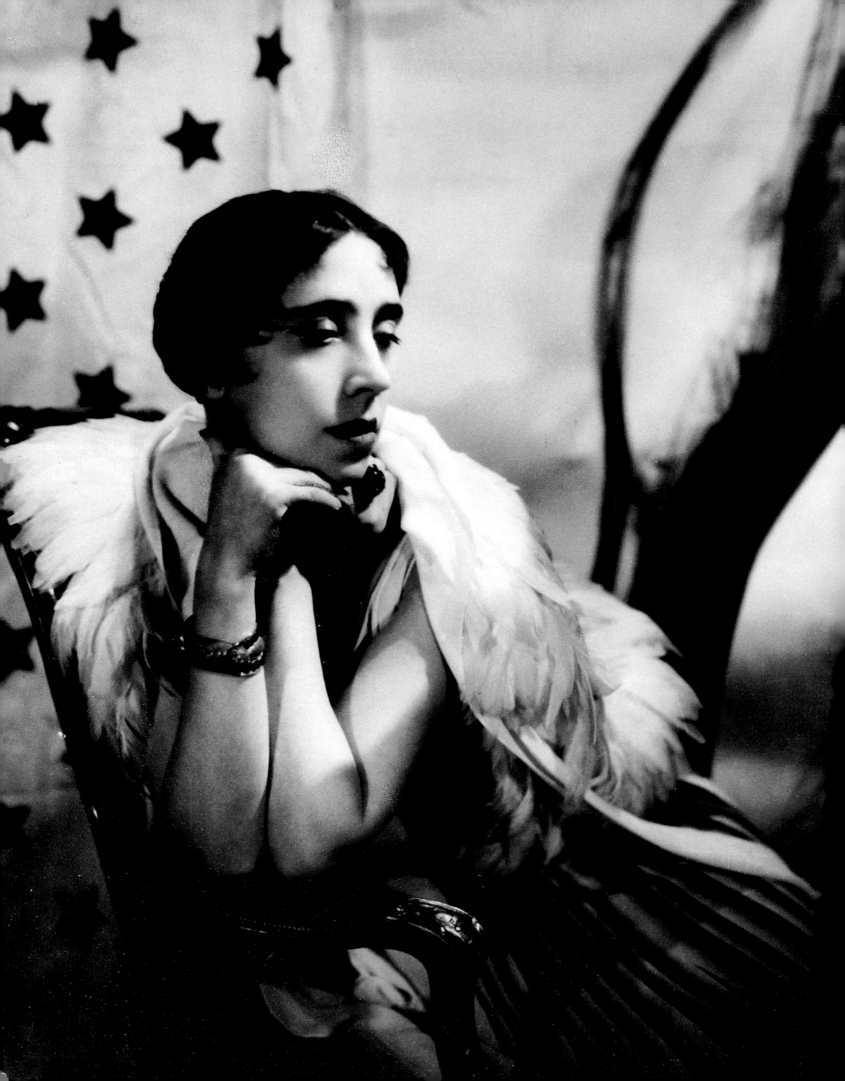

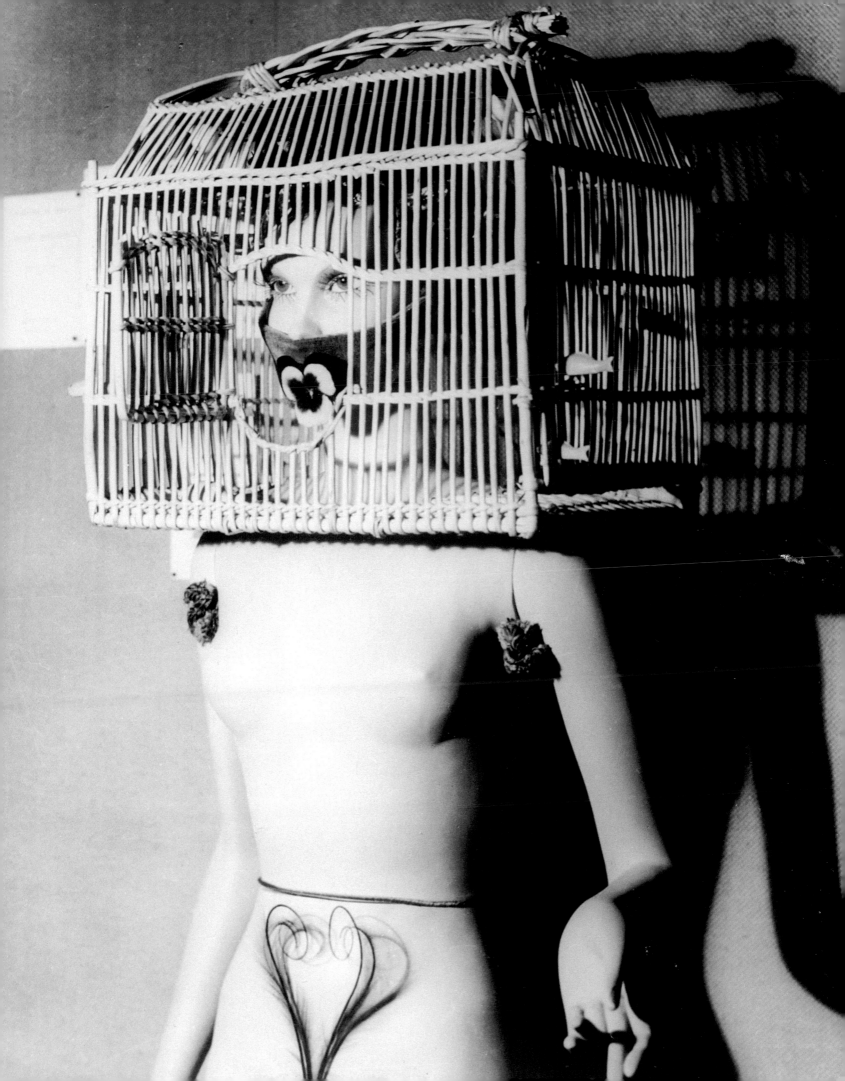

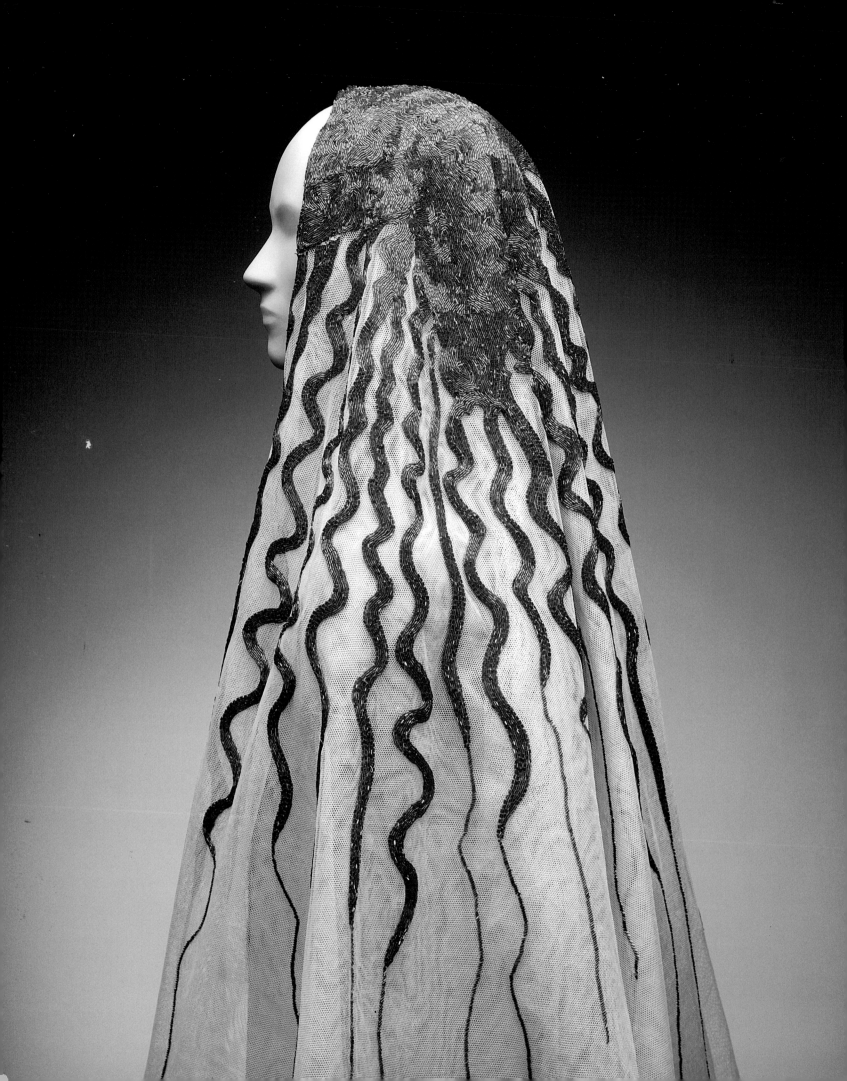

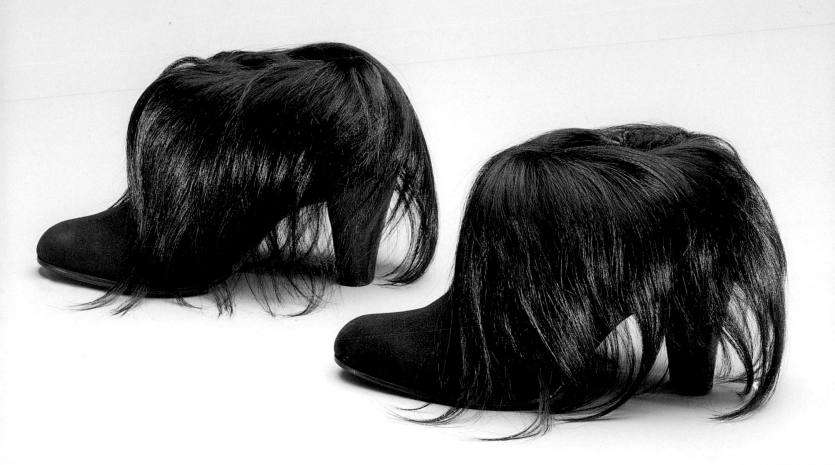

150 Man Ray
Elsa Schiaparelli sitting, 1935
(previous page, left)

Man Ray worked as a photographer in the
fashion houses of both Poiret and Schiaparelli
in Paris before achieving fame as a chronicler
and practitioner of dada and surrealist art.

159 André Masson
Surrealist mannequin 'Head in a Cage', 1938,
reconstruction 1981
(previous page, right)

Masson was a French artist associated with
the surrealist movement from the early
1920s. This mannequin was part of a group
of shop window dummies fantastically
dressed by surrealist artists as the set piece
of the 1938 International Surrealist Exhibition
in Paris.

222 Elsa Schiaparelli
Veil, c. 1938
(left)

Schiaparelli, a Paris-based fashion designer
and patron of artists, developed a
metamorphic, illusionistic style of design
which owed much to contemporary
surrealism.

219 Elsa Schiaparelli
Monkey Fur Shoes, 1938
(above)

Schiaparelli looked particularly to accessories
as an opportunity for fantastical design,
allowing her imagination to run free on hats,
shoes and gloves while maintaining the
integrity of the basic form of the dress.

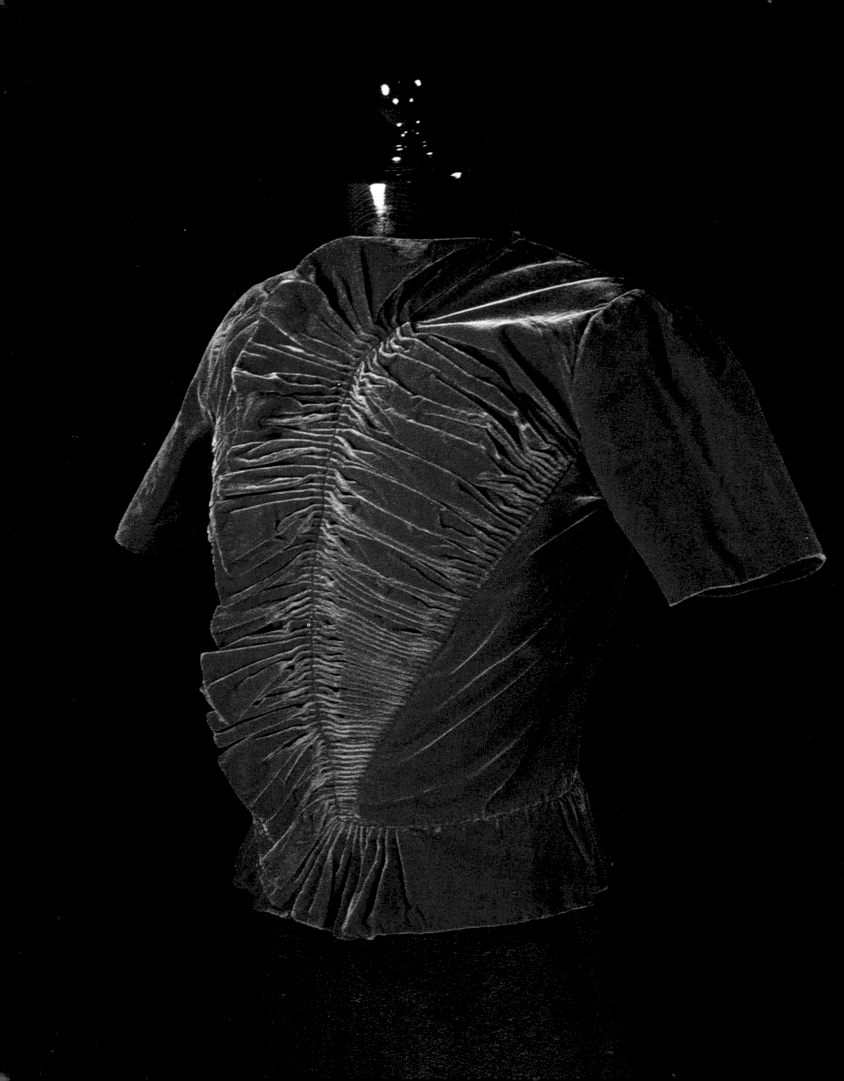

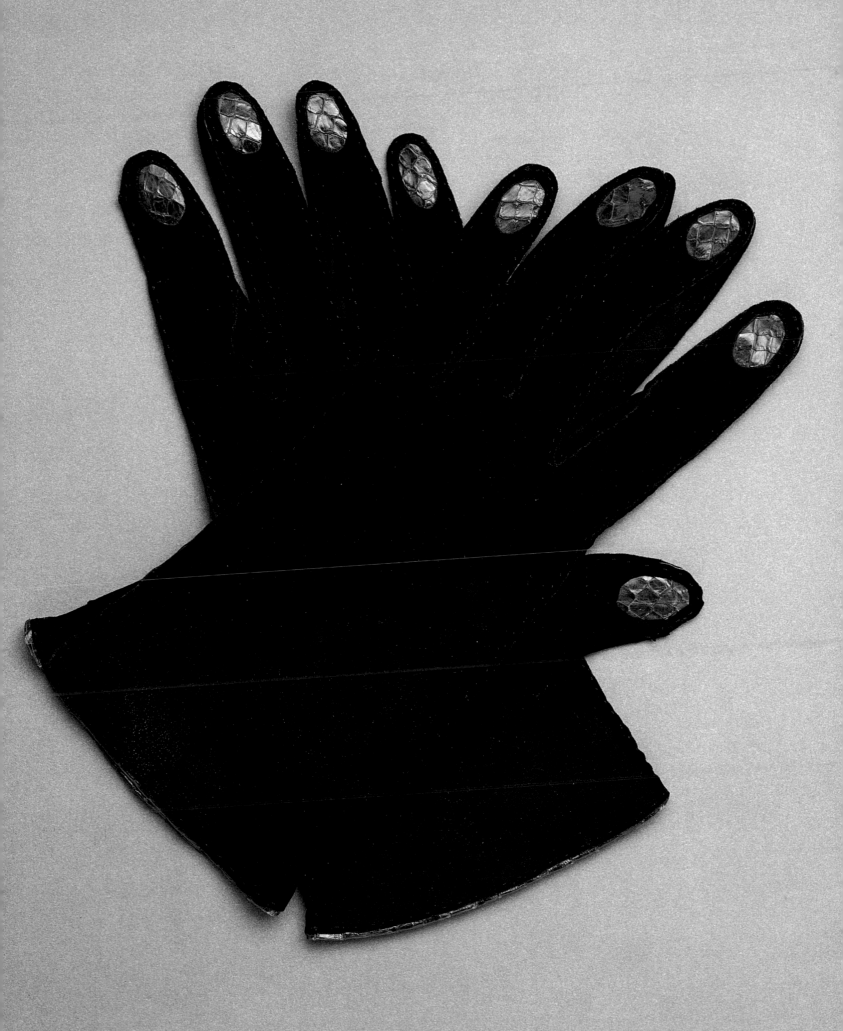

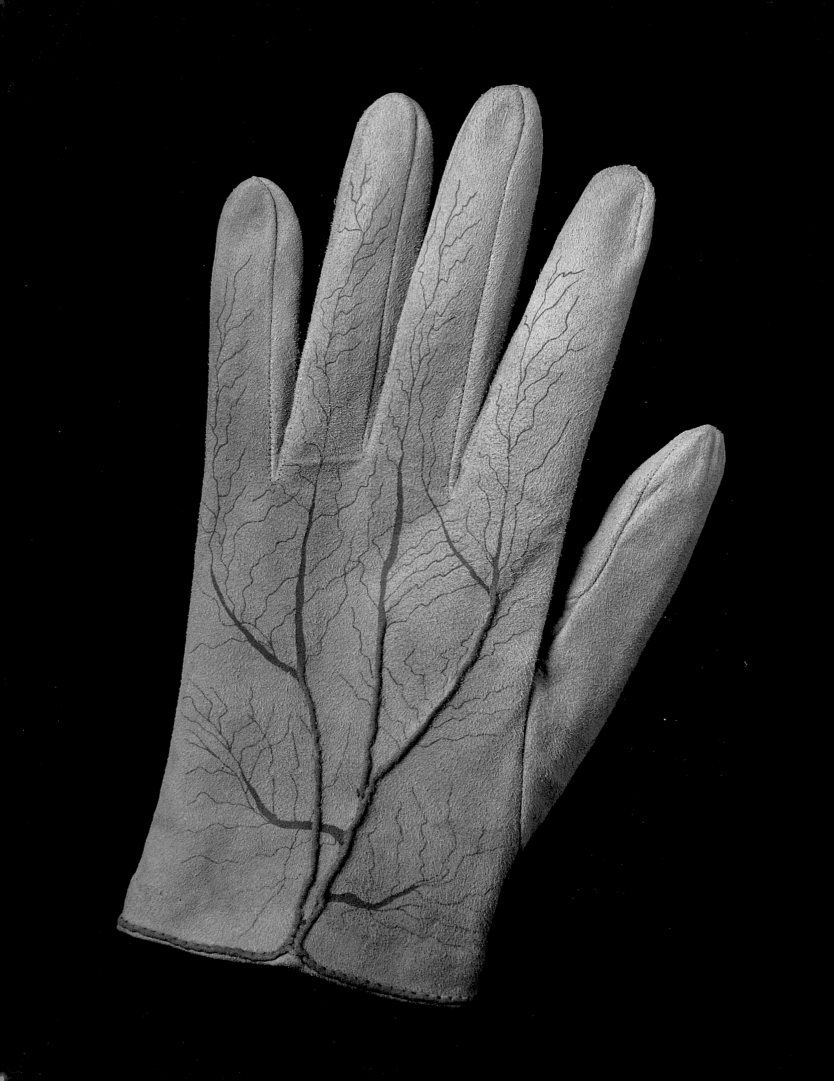

106 Madame Grès (Alix)
Short evening jacket, c. 1939
(previous page, left)

Madame Grès trained as a sculptor before
working as a fashion designer in Paris.
This highly structured jacket, made for
her 'Alix' label, suggests the form of the
rib cage beneath.

220 Elsa Schiaparelli
Pair of Gloves, c. 1938
(previous page, right)

The nails of these gloves are made from
red snakeskin, the unexpected flash of
colour suggesting an imaginative fusion
of glove and hand.

183 Meret Oppenheim
Project for Parkett No. 4, 1985
(left)

The Swiss artist Oppenheim spent the 1930s
in Paris, where she was closely involved with
the surrealist movement. This glove, made
as a multiple for Parkett Magazine, was
based on a much earlier drawing of a 'glove
with veins'.

27 Pierre Cardin
Men's shoes with toes, 1986
(above)

Cardin, a French fashion designer, realises
a fantasy taken from the paintings of
surrealist artist René Magritte, in which
clothes take on the characteristics of their
wearer, in an uncanny and disorientating
simulation of the body.

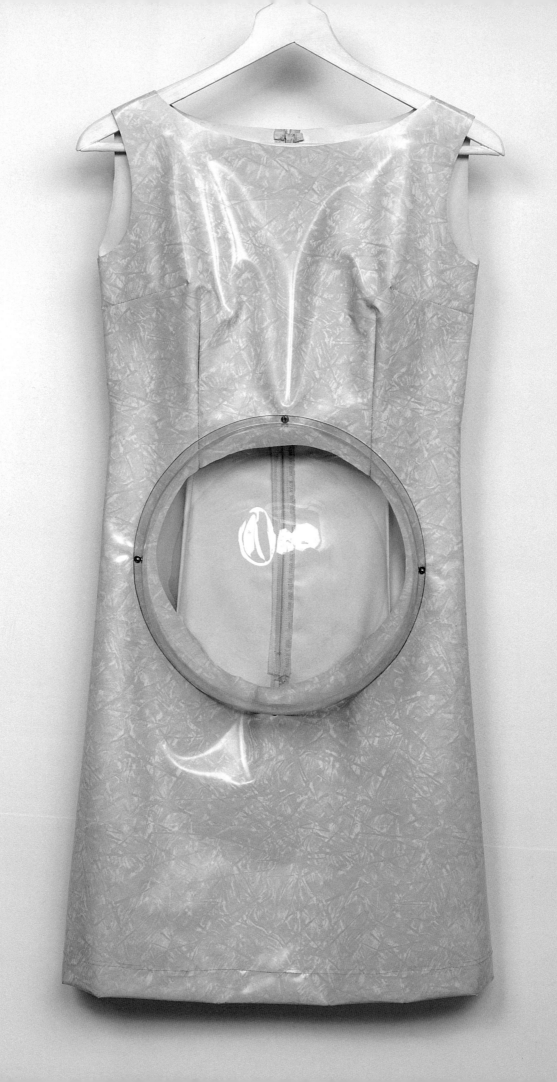

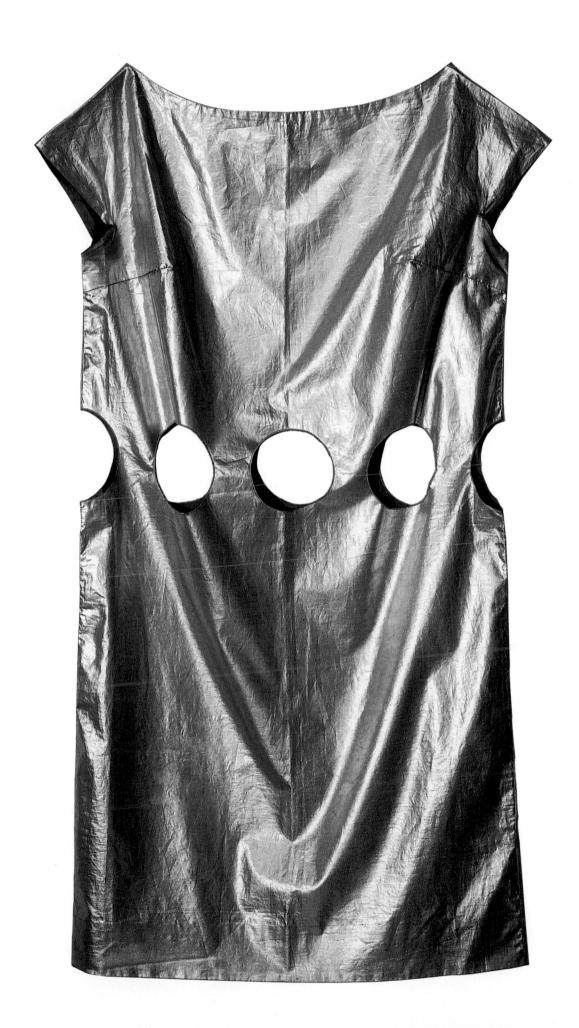

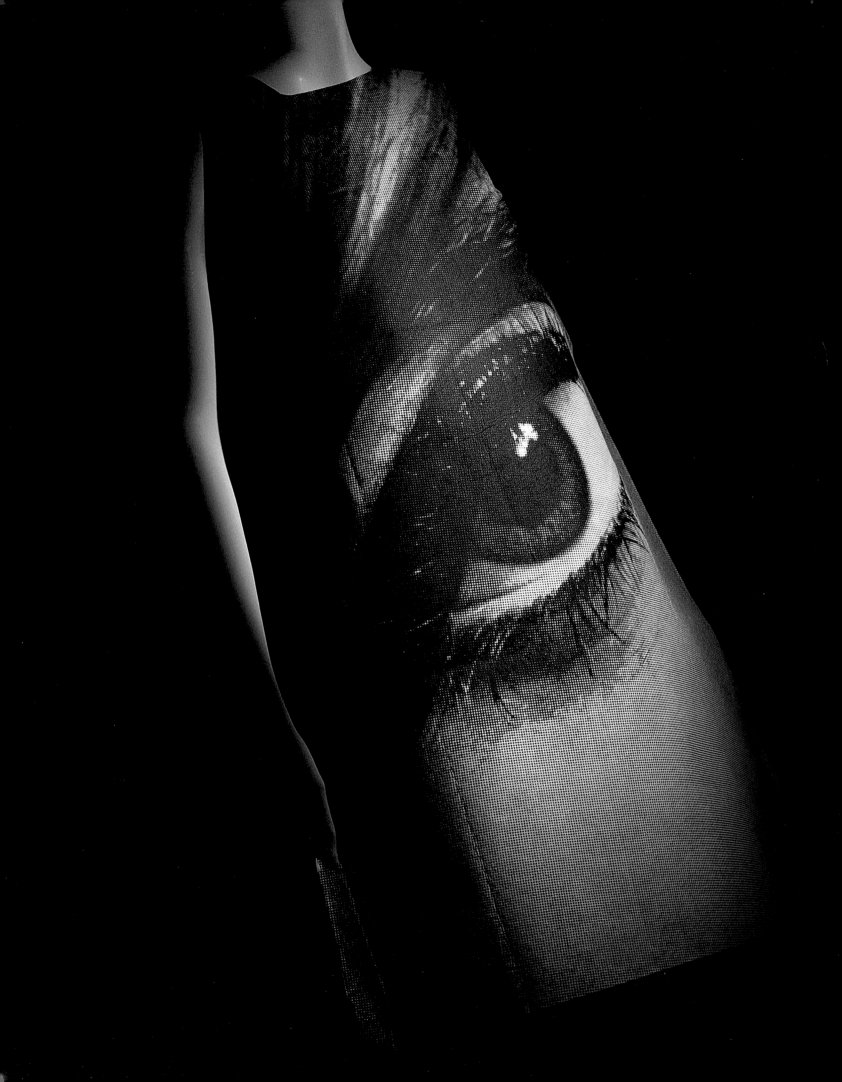

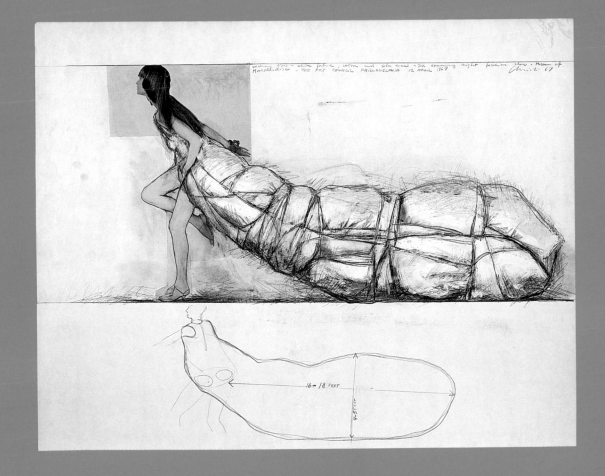

242 Mimi Smith
Maternity Dress, 1966
(previous page, left)

Smith is an American artist whose work engages overtly with feminism. Much of her art takes the form of clothing which both protects and politicises the female body. In this work, a plastic observation window recycled from an old washing machine marks the space of pregnancy.

81 Lucio Fontana for Bini-Telese
Dress, 1961
(previous page, right)

Italian artist Fontana worked with the fashion house of Bini-Telese to make this dress, authenticating it with a silver paper 'painting'. The cuts in the dress echo the slashes and holes Fontana made in his paintings, cutting through the canvas itself in a bid to overcome the material limitations of painting and liberate the space beyond the canvas.

103 Harry Gordon
Paper Poster Dress (Eye), 1968
(left)

In the 1960s, dresses were marketed as disposable fashion, intended to be cut to length, worn once then thrown away. Gordon, an artist, here plays with the current idea of the paper dress, using the eye, an icon of Pop imagery, to counterpoint the throw-away nature of the dress.

34 Christo
Study for Wedding Dress for opening night Fashion Show, Museum of Merchandise, The Art Council, Philadelphia, 12 April 1967, 1967
(above)

35 Christo
Wedding Dress, 1967
(overleaf)

The American artist Christo is best known for his performance works which use fabric and which often involve the wrapping of public landmarks, most recently the Reichstag in Berlin. To design his 1960s 'wedding dress', he added painted encumbrances to figures cut from 1960s women's fashion magazines. In the resulting dress, his 'bride' enjoys the freedom of a white silk hot pants suit, but must drag a huge, silk-wrapped boulder in her wake.

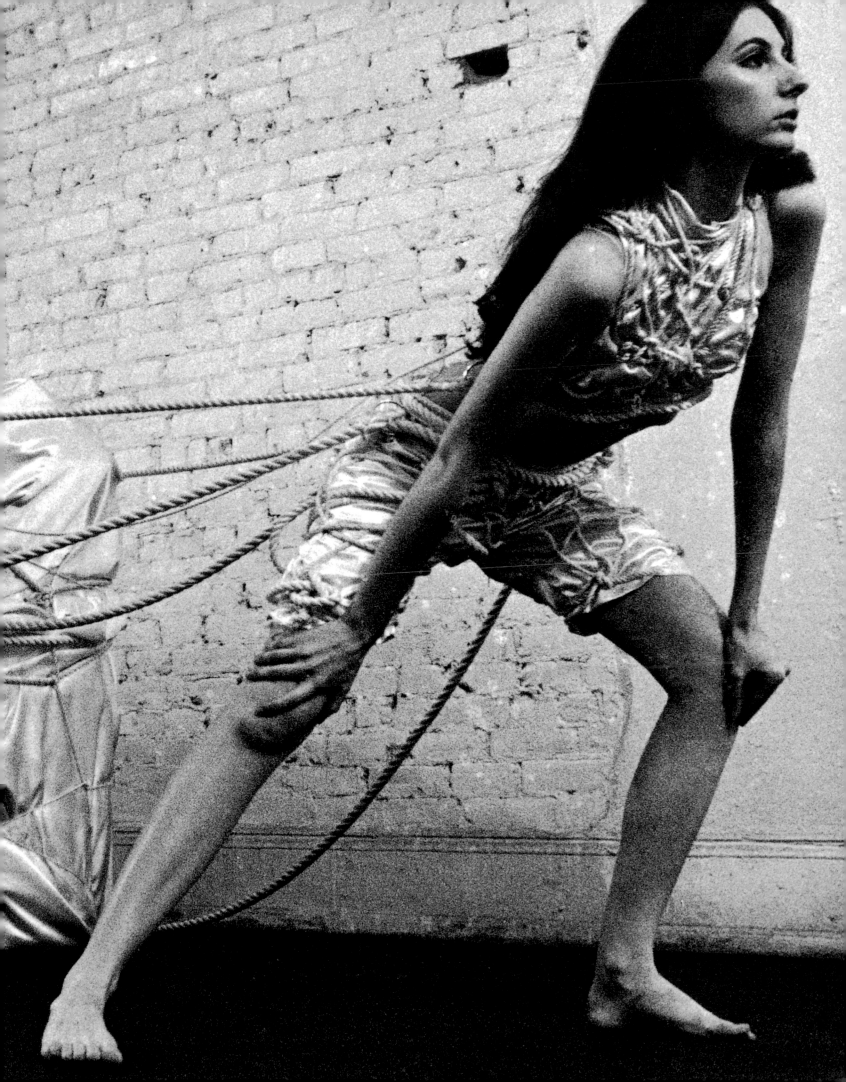

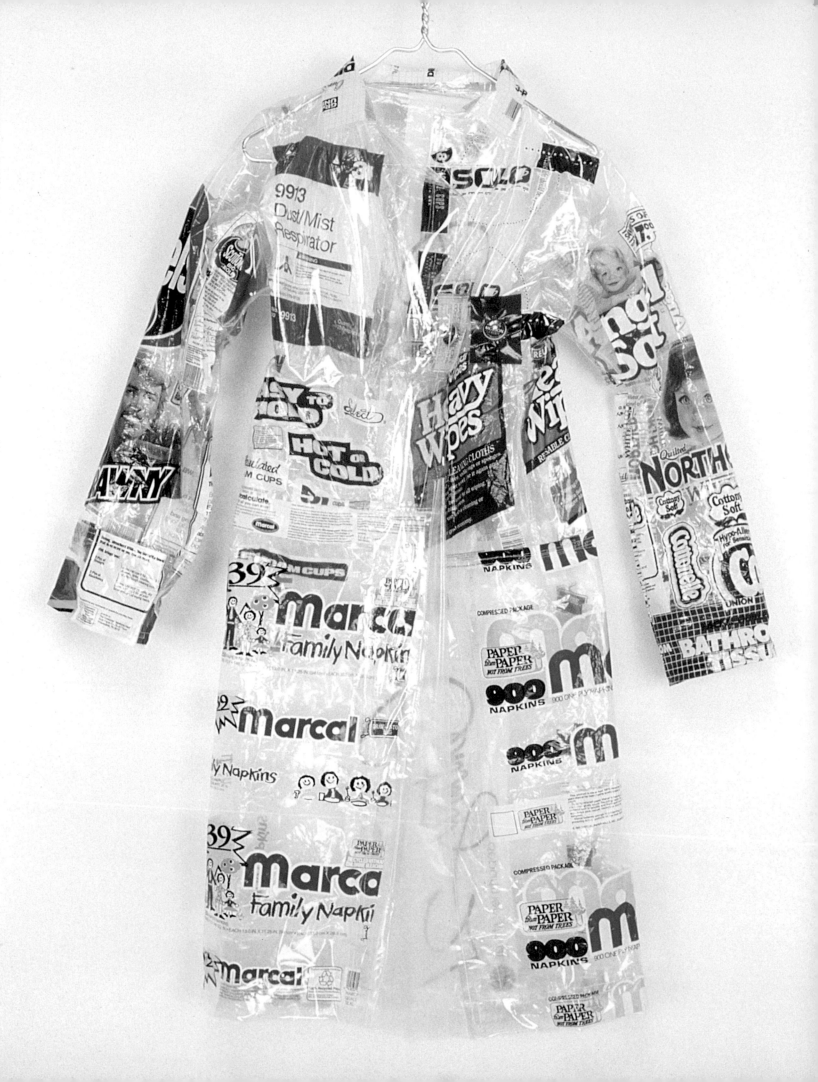

241 Mimi Smith
Recycle Coat, 1965, remade 1993
(left)

Smith began making clothes as part of her
art because she thought that as people had
more experience of looking at clothes than
at sculpture, her ideas would be more easily
transmitted in this form. She uses scraps and
recycled rubbish as part of an 'aesthetics of
survival', enjoying the sense of making
something out of nothing and building
a whole from fragments.

**158 Mars of Ashville;
Wastebasket Boutique**
Paper Poster Dress (Yellow Pages), 1968, detail
(above)

This 1960s paper dress was made for an
American fashion boutique. Using found
materials, it plays with Pop imagery and
an aesthetic of the everyday and familiar.

19 Erwin Blumenfeld
*Untitled Fashion Photograph for Dayton's
Oval Room*, 1962
(overleaf, left)

Blumenfeld was a German photographer who
worked mostly in New York. In his youth in
Berlin he had been associated with the dada
movement, and in his fashion photography
he developed a repertoire of techniques –
solarization, scratching, tinting, bleaching
and re-tinting and the reversal of positive and
negative – which led to some dazzling and
disorientating visual effects.

203 Paco Rabanne
Mini evening dress, Spring/Summer 1970
(overleaf, right)

The French fashion designer Paco Rabanne
is known for his innovative use of materials.
In the 1960s he responded to the rise of
'youth culture' by making chain mail dresses
made from shapes of aluminium or plastic or,
in this case, buttons. He has been described
as making dresses 'using pliers instead of
needle and thread'.

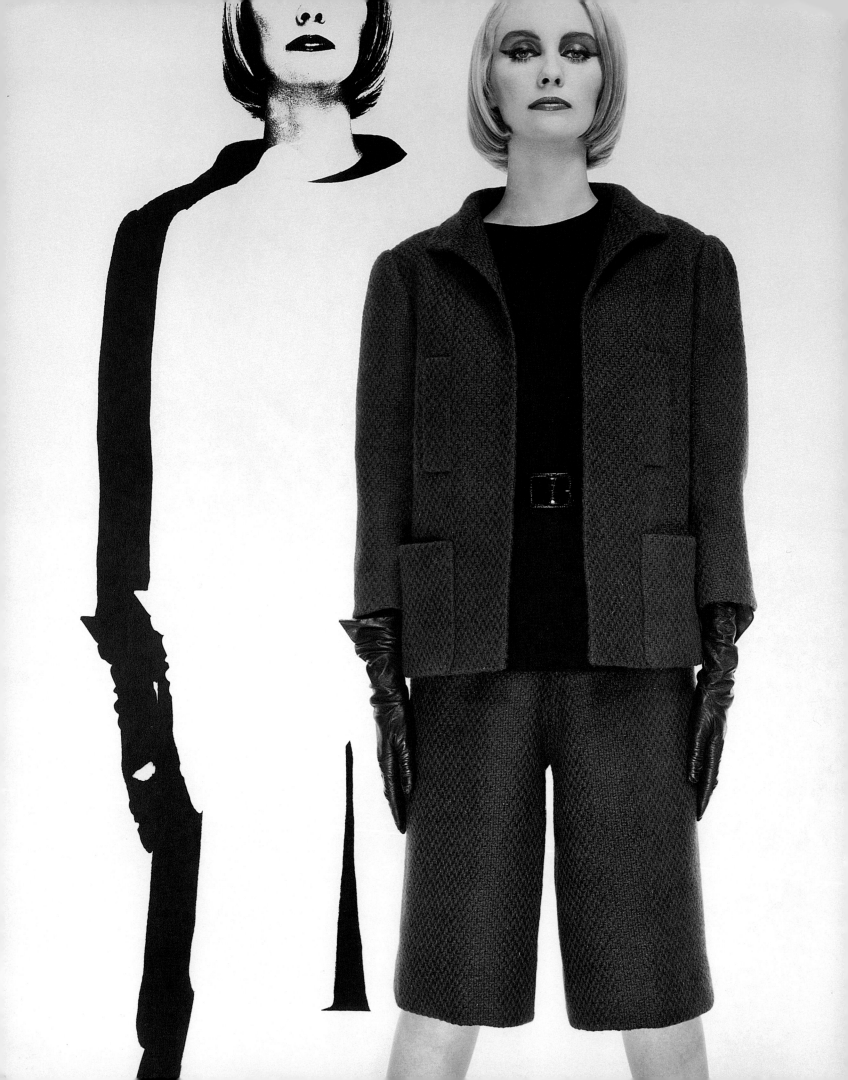

42 André Courrèges
'Dolly Bird' outfit, Spring/Summer 1973
(left)

Like Paco Rabanne, French fashion designer Courrèges created simple and striking 'Space Age' clothes. They were angular and geometrical, made from new types of plastic in bright, contrasting colours.

132 Yayoi Kusama
Dress, 1976
(right)

The work of Japanese artist Kusama hovers between installation and performance. Her dresses, sprouting an obsessive proliferation of nasty-looking fabric accretions, reflect her interest in the connections between the personal and the formal, the organic and the mechanical, and the physical and the intellectual.

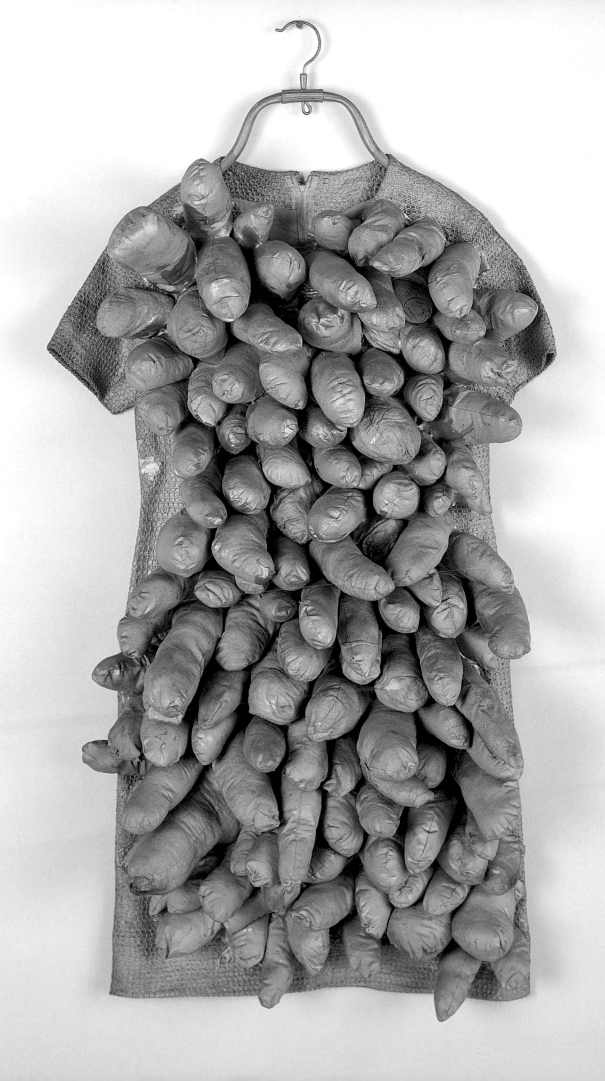

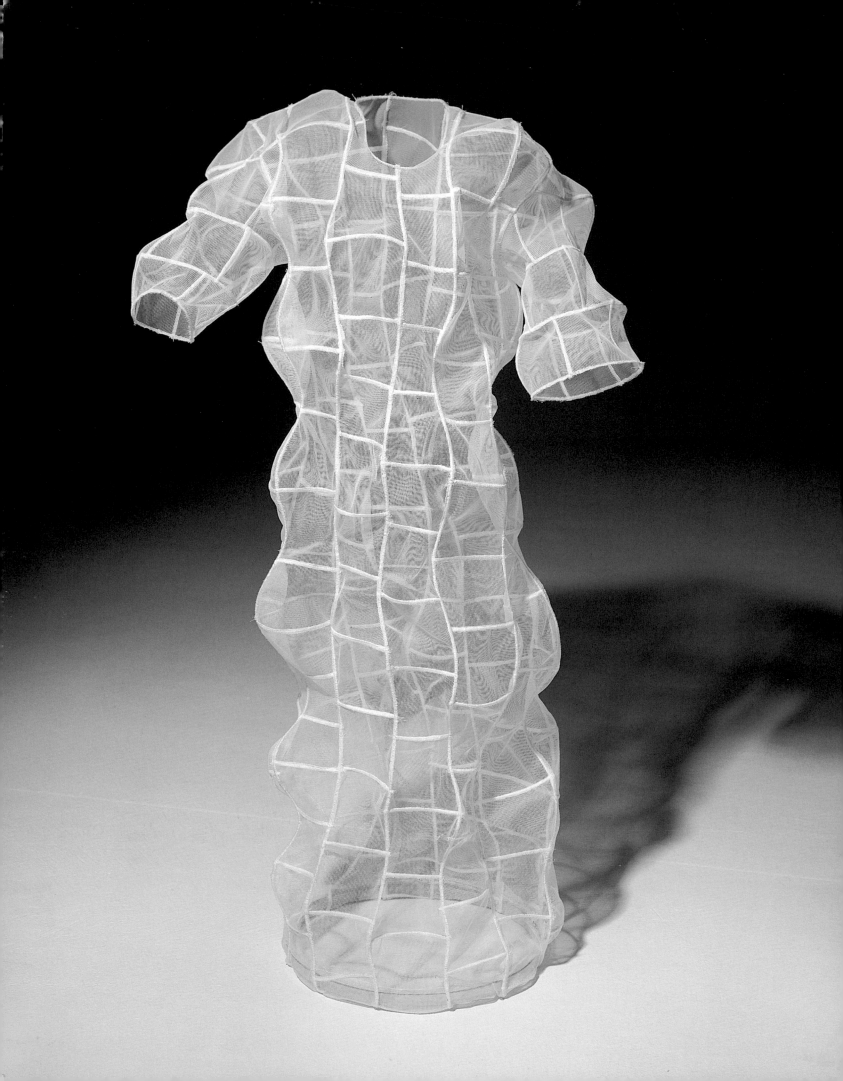

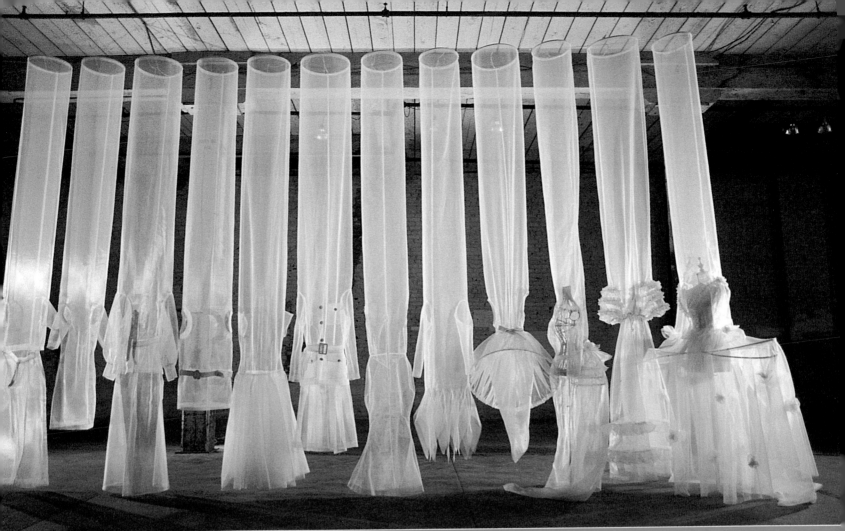

21 Caroline Broadhead
Wobbly Dress II, 1992
(left)

Broadhead, a London-based artist, makes work in the form of clothes which retain a sense of the performative, of something that may once have been worn. Her *Wobbly Dress* is made from nylon panels stitched in curving seams so that the dress distorts itself as it is sewn, its apparent movement an inherent part of its construction.

164 Lun'na Menoh
Spring and Summer Collection 1770-1998, 1998
(above)

Menoh, based in Los Angeles, is a fashion designer turned artist. This work evokes the ghosts of women and past dresses in uninhabited shapes which trace the evolution of the clothed female body.

268 Isabel Toledo
Packing Dress, Spring/Summer 1988
Baseball Collection
(overleaf, left)

Toledo, a New York-based fashion designer, designed this dress so that the view from the front is the inverse of the view from the back. The dress packs flat like a poncho, its billowy folds settling into a perfect circle with elliptical neck and arm holes, and a circular hole at the hem.

184 Lucy Orta
Refuge Wear, Collective Survival Sac 2 persons, 1994
(overleaf, right)

Currently based in Paris, Orta studied fashion and textiles and now makes art concerned with collectivity, shelter and urban survival. Her 'Collective and Refuge Wear Series' includes tents and sleeping bags which transform into functioning urban suits, and garments designed to link their wearers together.

63

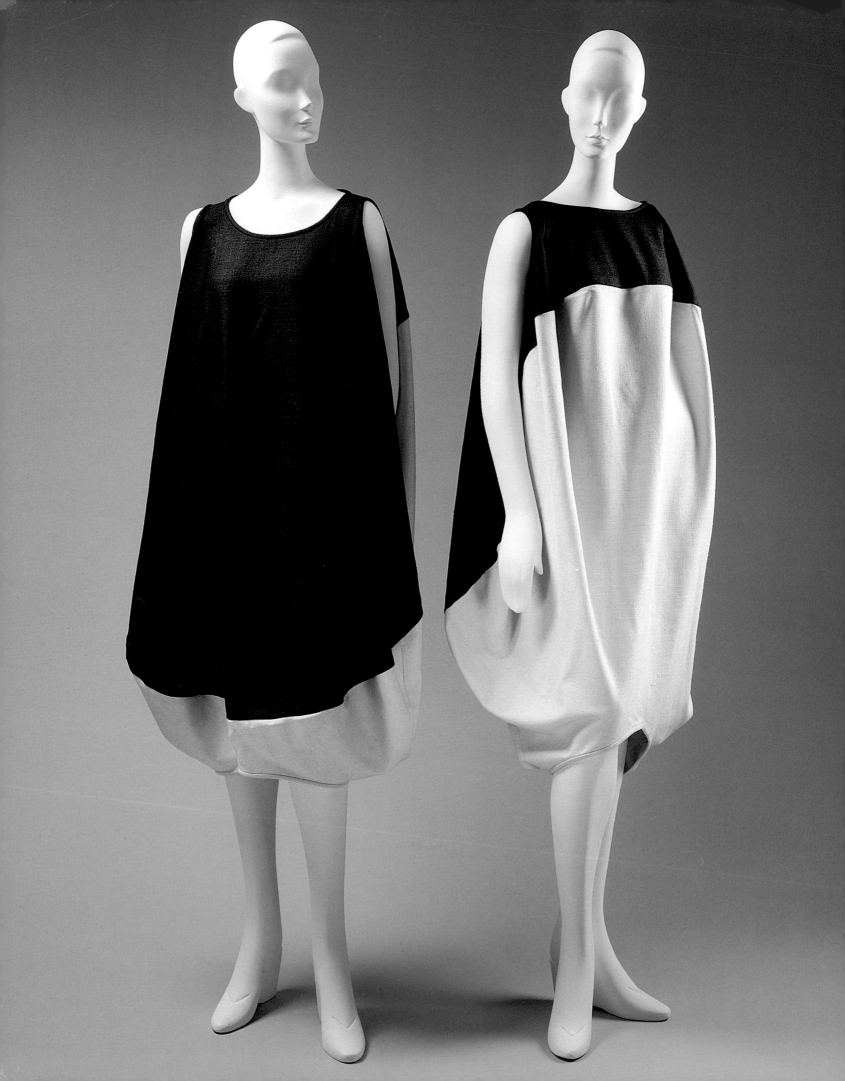

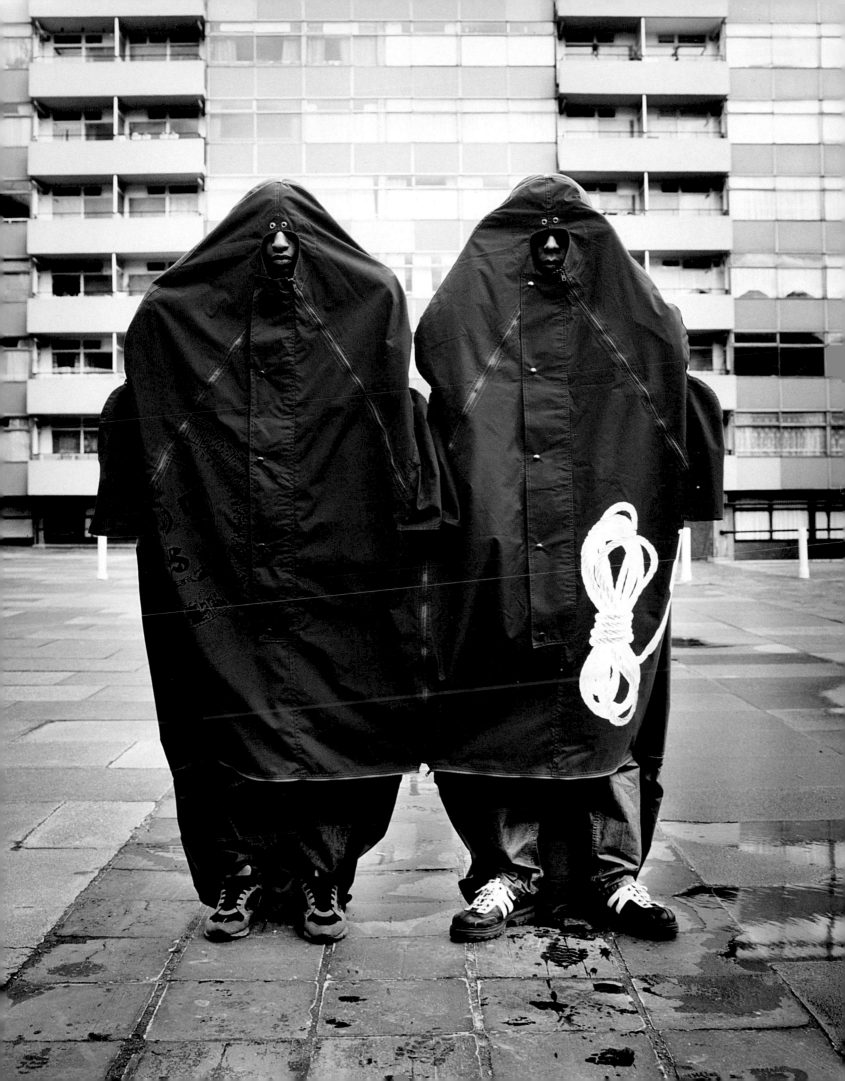

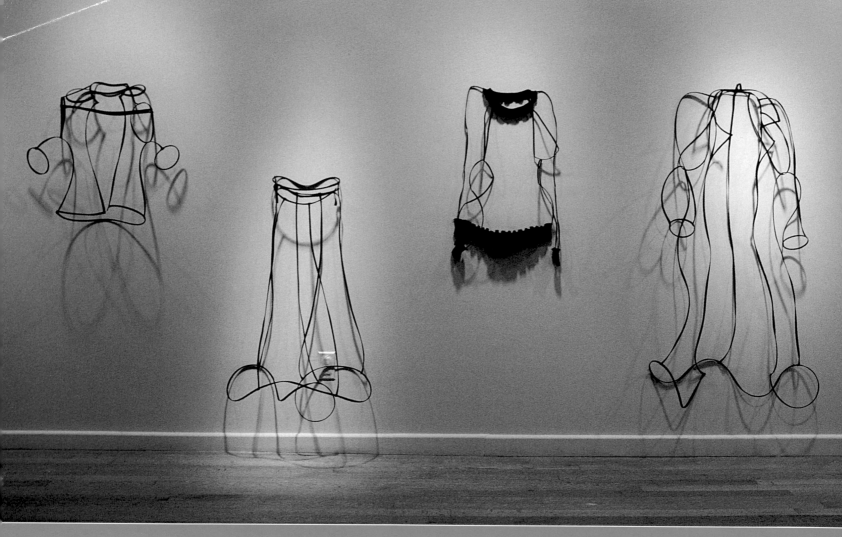

66 **20 Caroline Broadhead**
Seams, 1989
(above)

Seams looks like a wall drawing, but is in fact
a series of garments made only from their
seams, pinned simply to a wall. Mapping
the body in a complex web of clothing and
convention, this collection of garments,
from underwear to outerwear, implies the
process of robing and disrobing.

250 Helen Storey
Primitive Streak Collection:
Implantation Dress, 1997
(right)

Storey, a London-based fashion designer,
is currently making work to be exhibited
as art. Her 'Primitive Streak Collection' is
the result of a collaboration with her sister
Dr Kate Storey: a collection of garments
which traces the development of the human
embryo from the moment of conception.

168 Issey Miyake
Flying Saucer, Spring/Summer 1994
(overleaf)

The Japanese fashion designer Miyake
creates clothes to be worn and exhibited in
a fusion of fashion, craft work and sculpture.
His designs depend on highly sophisticated
fabric technology; the pleats of his *Flying*
Saucer expand like a Chinese lantern to
envelop the wearer in colour and texture.

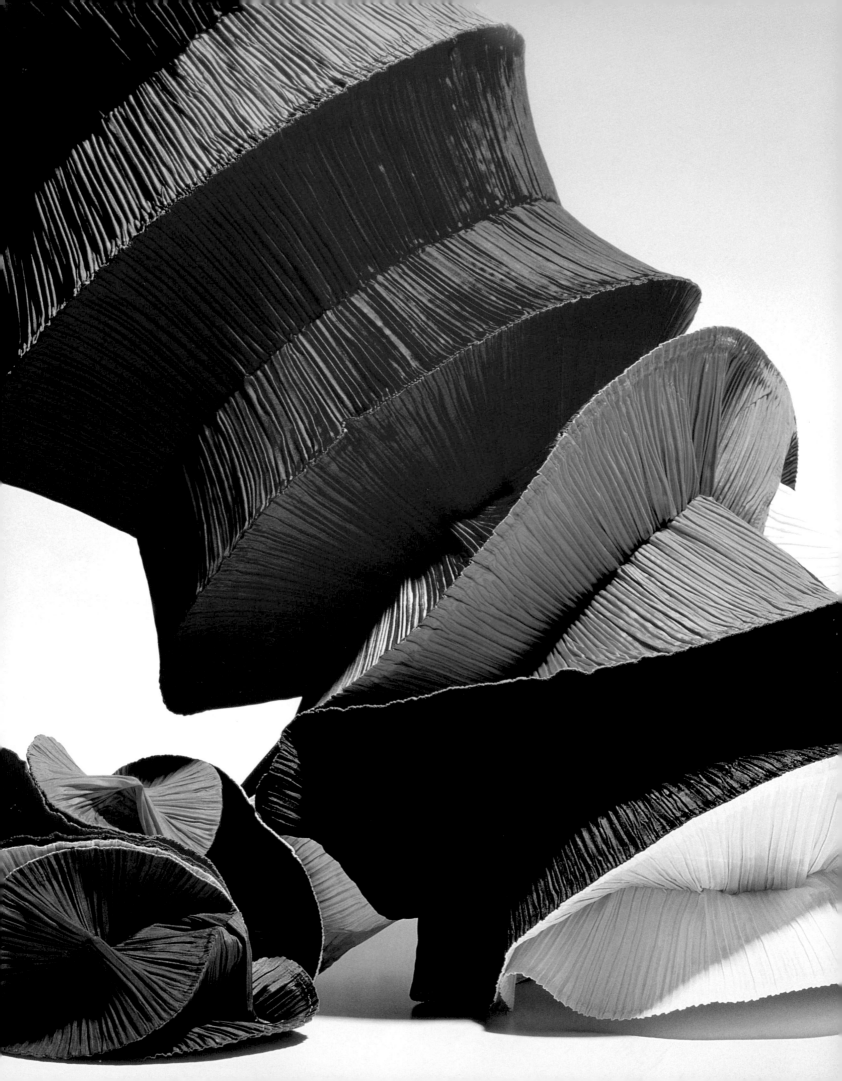

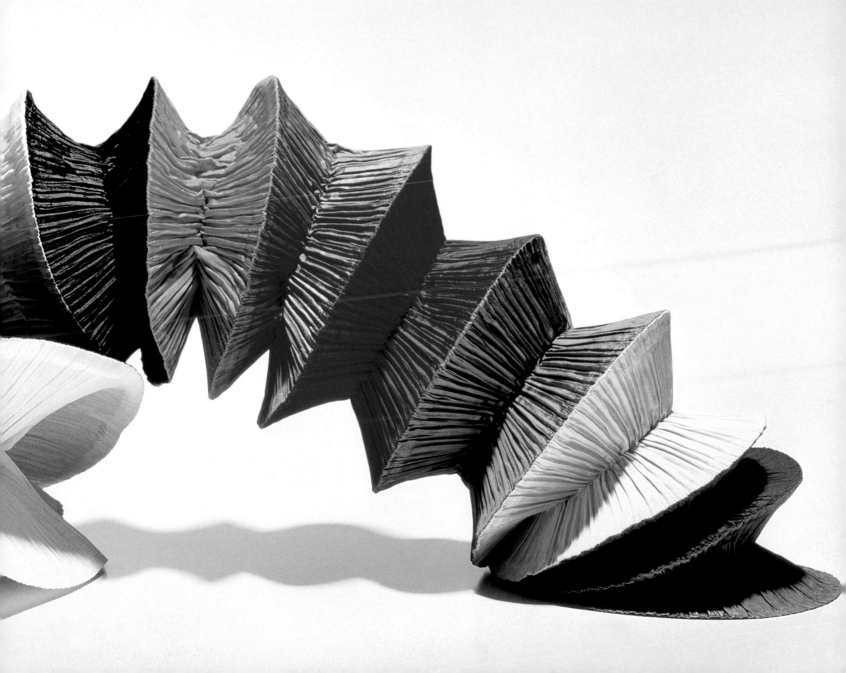

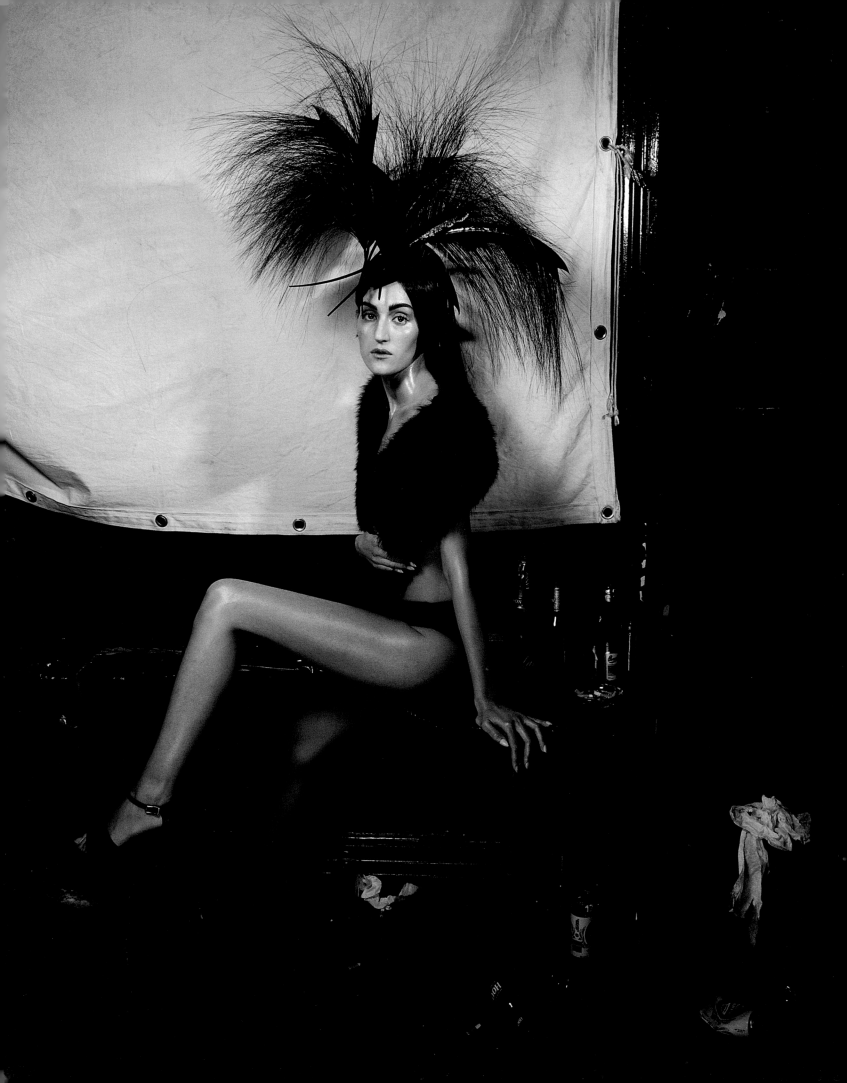

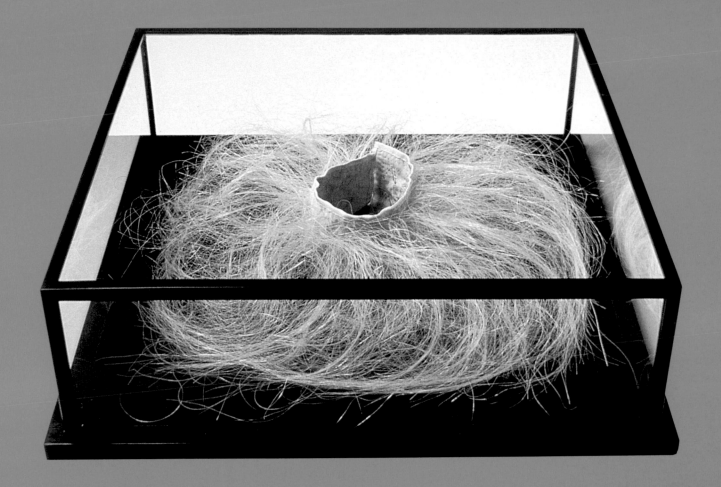

38 Mat Collishaw
*Image from Pampilion Catalogue: Dai Rees
Autumn/Winter Couture Collection*, 1998
(left)

Collishaw, an artist, and Rees, a hat designer,
recently collaborated to produce imagery
to accompany an exhibition of Dai Rees's
hats at Judith Clark Costume in London.
The dark and claustrophobic environments
of Collishaw's photographs heighten the
sense of drama and almost overwhelming
exoticism of Rees's hats, masquerading as
extravagant yet forbidding birds of prey.

111 Ann Hamilton
Untitled (haircollar), 1993
(above)

An American artist known principally for
her large-scale installations, Hamilton often
makes work with materials found around
or relevant to the site in which they will be
exhibited. This small-scale work consists
of a collar with the letters of the alphabet
stitched into the inside, and a circle of hair
on to the outside.

12 Adrian Bannon
Thistledown Coat, 1998
(overleaf)

An artist based in London, Bannon here
traces the outline of a body in thistledown,
the lightest of materials. A study in transience
and the ephemeral, the work offers a
commentary on the mutability and ultimate
insubstantiality of the human body.

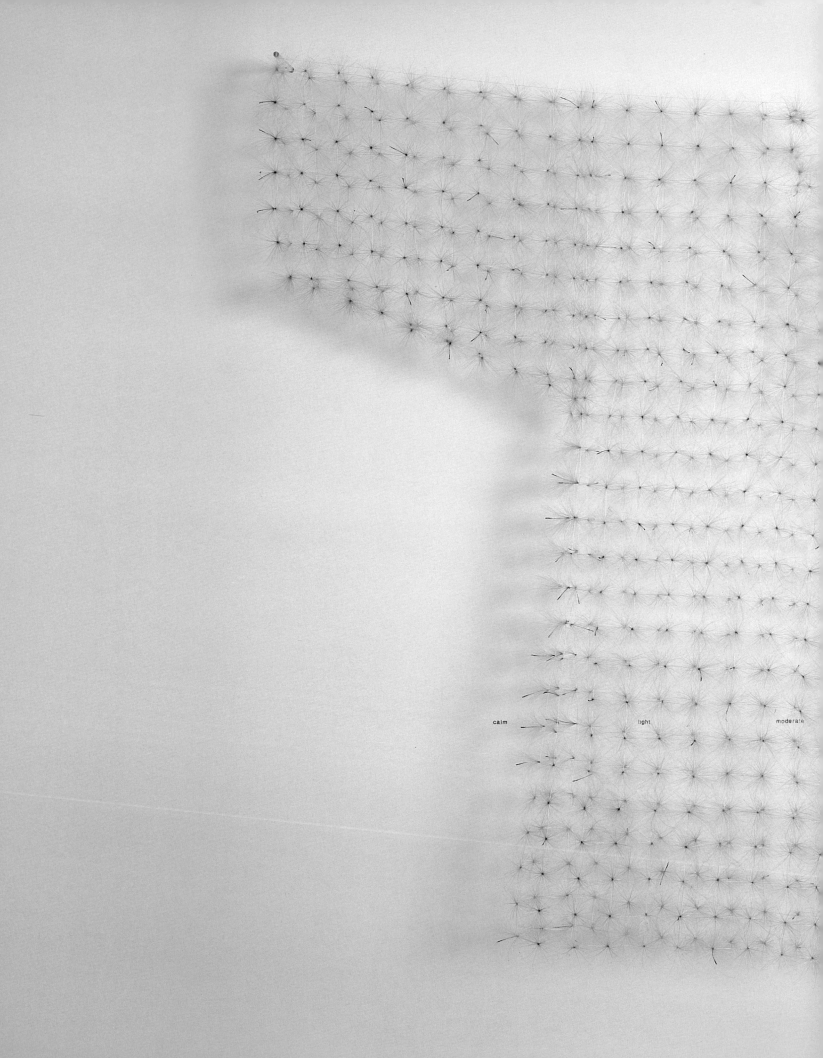

calm light moderate

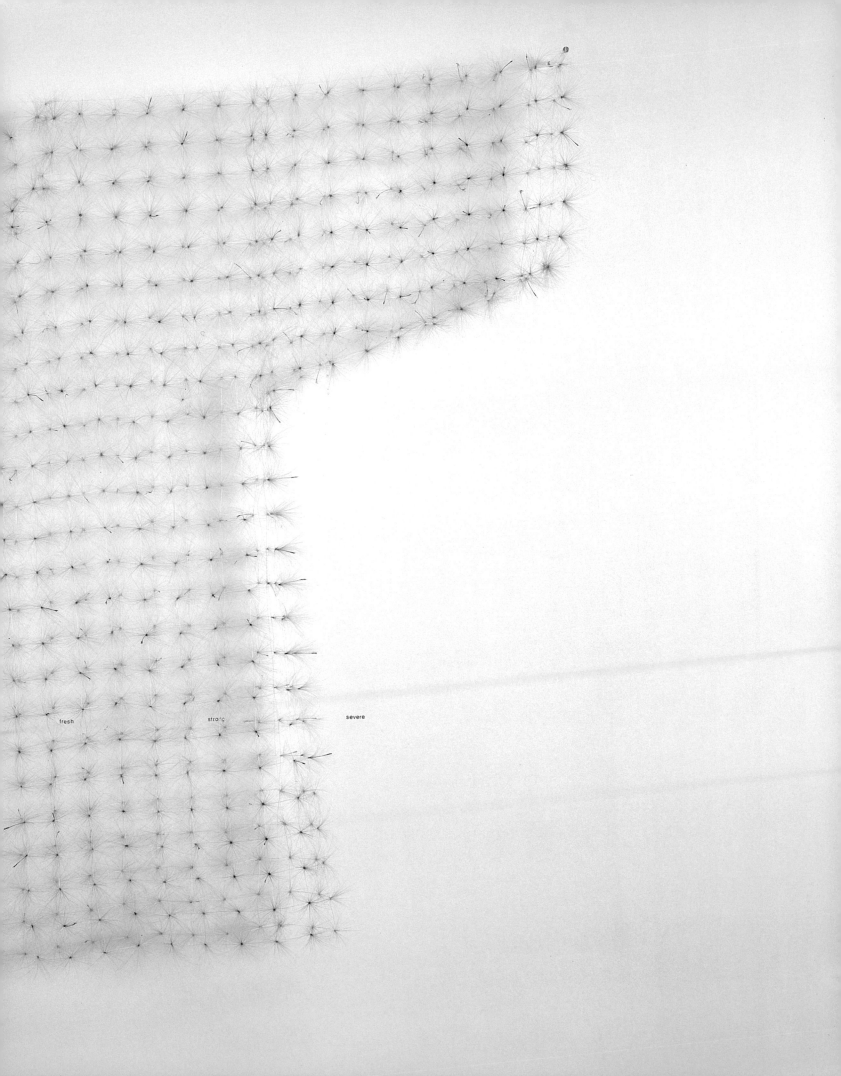

fresh strong severe

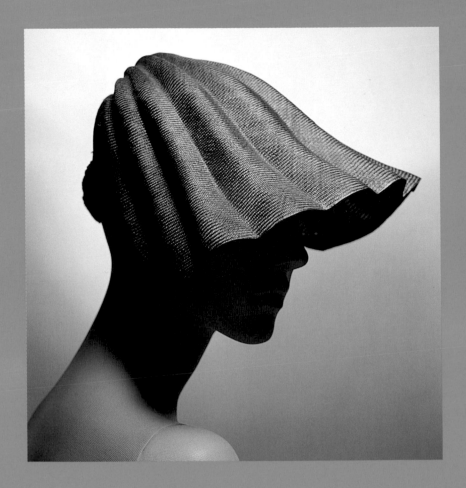

126 Nick Knight
*For Yohji Yamamoto (Art Director
Marc Ascoli)*, 1986
(left)

A London-based photographer who has done
much to shape the look of fashion in Britain
and abroad in recent years, Knight makes
photographs which are characterised by their
bold use of colour and strong sense of design.

130 Krizia
Shell Hat, 1980
(above)

Mariuccia Mandelli of Krizia in Milan makes
a shell – a hard, protective casing – from
delicate straw. The curvilinear geometry of
the hat both defines and partially obscures
the shape of the head.

105 Fergus Greer
Leigh Bowery, 1991
(overleaf)

Greer's photograph of designer and
performance artist Leigh Bowery (1961-1994)
shows him in his 'Future Juliette' look.
Bowery's provocative, often transgressive
re-shaping of his body was the basis for his
own art and his collaborative work in theatre,
performance and dance.

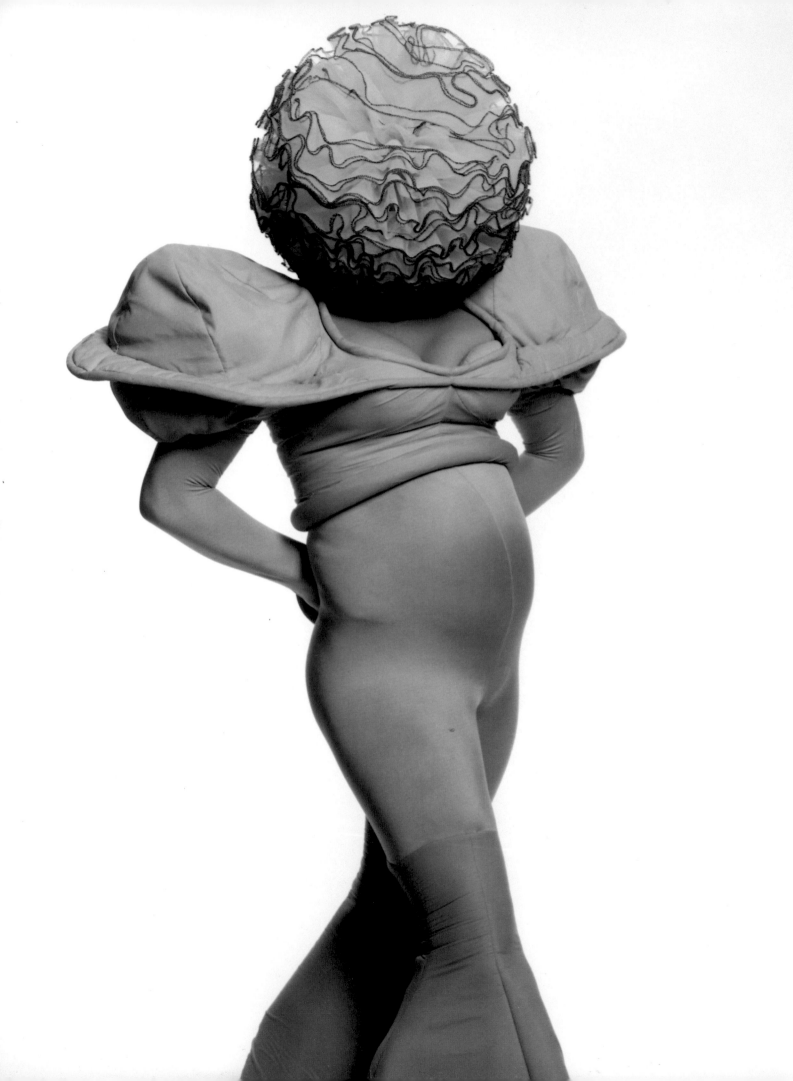

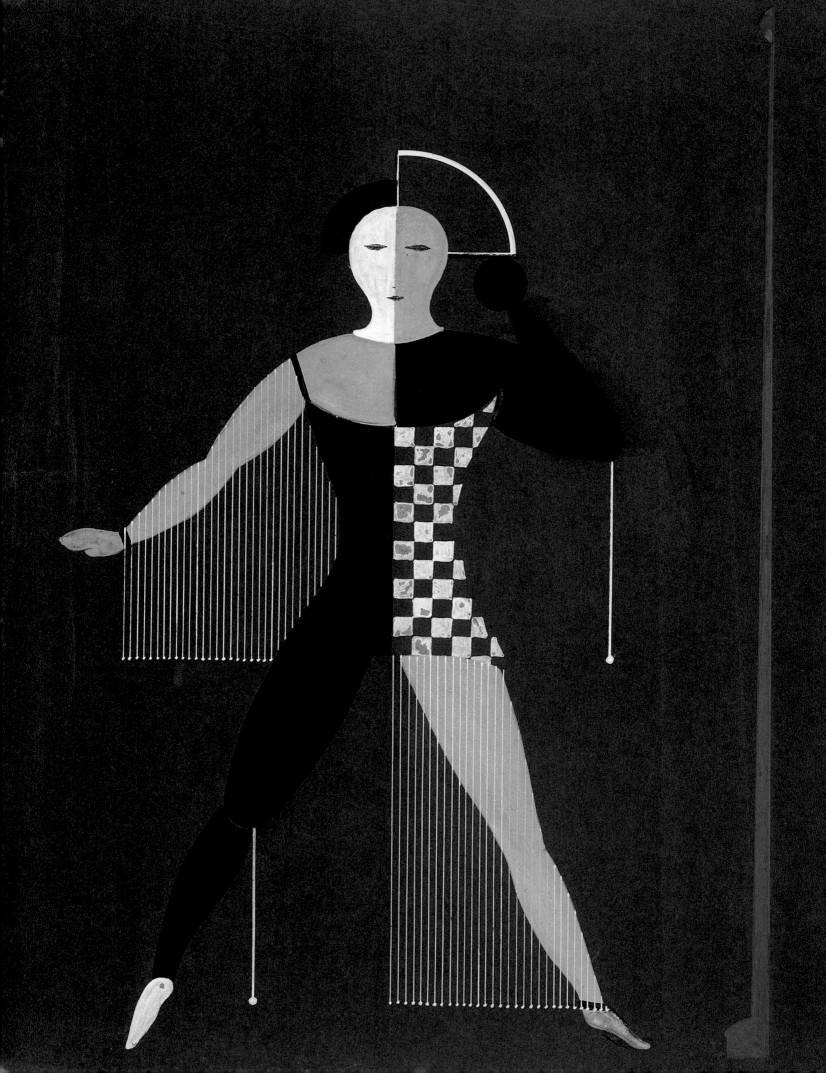

Kinetic Beauty: the Theatre of the 1920s
Judith Clark

The history of art in the 1920s is inextricably linked to both the history of dress and of the theatre. Any study of 1920s art or fashion involves an understanding of how modernist ideals were interpreted within the theatre across Europe. Theatre and costume design were critical components of an interdisciplinary artistic fusion begun in the early 1900s which in the 1920s provided a context for the developing vocabulary of modernism. Directors worked closely with artists, rejecting the decorative order popular at the turn of the century to develop visual solutions to an increasingly mechanised and urban society. Theatre was a micro-environment in which the costumed body became the expression of plastic movement within scenic space. Costume could reform, restrict, modify, seemingly mechanise, sexualise or de-sexualise the body; and through their identification with the clothed actors, audiences could be projected into a new, progressive, dynamic and productive world. Intriguingly, this was true throughout Europe: from the new communist state of Russia to post-war fascist Italy. Although the political objectives of artistic endeavours were often starkly contrasting, there were nevertheless revealing similarities and even opportunities for collaboration.

The Paris Seasons

The first indications of a fusion of the arts in theatre were the extravagant, decorative designs for Sergei Diaghilev's seasons of the Ballets Russes in Paris. Diaghilev's role as disseminator of artistic trends working with, for example, Henri Matisse, Pablo Picasso, Joan Miró and André Derain, continued until his death in 1929. The designers of the first Paris season, which lasted from 1909 until 1914, were painters belonging to the Mir Isskustva (World of Art Group) which had been established in St Petersburg in 1898. Through productions such as *Le Pavillon d'Armide* (1909, costumes and décor by Alexandre Benois, music by Nicholas Tcherepnine) and *Schéhérazade* (1910, costumes and décor by Leon Bakst, music by Nikolai Rimsky-Korsakov) the Ballets Russes achieved a synthesis of the arts in which the exotic East was flourished in all its extravagant detail for audiences all over Europe.

In the subsequent seasons Diaghilev's taste evolved with the European vanguard, bringing fresh ideas to ballet and developing a new language of dance. In the early 1920s the aestheticism of the World of Art painters gave way to the visual language of a younger generation of abstract artists. The compositions executed by Natalia Goncharova and Mikhail Larionov in 1914 and 1915 for Diaghilev signalled

143 Fernand Léger
Design for curtain for 'Skating Rink', 1922

Thayaht
Photograph of the Artist Wearing a Tuta

the beginning of the modernist theatre aesthetic. In 1917 Diaghilev asked the Italian Futurists Giacomo Balla and Fortunato Depero to collaborate on the production of *Le Chant du Rossignol* and *Le Feu D'Artifice*. Here the human body was abstracted to a mere moving force for their stylized costumes. The body disappeared under cylindrical, square and triangular shells covering heads, arms and hands – constricting actors and creating rigid movement.

Another vehicle for artistic experimentation at that time was the lesser-known Ballets Suedois. The director, Rolf de Maré, was a Swedish aristocrat who recruited his ballet corps from the Royal Swedish Ballet. Like the Ballets Russes, the Ballets Suedois was also resident in Paris, based at the Theatre des Champs-Elysées between 1920 and 1925. Jean Borlin was the soloist and choreographer. Michel Fokine, who choreographed the famous production of

Schéhérazade in 1910 for the Ballets Russes, took the role of Director of Ballet, having fallen out with Diaghilev a few years earlier.

Like Diaghilev, de Maré was an art collector and patron with a fascination for the artistic avant-garde. He was responsible for collaborations with artists and composers such as Giorgio de Chirico, Luigi Pirandello, Fernand Léger, Riciotto Canudo, Erik Satie, Claude Debussy, and Arthur Honegger. In 1921, the ballet presented the poet Canudo's *The Skating Rink*, designed by Léger using ballet movements that were inspired by skating. The programme announced:
Canudo has expressed one of life's major, elemental forms of anguish. That is, sensual longing which thrusts living beings towards and counter to one another and creates collisions, unions, all the harmonies and disharmonies of love and hate …

This anguish was expressed through the saturated colours of the costumes which clashed in choreographed routines. The dancers, through their cubist costumes, became a moving section of the décor, almost like a mobile painting.

Futurism
Although it was the poet Filippo Tommaso Marinetti who wrote the first manifesto of Futurism in 1909, declaring war on academic institutions, traditions and bourgeois passivity in all areas of art, it was Balla, and to a lesser extent Depero, who did most towards translating futurist ideals into prescriptive designs for dress.

Marinetti famously vilified everything that was feminine. He scorned women for their 'Toilettitus', turning vanity into a modern day disease. The first and second Manifestos of

68 Fortunato Depero
Marinetti's Futurist Waistcoat, 1923

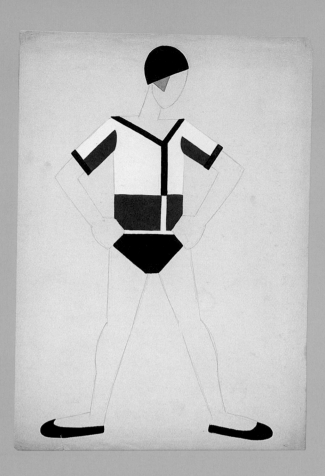

22 Tat'jana Bruni and Georgij Korsikov
Design for 'Young Ballet', Sporting Outfit, 1920

23 Tat'jana Bruni and Georgij Korsikov
Design for 'Young Ballet', Sporting Outfit, 1920

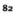

Dress, written by Balla in 1914, were for menswear, and in practice the majority of Futurist dress designs were for men. It was only in 1920 that a Manifesto of Women's Dress was finally written, by Volt (Vincenzo Fani). The manifesto proposed that the *belle époque* S-shaped corseted figure be rationalised into a cylindrical composition, feminine curves forgotten. He urged women to give up luxurious silks, jewels and timid colours in favour of dynamic and expressive 'living poems'.

'Fashion has always been more or less futurist', he announced, realising that fashion was one of the most immediate and successful expressions of the values of modernity. To harness a system based on the passion for what is new and hatred for what has already been seen was the most immediate way to bring art into everyday life as well as anticipating the desire for novelty which drives the fashion

business. Futurist techniques have persisted in marketing today.

Futurist dress should be 'aggressive, agile, dynamic, simple, comfortable, hygienic, joyous, asymmetrical, transigent and variable'. Clothing was to become not only an object but an event, the creation of optical patterns creating an irregular, active disorder bursting onto the streets. Colour was invested with sensation: 'Reds, rrrreds, the rrrrrrrreddest rrrrrrrreds that shouuuuuuuuut; Greens that can never be greener, greeeeeeens that screeeeeeeeam, yellows, as violent as can be: polenta yellows, saffron yellows, brass yellows'[1]: wedges of colour decorated fabrics, projecting the designs beyond the contours of the wearer's body into space, in the manner of Sonia Delaunay's 'simultaneous' gowns.

The Futurists scorned the gestures of traditional theatre and set against them the

modernist insistence on rupture and change. Driving towards a synthesis of the behavioural (human) and plastic dimensions of theatre the Futurists continued their dedication to exhortatory and adjective-studded manifestos with tracts on Variety Theatre, 1913; Synthetic Theatre, 1915; Futurist Dance, 1917; Aero Theatre, 1919; Visionic Theatre, 1920; Tactile Theatre, 1921; Surprise Theatre, 1921; and Magnetic Theatre, 1925; rejecting the 'the Solemn, the Sacred, the Serious and the Sublime' in favour of *fisicofollia* ('body-madness'), record-setting, and amazement.

Dress design should vary according to mood and environment, with different designs for morning, noon and night. By the application of *Modificanti* (Modifiers) which were small pieces of coloured cloth or badges to be buttoned on at will, the wearer could add a visible sign of internal feelings. Balla suggested, for example,

196 After a design by Ljubov Popova
One piece trouser suit, 1922, reconstruction c. 1979

arrogant, festive, amorous, daring, diplomatic and, of course, war-hungry, in his Manifesto of Anti-neutral Dress of September 1914.

Another Futurist, Ernesto Thayaht, believed the solution to everyday wear to be a unisex overall which he named 'Tuta' (which continues to be the word for overalls in Italian), promoting economy both of fabric and construction and increasing agility and flexibility. He derived the word from the Italian 'Tutta' meaning 'All'. From this he removed one 't' which represented the shape of the overall itself. Thayaht's interest in fashion continued throughout the 1920s establishing a professional relationship with the fashion house of Madame Vionnet in Paris.

Constructivism
When in 1917 the Bolsheviks came to power in Russia and announced a new socialist state, the

245 After a design by Varvara Stepanova
Three piece trouser suit, 1922, reconstruction c. 1979

search for new art focused on finding ways of manifesting the socio-economic ideas of the revolution. The worker was to be central to the new proletarian culture, which called for the industrial production of useful, necessary things.

In March 1921 three members of INKhUK (The Institute of Artistic Culture set up the previous year) – Alexander Rodchenko, Varvara Stepanova and Aleksei Gan – laid out the principles of the First Working Group of Constructivists based on these communist beliefs. They concentrated on deploying industrial techniques to manufacture utilitarian products. The manifesto was based on the marriage of labour, technique and organisation and the rejection of purely decorative elements.

The group sought to influence other artists through teaching at the recently established VKhUTEMAS (Higher State Artistic and Technical Workshops). This institute had been set up in 1920 to equip artists with the technical knowledge necessary for intervention at an industrial level, to make them 'master artists of industry'. However, its success was impeded by the material poverty which dominated much of the work carried out during the 1920s due to the devastation of the First World War and the Civil War.

Nevertheless, this poverty did not constrain the Constructivists' ability to use theatre in order to experiment with industrial design prototypes. Their anti-aesthetic approach was a natural ally for Vsevolod Meyerhold's fight against traditional theatrical décor and a showcase for the practical exercises carried out in his workshops. Their theatre sets were stripped to skeletal structures made up of intermediary places facilitating and accentuating movement: stairs, ramps, lifts, narrow platforms and landings dynamically intersecting.

Stylization is opposed to the techniques of illusion. It does not need the illusion of Apollonian fantasy … [The stylized theatre] aims at a deft mastery of line, grouping and costume colour, which even when static creates an infinitely stronger impression of movement than the naturalistic theatre. Stage movement is achieved not by movement in its literal sense, but by the disposition of lines and colours, and by the ease and cunning with which these lines and colours are made to cross and vibrate. (Vsevolod Meyerhold)[2]

The evolution of the stage set, from painted backdrop to a constructed three-dimensional environment, was perhaps most clearly illustrated in the experiments carried out by Meyerhold in 1922. Meyerhold, then a director of the newly formed State Higher Theatre Workshop in Moscow, developed a system of

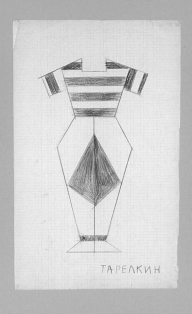

247 Varvara Stepanova
Costume Design for 'The Death of Tarelkin'
(Tarelkin), 1922

229 Oskar Schlemmer
Wire Figure – Technical Drawing for Skirt from
'The Triadic Ballet', Black Series, 1923

exercises for actors called 'Biomechanics'. These were the theatrical equivalent of industrial time and motion studies and he compared them to the experiments in the scientific organisation of labour carried out by the American Frederick Winslow Taylor and his Russian follower Alexei Gastev. The resemblance was exaggerated by Meyerhold to show that his system had been devised in response to the demands of a new mechanised age, where economical use of the body eradicated superfluous and unproductive movements. In Russia, throughout the 1920s the study of mechanised movement took on a scientific role as Laboratories of Choreography and Choreology were set up at the Russian Academy of Artistic Sciences. Their mandate was to study the theory and record the practice of 'art in movement'. Every aspect was explored – dance, acrobatics, gymnastics, 'plastic' and 'artistic'

movement – in order to develop a language of scientifically transcribed motion.

The first production where Meyerhold's system of Biomechanics was illustrated was *The Death of Tarelkin*, staged in 1922 with both set and costumes designed by Stepanova. Stepanova designed costumes that would facilitate movement. Cut into simple forms which reflected the shape of the body, each costume was differentiated visually by strong linear patterns creating striking compositions when viewed next to the slatted wooden furniture of which the set was made. Popova's designs for *The Magnanimous Cuckold* produced the same year, also illustrated an interest in reflecting Constructivist ideals through dress. Popova made the costumes as uniforms for the actors and as prototypes for workers uniforms (*prodezhda*), with coloured badges being used to identify one actor from the

next. It is interesting to note the similarity between this design and the unisex 'Tuta' designed by Thayaht.

Today's dress must be seen in action – beyond this there is no dress, just as the machine cannot be conceived outside the work it is supposed to be doing ... the seams themselves – which are essential to the cut – give the dress form. Expose the ways in which the dress is sewn, its fasteners etc. just as such things are clearly visible in a machine ... (Varvara Stepanova)[3]

Based on their experience within the theatre, Stepanova and Popova were able to develop innovative textile and clothing designs as part of their work at the First State Textile Factory. The machine aesthetic dictated clarity, simplicity, functionality, and economy of line, creating a perfect accord between its interdependent parts. The use of dynamically intersecting geometric motifs reflected their earlier canvas

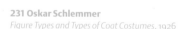

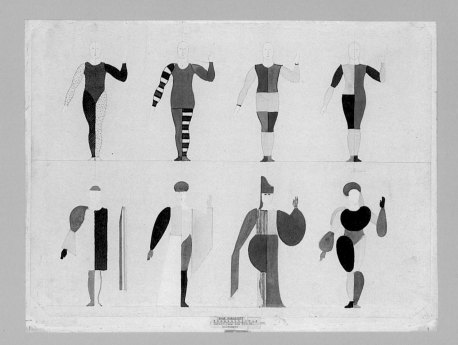

231 Oskar Schlemmer
Figure Types and Types of Coat Costumes, 1926

230 Oskar Schlemmer
Examples of Costume Forms, 1926

works which betrayed a decorative rather than utilitarian link with the simplification of cut and shape.

Though largely decorative and not intrinsic to the Constructivist credo, this did allow them to put work into mass production, and through it to further disseminate geometric forms to replace the traditional Russian floral patterns. It turned out to be the most successful of the Constructivists attempts to enter industry.

The Bauhaus Stage Workshop and Oskar Schlemmer

Reflected in the title of the first exhibition held in Weimar in 1923, *Art and Technology – A New Unity*, the preoccupation with the relationship of 'Man and Machine' was just as central within the Bauhaus as it was to the Futurist and Constructivist theatres. In April 1919 the Bauhaus School for the Arts opened to students,

calling for a progressive unification of the arts. The director and founder, architect Walter Gropius, together with artists such as Wassily Kandinsky, Lyonel Feininger, Laslo Maholy-Nagy and Paul Klee, who took up positions as masters, laid out a curriculum which aimed to remove the barrier between artist and craftsman and to acknowledge the possibility of artists' influence on industrial production.

Lothar Schreyer, a member of the *Sturm* group in Berlin, was appointed head of the Stage Workshop (the first of its kind within an art school) during its initial phase which lasted from 1921 until 1923. His expressionist style clashed with the Bauhaus brief of achieving a synthesis of the arts in 'pure' forms and Oskar Schlemmer was invited to take on his role. Schlemmer remained at the Bauhaus from 1923 until 1929, during which time he transformed the Stage Workshop into a multi-disciplinary focus of

experimental work. Schlemmer's 'events' reflected in dynamic forms the artistic and technological sensibilities of the Bauhaus, gaining an international reputation. However, it was not until the Bauhaus moved from Weimar to Dessau in 1926 that a theatre was constructed.

Schlemmer developed a notational system for recording the movement of forms in space, graphically describing the linear paths of motion. Conversely, the translation of two-dimensional geometry into spatial depth was illustrated in performances such as *Dance in Space (delineation of space with figure)*, *Dance of Forms*, *Chorus of Masks* and *Gesture Dance*. The effect was one of precise, measured movements, with a dynamic contrast of solid colour used for its purity.

The most documented and repeated of performances was *The Triadic Ballet*, first

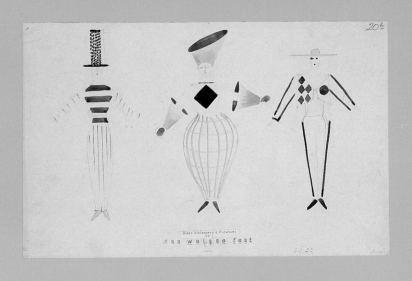

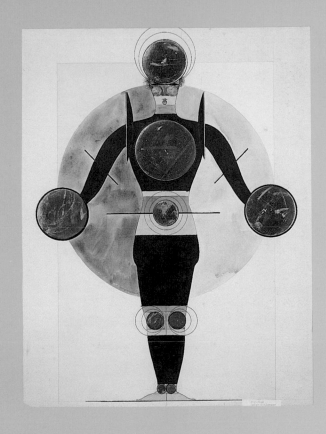

235 Oskar Schlemmer
Three Figurines for 'The White Party' at Bauhaus Dessau, 1926

232 Oskar Schlemmer
Figurine with Bronzed Discs, 1926

performed by Schlemmer when still in Stuttgart in 1922 and developed at his workshops at the Bauhaus. The ballet contained the full range of Schlemmer's performance theory, and remains the most interesting and complete fusion of dance, costumes and music. Three figures, wearing red, yellow and blue respectively, executed complex 'geometric' gestures within a predetermined spatial web, not only traced literally on the floor but three-dimensionally in space. The body became the moving force behind extravagant costumes which in turn extended the body's contours into space, rationalised into Platonic shapes through heavy padding, or distorted by the wearing of concentric metal circles. All traces of expression were literally concealed by masks. The anthropocentric designs added more to the sense of Dada play than literal prescription for clothing, their absurdity drawing from the variety theatre, the circus and puppet theatre.

In France, Italy, Russia and Germany, artists turned to the theatre as a place to experiment freely in order to find solutions to the challenge of modernist artistic representation. Separated by both geography and politics, European artists of the 1920s shared the sense that a still life or figure in repose could no longer reflect the excitement of the modern city, or the relationship betweeen man and his increasingly mechanised environment. Movement is a leitmotif throughout the history of art in the 1920s; the dynamic movement of asymmetrical design could not be constrained within the boundaries of a classically-framed composition. The theatre offered the chance to solve the paradox that in order to depict action, art had to detain it, and in order to structure energy, it had to contain it. In the theatre, art was free to move.

Notes
1 Carlo Carrà, *The Painting of Sounds, Noises and Smells*, Futurist Manifesto, Milan, 11 August 1913.
2 *Teatr, kniga o novum Teatre*, translated in Edward Braun, *Meyerhold on Theatre*, Methuen Drama, London, 1991, p. 63.
3 Varvara Stepanova in Christina Lodder, *Russian Constructivism*, Yale University Press, New Haven and London, 1987, p. 149.

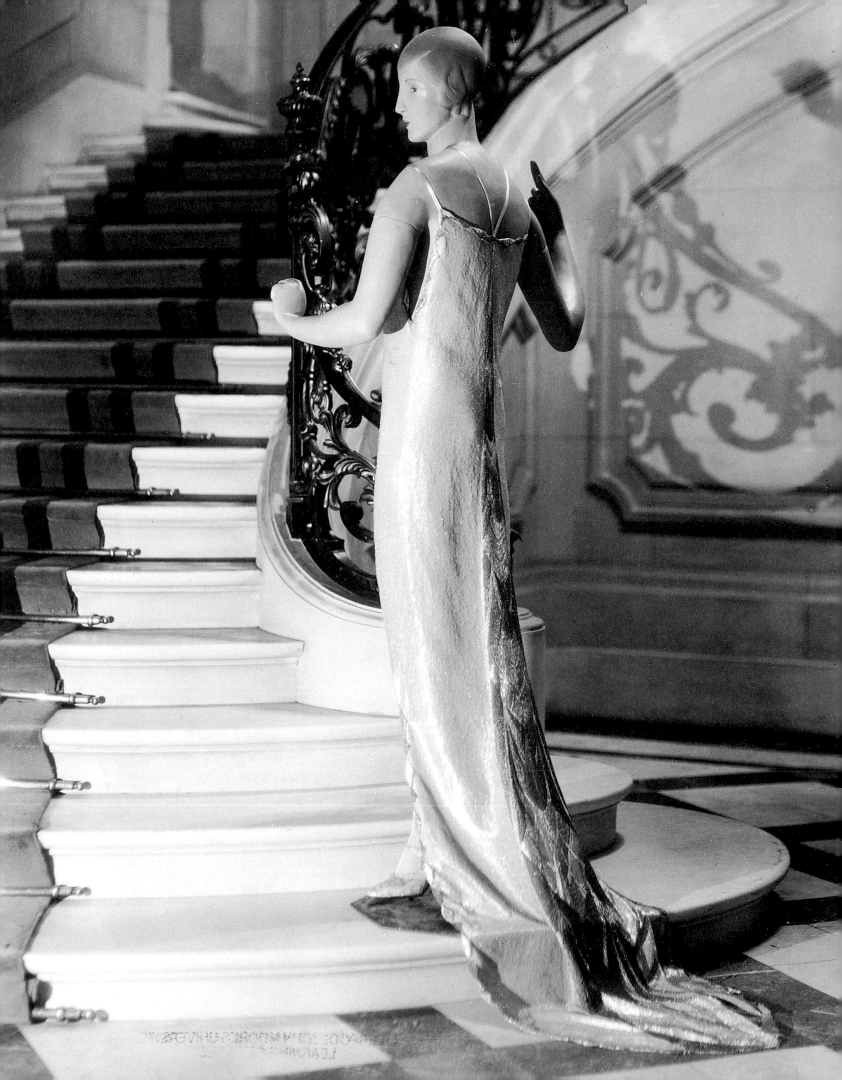

Stripping Her Bare: the Mannequin in Surrealism
Ulrich Lehmann

Because they expect too much of her, men feel awkward and timid towards the Great Mannequin. They do not know how to present to her the choice of epidermis which she changes more often than her blouse. (René Crevel, 1933)

The layers of meaning inherent in the figure of the mannequin are as manifold as the layers of clothing that fashion her appearance. An underlying structure covered with a choice of skin – first wood, wax, then plaster (to withstand the heat of electrically spotlit shop windows), now papier-mâché or fibreglass – creates an artificial figure which has always instilled feelings of awe, together with a sense of fantasy. This brief study will peel away some of the layers of material and meaning which shrouded the invariably female mannequin in surrealist circles between the wars. It begins in 1938 and looks back as far as 1917.

The first layer of meaning encountered in the mannequin is her close (in Freudian terminology 'uncanny') resemblance to the human body. She presents the perfect simulacrum – a copy without original – since the idealisation of the showroom or shop window figurine rarely reflects a sculpted truthfulness, but rather an imagined perfection. Elongated, miniaturised, broken into fragments, endowed with artificial joints and buffed to a shiny smoothness, the mannequin exists primarily to make people dream. In the context of surrealism, the mannequin's impossible resemblance to the human body becomes the object of the anxieties, subliminal longings and erotic obsessions of the male artist. The artificial woman is the ideal woman, both in her availability and in her remoteness, in the unperturbed distance she maintains

from any artistic or erotic manipulation.

The surrealists engaged spectacularly with this conceptual version of the mannequin in the International Surrealist Exhibition in Paris in 1938. On arrival, the visitor was invited to walk down a corridor of 'mannequins de la maison', fashion house mannequins, each posed in front of an imaginary Parisian street sign, presenting her as an available night walker. The mannequins were dressed by surrealist artists with a variety of accessories, each suggesting new sexual or social roles for the artificial women. These surrealist mannequins betrayed a lack of imagination: confronted with naked feminine 'perfection', each male artist had contemplated his potency and omnipotence, then simply transformed his mannequin's body (and especially her genital area) with objects belonging almost exclusively to the established surrealist canon. Max Morise

72 Marcel Duchamp
Surrealist mannequin 'A woman dressed as a man', 1938,
reconstruction 1981

had anticipated this installation in his story 'The Preserve' (Chasse gardée) of 1922 (written when he was 19), which imagined its protagonist trapped in a corridor lined with combative mannequins, ready to make love and war. André Masson typified the stereotypical surrealist approach, surrounding his figure with the symbolic trappings of vanity juxtaposed in an unfamiliar combination to suggest an aesthetic mystique. With peacock feathers between her waxen legs, and her head surrounded by a gilded cage, Masson's mannequin was rendered mute by a velvet gag adorned with a forget-me-not flower.

The surrealist installation was inspired by the 'Pavilion of Elegance' at the International Exhibition of the Arts and Techniques of Modern Life in Paris the previous year, whose designer, Etienne Kohlmann, worked in an artistic, 'surrealist' mode to dramatise a display of Parisian fashion. Faceless figures, gesturing elaborately, were adorned with the latest gowns and accessories. Their limbs were frozen in positions similar to the sculpted drapery and foliage of the stark scenery against which they were displayed. Sparse lighting created an atmosphere of mystery more usually evoked by surrealist writing, revealing a layer of meaning beyond uncanny human resemblance: the mannequin as mysterious muse, catalyst for the human imagination.

This exhibition dispensed with the usual realism expected of the mannequin as the mechanical echo of the catwalk model. Surrealism, here understood in a purely decorative vein, was the aesthetic order of the day, and fashion as well as interior designers responded to it. Couturière Elsa Schiaparelli used her contacts in surrealist art circles; earlier, she had enlisted the creative assistance of poets such as Louis Aragon and painters such as Leonor Fini and Salvador Dalí. She presented her mannequin stripped bare of sartorial trappings, her exclusive dress flung carelessly on to a clothes line nearby. Surrealist artists passing the mannequin lying on a bed of roses felt compelled to enact an old-fashioned bourgeois tradition and left calling cards expressing their condolences next to the naked, lifeless figure. Although decorative in impulse, this and other displays penetrated deeper into the layers of meaning shrouding the mannequin, perversely because of the displays' apparent negation of the mannequin's proper purpose. Fashion, exclusively created and expensively marketed, was cast aside, relinquishing its prime position to the bare, artificial female. Unlike in the surrealists' installation the following year, here the mannequin itself, the artifice rather

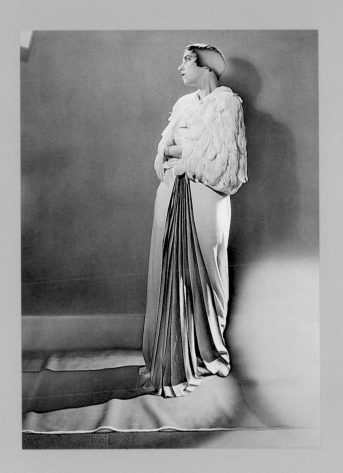

than its adornment, was the central focus.

Etienne Kohlmann's display ideas and fashion designers' response to them were inspired by surrealist language and readable in the context of surrealist ideas and imagery. The German surrealist artist Wols (Wolfgang Schulze) was commissioned by *Harper's Bazaar* magazine to document the construction of the 1937 Pavilion of Elegance. His photographs, produced with a small camera in the nocturnal gloom of the installation, attempted, like Schiaparelli's troubling presentation, to imbue with fantasy and mystery the unclothed mannequins in their stark setting. Wols' images showed the mannequin in a pure naked state, prior to its corruption and commodification by fashion.

In 1925, one of the other great Parisian decorative art exhibitions, the Exhibition of the Decorative and Industrial Arts, had presented a much more mundane 'Pavilion of Elegance',

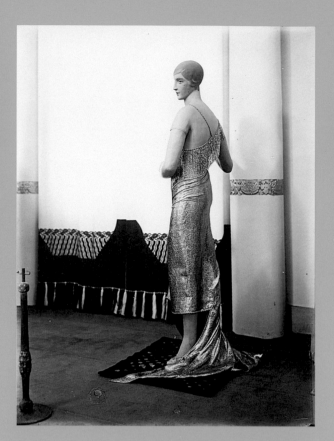

149 Man Ray
From *The Siégel Mannequins Series*, 1925

149 Man Ray
From *The Siégel Mannequins Series*, 1925

featuring six- to seven-foot wooden mannequins designed by André Vigneau for the famous manufacturer Siégel, arrayed in purely commercial splendour. No bare bodies for these women, only the most sumptuous creations by designers like Lucien Lelong, Madeleine Vionnet and Paul Poiret, advertising the French dominance of the world of haute couture. Photographer Man Ray, at that time already the chief chronicler of dadaist and surrealist activities in the French capital, used his early contacts with couturiers Poiret and Mainbocher (the editor of *Vogue*) to secure the commission to photograph the mannequins for the August issue of *Vogue*. In work more decorative and affable than Wols' would be over a decade later, Man Ray portrayed the mannequins in their innocence, as unconcerned signifiers of sartorial luxury.

Man Ray's sole creative indiscretion while carrying out this tasteful assignment was to present his photographs at a surrealists' meeting. He was persuaded to lend the best of his pictures – featuring Poiret's silk and chiffon embroidered slip dress on a mannequin at the foot of a grand staircase – for the cover of Issue 4 of the periodical *La Révolution surréaliste*. He agreed, and the picture was printed with the slogan 'et guerre au travail' (and [let us declare] war on work). When the issue went on sale in July 1925 in the bookshops of the Left Bank in Paris, the editor of *Vogue* was most displeased. Even to the untrained eye, the mannequin was transformed by its context from an icon of ephemeral beauty into an exemplar of bohemian satire. In this photograph the reified, idealised feminine is no longer a representation, nor an artwork, but part of a wider critique of modern life. Removed from the context of the fashion magazine, Man Ray's photograph of the wooden figurine now spoke of an estranged representation, and of the dangerous lure of the commodity. Not surprisingly, *Vogue* swiftly changed its August cover – although they honoured their agreement and printed some five photographs inside the magazine – and from then on they employed non-subversive photographers (i.e. those without too many artistic pretensions) to picture the eternally perfect artificial woman.

When André Breton, the charismatic dogmatist of surrealism, commented on the mannequined cover of his journal, he made reference to much earlier models: 'Beyond the amorality of style, the style that will continue to represent class for long periods of time, we denounce the amorality of man…. It is the perfect mannequin by Giorgio de Chirico that descends the staircase of the stockmarket. Everywhere we find ourselves in contact with it.

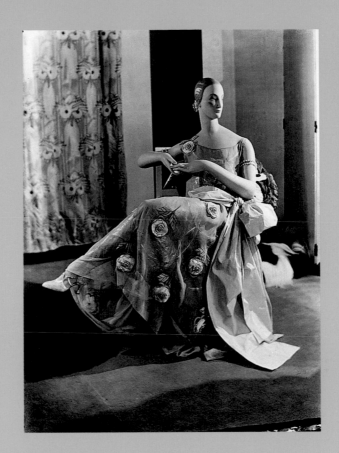

Forever we will reproach it for its bitter egoism'.[1] This thinly veiled attack on de Chirico, whose imagery was for a decade one of the founding inspirations of surrealism, was directed at his latest exhibition at the Galerie de l'Effort moderne. The surrealists detested de Chirico's exhibition, and his choice of venue, for its commercialism as well as for its implied combination of art and fashion. De Chirico's earlier 'perfect mannequins', much admired by Breton, were here presented not, as formerly, as pure signifiers or simulacra, but rather as commercially-exploited commodities. The surrealists, uninterested in fashion, wanted the mannequin explored rather than exploited.

Breton's criticism is surprising, since many avant-garde artists in the French capital were interested in the overlapping of art and fashion. Although the surrealists regarded themselves as thoroughly modern, and performed as the

artistic vanguard on all fronts (literature, painting, sculpture, film etc.), they had not displayed a profound interest in, or insight into, the latest fashions. Despite the stylistic endeavours of dandiesque artists such as Louis Aragon or Salvador Dalí, who dressed for effect and who in the 1930s created accessories or fabrics for progressive designers such as Schiaparelli, most of the surrealists' taste in clothing was old-fashioned. Yet they claimed this to be an integral part of an extended strategy: recently outmoded gowns and suits held for them the key to the dreamscapes where true realities may exist. If social convention lay in the attire, or more precisely in its folds, cultural truths were hidden in the folds of time. The most up to date, fashionable clothing could not assist the surrealist objective; it first had to age and ferment in order to create a potent artistic product.

Walter Benjamin described this phenomenon in the late 1920s: 'Surrealism encountered revolutionary energies first in the "old-fashioned", in the first iron construction, the first factory buildings, in early photography, in the objects that begin to die out, the pianos, the umbrellas, the clothes of five years past...'.[2] He concluded, with reference to Breton and the surrealist chronicler Pierre Naville, that this perception had to be employed 'to render the incredible tensions in the collective, which are expressed by fashion, subservient to the revolution'. Fashion – expensive, desirable and outmoded almost at the moment of purchase – exemplified the contradictions inherent in materialist society, but for the surrealists (with the exception of Aragon and a few others) art rather than politics was seen as the ultimate weapon with which to attack these contradictions. If in the world of the latest

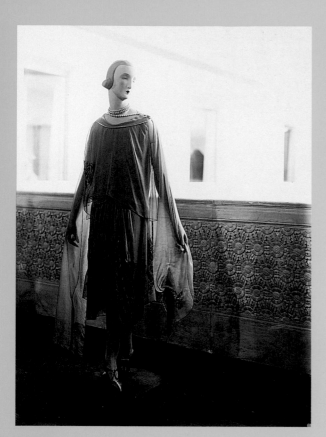

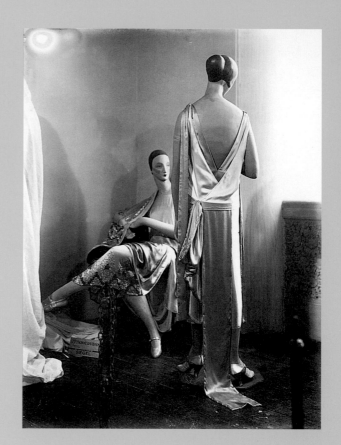

149 Man Ray
From *The Siégel Mannequins Series*, 1925

149 Man Ray
From *The Siégel Mannequins Series*, 1925

fashion it is the vision of the designer that is important; in that of the old-fashioned, the focus is rather on the person wearing, or deciding not to wear, the clothes. The clothes may be seen as cultural rather than material commodities, and their wearer, especially if she is the ageless mannequin, the mysterious inhabitant of a timeless (if outmoded) surrealist dream world.

In 1919, Max Ernst, a young dadaist artist from Cologne who would later become one of the most prominent surrealist artists, persuaded local authorities to finance a portfolio of lithographs, published under the title *FIAT MODES, pereat ars* (art perishes, LET THERE BE FASHION). This epitaph to fashion was an ironic adaptation of the humanist motto 'fiat iustitia et pereat mundus'. The first lithograph presents an elegant tailor measuring a hybrid figure halfway between a showroom dummy and a

couturier's house model. The mannequin appears lifeless and passive, yet has lifted her arms to help the tailor clothe her with the chalk-marked cloth, the commodified armour of civilisation. Both tailor and dummy are de-personalised, faceless representatives of modernity, yet Ernst injects a dose of humour into the proceedings. The third lithograph of the series is titled *Latest creation through the division of FASHION*, yet the fashion is absent and the dummies dispersed into pre-surrealist, impossible hybrids. The division of fashion is incomplete: the amorphous forms sport only topstitched underwear and an enthusiastically raised bowler hat.

Ernst's lithographs strip the outer shell of human resemblance away from the mannequin, revealing her as a social and structural signifier rather than a substitution for an idealised femininity. In this he both

anticipated the treatment of the mannequin within surrealism (epitomised by the 1925 coup of stealing, or rather conceptually appropriating, the mannequin from the fashionable confines of *Vogue*) and developed the interest in the semiotic possibilities of the mannequin evident in the *manichini* of de Chirico's *pittura metafisica* of the 1910s, the 'metaphysical painting' which was such a powerful influence on surrealism. In this work, the mannequin was literally stripped bare. In a drawing of 1917, *The Prodigal Son* (the model for Ernst's lithograph), de Chirico presents a father figure in an outmoded morning coat, embracing a reluctant mannequin, of whom nothing remains but a basic wooden skeleton. Armless and sexless, the mannequin's measurements appear behind it as if to compensate for its tragically reduced state, brought about according to the Bible story by a

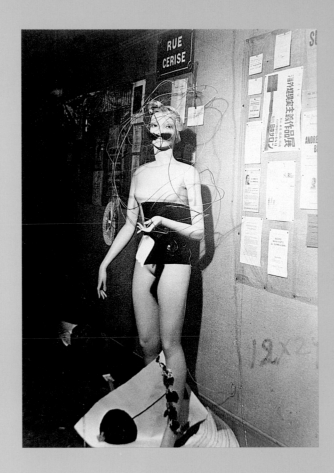

dissolute lifestyle among prostitutes. His properly-attired father has forgiven it, but will the wooden mannichino ever be able to afford a new clothes with which to erase its past?

De Chirico's symbolic undressing of his manichino presents us with the mannequin deconstructed, a mystical figure representing at once the infancy of Western art (in the drawing's allusion to classical statues and Biblical narrative) and the psychoanalytic trauma of childhood (in the title and the Oedipal paternal embrace with which de Chirico interprets it). The mannequin is stripped bare, reduced to an armature which, free from either conceptualisation or commodification, could be used by the artist to express the basic urges and anxieties of both woman and man. Moving backwards in time, we have arrived at the underlying structure of the mannequin with which we started. In the

decades that followed, surrealism would pile meaning on to the figure, turning her into first an ironised, commodified supporter of the latest sartorial design, then a manipulated object of desire and an eroticised target for male projection and sublimation. In her progress through the art and fashion of the 1920s and 1930s, the mannequin lost her innocence and, eventually, her relevance within modern artistic discourse. The mannequins of the 1938 International Surrealist Exhibition, fully-fashioned by surrealism, signalled, ironically, the end of the mannequin's reign as an artistic motif. Having stripped her bare, then re-clothed her in layer upon layer of social, political and artistic interpretation, the surrealists tired of her. Even for them, she looked too outmoded – a situation quite unbecoming for the perfect supporter of fashion.

Notes
1 André Breton, 'Pourquoi je prends la direction de la R.S.', *La Révolution surréaliste*, no. 4, Paris, 15 July 1925, p. 2.
2 Walter Benjamin, 'Die Gewalt des Surrealismus' (Surrealism's Violence), unpublished manuscript page, written 1928/29, in *Walter Benjamin. Gesammelte Schriften, II.3*, Frankfurt, 1991, p. 1031.

Mutability and Modernity: the 1990s
Caroline Evans

'Let there be fashion, may art perish'. Max Ernst's provocation of 1919 contrasted the enduring values of art with fashion's ephemerality and superficiality. In 1914 Marcel Fabre's Italian Futurist film *Amor Pedestre* (Love Afoot) issued a polemical challenge to the separation of art and life. In an urban tale of love and honour, performed solely by the actors' feet, three fashionably-shod figures of the *haute bourgeoisie* form an eternal triangle to dally, duel and disrobe. In Sylvie Fleurie's video *Twinkle* (1992) the artist's feet are framed greedily and compulsively trying on and discarding a mountain of fashionable shoes. Offering an ironic commentary on the convergence of art and fashion, the artist, a socialite and serial shopper, turns her life into a work of art. Fashion, possibly, has more to tell us about life than we thought.

Art, on the other hand, is more economical with eternal truths these days, replacing master narratives with tentative tales of embodiment and identity. Historically, the ideal nude stood for value and permanence; the fashion silhouette, though no less idealised, represented inconstancy and mutability. In recent years these antithetical images have converged on the terrain of the fragile, mutable, human body which artists have represented as abject, traumatised and fissured. Designers too have played with its parameters; Georgina Godley experimented with a row of Barbie dolls whose bodies she altered with plasticine, before producing her biomorphic dresses in the mid-1980s. In 1997 Rei Kawakubo of Comme des Garçons used goose-down padding in dresses to morph the post-industrial body into new forms, producing a series of poetic speculations on the theme of embodiment in the modern age.

Birth and death are evoked in designer Helen Storey's visualisation of the moment of life, the beginning of all narrative, and in artist Emily Bates' hair dresses in which the dead stuff of human hair acts as a *memento mori*. For an installation at the Museum Boijmans van Beuningen in 1997, the designer Martin Margiela sprayed his clothes with mould to produce a patina of decay.

This work occupies the space traditionally taken up by art. Meanwhile much art has moved towards the condition of fashion: Ann Hamilton, Adrian Bannon and Lesley Dill use materials like muslin, gauze, voile, net, feathers, even thistledown, to evoke ephemerality and transience. Their mood recalls the flaking plaster and sad poses of Deborah Turbeville's *Wallflower* series of photographs from the 1970s. Adrian Bannon's thistledown coats combine two signifiers of

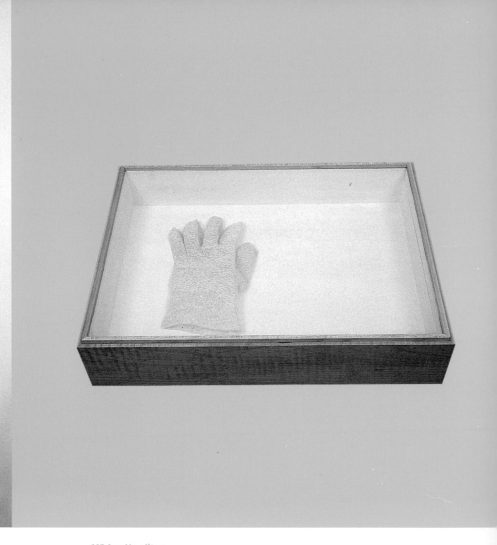

70 Lesley Dill
Hinged Copper Poem Dress, 1997

112 Ann Hamilton
The Slaughter, 1997

evanescence in one object: the thistledown and the garment will both blow away in the end. Art that *will* perish joins hands with fashion that *is* perishable.

As in a *vanitas* painting, the theme of transience punctuates this work, but the transience of fashion in particular seems to articulate the postmodern condition. The very mutability of fashion is itself a kind of *memento mori*. Its rapid style changes, which try to hold death and decay at bay, give it a fatal fascination and chime with the dominant intellectual modes of the late twentieth century: pessimism and nihilism. Fast forward, rewind, cut to the chase: in its relentless changeability fashion trains us to be flexible in a fast-changing world. Endlessly recycling the old into the new, fashion revivals replace linear time with cyclical time. Nineteenth-century haute couture

introduced the fashion season, regular as clockwork. Its repetitive pattern of seasons smoothed out time, regulating daily life more effectively than the unpredictable natural world. In the twentieth century, life after the electronic revolution seems to imitate fashion's stop-start timing so that real time seems more like fashion time: circular, disjointed, jerky, like the Jurgen Teller video loop made for the Jigsaw retail chain in 1997, which shows a man falling from a building endlessly – again, and again, and again. That year, Martin Margiela doubly inverted fashion time when he deconstructed secondhand clothes and revived them as new, only to age them again by spraying them with mould.

Margiela reflects an approach to modernism stemming from the nineteenth century. Fashion time is part of the temporality of the metropolis, with its

potential for display and self-invention. In nineteenth-century Paris, Baudelaire characterized modernity as fleeting, ephemeral and transient, and this characterization continues to reverberate in the late twentieth century as an attitude, rather than a period in history. 'Life is threatening to become public' wrote the de Goncourt brothers in their journal in the 1860s[1] and, as meaning mutates to the surface of things, fashion has more and more to say about the society of the spectacle. Modernity puts fashion centre-stage as part of the theatricalization of everyday life and the staging of the self. Michel Foucault observed that 'modern man, for Baudelaire, is not the man who goes off to discover himself…he is the man who tries to invent himself',[2] and this new type of kinetic, fashionable, open personality is what

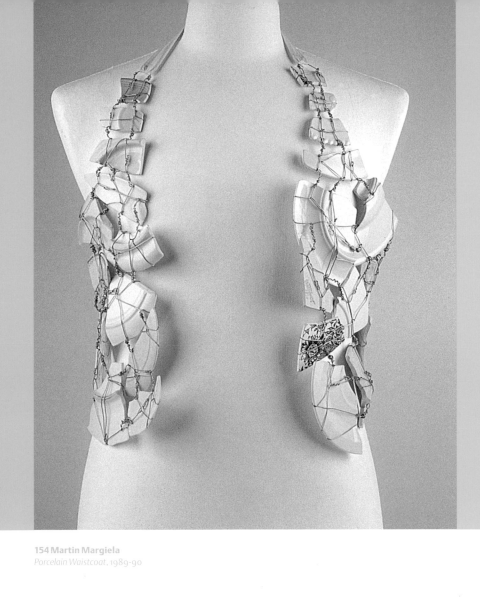

154 Martin Margiela
Porcelain Waistcoat, 1989-90

13 Emily Bates
Depilator, 1994

societies in perpetual motion need most.

 Baudelaire's idea of modernity was closely bound up in the experience of the newly industrialized city of the second half of the nineteenth century. Lucy Orta's work reconfigures this experience in the late twentieth century city. Her hybrid dress-shelters are defensive armour, tents which transform into garments and rucksacks – urban survival gear. Her work is comparable to the London-based Vexed Generation whose clothing exhibits a concern with the late twentieth-century metropolitan experience – pollution, surveillance and police powers of arrest. Walter Benjamin linked modernity to 'shock' which he defined as a kind of vivid presentness inherent in the contemporary city.[3] For Hal Foster the shock is electronic: we are *wired* to spectacular events and psycho-techno thrills as we map

meaning on the surface of the visible world.[4] Billboards, the Internet, shopping, fashion, videos and magazines all mess with appearances rather than trying to perfect them into ravishing images. With the new electronic media comes a profound change in cultural identity; like Baudelaire's dandy, we endeavour to know ourselves through various visual fictions which are played out in the spectacular arenas of fashion and the newer media. Hussein Chalayan's work, for instance, refers to the high art gravitas of the installation, with its legacy of profundity, but his use of mirrors testifies to the slippery instability of surfaces. The faithlessness of the mirror signals a contemporary anxiety about the constantly changing flow of signs and images in contemporary culture. If our fictions are all visual ones, they are not reassuring but treacherous and unstable.

Notes
1 De Goncourt brothers' journals, quoted in Elizabeth Wilson, *The Sphynx in the City: Urban Life, the Control of Disorder, and Women*, Virago, London, 1991, p. 52.
2 Michel Foucault, 'What is Enlightenment?', trans. Catherine Porter, in Paul Rabinow (ed.), *The Foucault Reader*, Penguin Books, Harmondsworth, 1984, p. 42.
3 Walter Benjamin, 'On Some Motifs in Baudelaire', and 'The Work of Art in the Age of Mechanical Reproduction' in *Illuminations* (edited and with an introduction by Hannah Arendt), translation Harry Zohn, Fontana/Collins, London, 1977, second impression, pp. 157-202 and 219-254. See too Mike Featherstone, *Consumer Culture and Postmodernism*, Sage Publications, London, Thousand Oaks, New Delhi, 1991, pp. 65-82, for a discussion of 'shock'.
4 Hal Foster, *The Return of the Real: the Avant-Garde at the End of the Century*, An OCTOBER Book, The MIT Press, Cambridge, Mass. and London, England, 1996, pp. 221-22.

A Subversion of the Genre
Robin Muir

Sometime in the 1950s, the photographer Clifford Coffin, a maverick and neurotic perfectionist, who lived purely for fashion – 'a young man in such a hurry' as Cecil Beaton recalled – was asked whether the fashion photographs he took for American *Vogue* or the huge amount of advertising pictures he carefully crafted were 'art'. They were not, he replied, they were taken, they were published, he was paid (a lot – at that time he was one of the industry's highest earners) and then, he said 'they are forgotten'. 'It is not anything', he continued, 'about art'. His expectations for a secondary role for them were not high (his work was not exhibited in his lifetime) and not sought for. When he died in 1972, his *oeuvre* remained untouched and in the archives of *Vogue* in London and New York.

However, Coffin had allowed his pictures to be published in *The Art and Technique of Color*

Photography in 1951.[1] Since it contained reportage stories, such as a portfolio on Gandhi's India, it cannot be classed as the first compilation of fashion photographs, but every photographer featured in the book shot fashion or beauty pictures for the Condé Nast magazine empire. And contrary to Coffin's assertion, though tempered by 'Technique', 'Art' loomed large not only in its title but also in the graphic presentation of the photographs designed by *Vogue*'s then art director Alexander Liberman. It proved also that Coffin, like so many of his colleagues and so many of his predecessors, possessed a painterly eye, a flair for graphic design, a feeling for dynamic composition and an enthusiam for conspicuous beauty. These attributes have over the decades (fashion photography generally is reckoned to be an invention of the late Victorian age) helped transcend the notion that the medium has

existed purely to satisfy the demands of the magazine-devouring, fashion-buying consumer. It is art of a particular and peculiar kind. How disenchanting it would have been for Coffin, who ended his days alone and semi-deranged, in a black-painted apartment, that there are so many practitioners of the art and technique of fashion photography, whose pictures prove above all that there is little doubt about its status. And Coffin's experience is emblematic of the prevailing stigma of insubstantiality and ephemerality that has dogged the reputation of this aspect of commercial photography for most of our century.

Towards the end of his life, Coffin's teacher and mentor, George Platt Lynes, a prolific contributor in the 1930s and 1940s to *Vogue* and *Harper's Bazaar*, destroyed many of his own photographs; he did not want his fashion

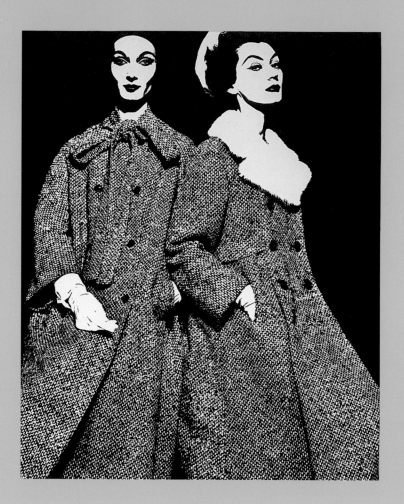

18 Erwin Blumenfeld
Untitled Fashion Photograph for Dayton's Oval Room, 1959

oeuvre, which he considered to be commercial and vapid, to obscure the dreamlike tableaux he constructed purely for himself. The former were highly idealized, idiosyncratic fantasies, borrowing heavily from surrealism. They bear little resemblance to the static, formal and over-stylised fashion poses that characterized magazine photography in the first few decades of the century. Lynes' fashion photographs are, at least on the surface, works of art in miniature, at least as interesting and as brilliantly conceived as the nudes and portraits that have generated at least half a dozen books and many more gallery exhibitons.

Contemporaneous with Lynes, Erwin Blumenfeld, a New York-based *emigré* from Berlin, removed fashion photography further from the salon tradition of its origins. His striking images, disembodied heads shot through rain-pitted glass, the effects of blur and spatial distortion, were inventive and innovative. Though the art of photography is frequently threatened by a subservience to the art of graphic design, Blumenfeld, manipulated his fashion photography (a term which he hated) with clever, almost painterly devices, to such an extent that its resonance was still felt decades later and beyond the pages of the magazines for which it was commissioned. He paid, as might be surmised, little attention to the delineation of the clothes it was intended he document. They served only as the point of origin of his visual follies – 'freaks of illusion and beauties of impression', as the critic Richard Martin has termed them.[2] The true significance of a Blumenfeld photograph – the totem of the artist as fashion photographer – lay in the groundwork he prepared for his *mise-en-scène* before allowing his picures to hit the page. Solarization, scratching, tinting, bleaching, and re-tinting, the reversal of postive and negative were the creative techniques and dazzling visual effects of an artist close to the German Dada movement and a master subversive.

Another figure from the avant-garde, Man Ray, found on his arrival in Paris in 1921 that fashion and the depiction of it were cross-cultural in its inspiration and interpretation: Chanel worked on costumes with Salvador Dalí who created illustrations for, among others, *Vogue*. For his first few years as a practitioner of the new art, it served Man Ray only as the means to an end, a quick way to make easy money to finance personal projects (a common story among fashion photographers from Edward Steichen to William Klein, and to the younger fashion photographers of today) but the lure of the possiblities of subversion and experimentation in fashion photography intrigued him too. For *Harper's Bazaar*, then

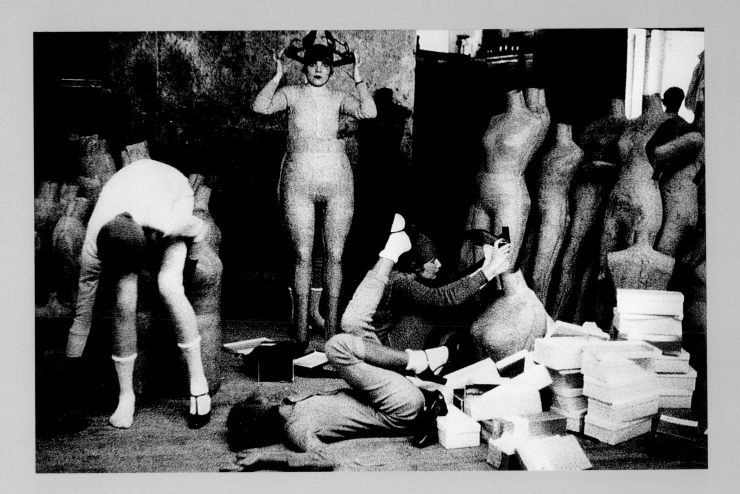

273 Deborah Turbeville
Mary Martz and friends trying on shoes, June 1974

under the aegis of its art director the Russian Alexey Brodovitch, Man Ray produced his most incendiary compositions. In the words of the critic Martin Harrison: 'Brodovitch was devoted to the gospel of the "new", to the visual shock. He brought to the magazine page a fusion of the characteristics of several of his fellow countrymen – the filmic urgency of Eisenstein, the constructivist dynamism of El Lissitzky and the fluidity and theatrical panache of Diaghilev'. Man Ray's fashion *oeuvre* becomes as much a part of his artistic contribution to the culture of our century as his metronomes, his nail-studded iron or his lips of Lee Miller. Like Blumenfeld he showed a disregard for fashion which allowed him the freedom to break the rules and to formulate his own in clever, witty, and fantastical ways. Man Ray's work for Brodovitch and his editor-in-chief Carmel Snow went far beyond their expectations and he delighted in

sending out to readers, by way of his frequently obscured fashion pictures, opaque meanings and confusing messages. He used the techniques of distortion and double exposure; he elongated limbs, foreshortened torsos and overlayed his prints with gauze and coloured gels; he distressed them before publication; he brought in extraneous props like the fluid sculptures of Brancusi or African tribal effigies for no reason other than that it felt appropriate or, more often than not, inappropriate. In the fashion work of Man Ray the presence of art is strongly felt; the cut, movement or delineation of clothes is of secondary consideration: 'I never think of the public', he pronounced, 'of pleasing them or arousing their interest ...'. The historian Nancy Hall-Duncan has written with understatement that the information provided by Man Ray's experimental images 'is often extremely sparse'.[3]

In terms of visual excitement the *Vogue* to which Coffin contributed was generally agreed – not least of all by its art director Alexander Liberman – to be inferior to Brodovitch's *Harper's Bazaar*. Liberman's riposte was to hire the Paris-based artist/photographer William Klein, an abstract painter and sculptor of kinetic art. 'An American from the Bronx with a brashness and a sort of violence I liked', according to Liberman, Klein was famous by 1956 for his book *New York*, a head-on visual assault on the city he had left behind, focusing on the chaos of the streets and the lunatic display of everyday life.[4] He developed a 'snapshot aesthetic' and a kaleidoscopic variety of techniques, which embodied distortion, imbalance, close-cropping, blur and, to some extent, a reliance on the accidental or unintentional. Klein brought his idiosyncratic visual language to the pages of *Vogue* and for a

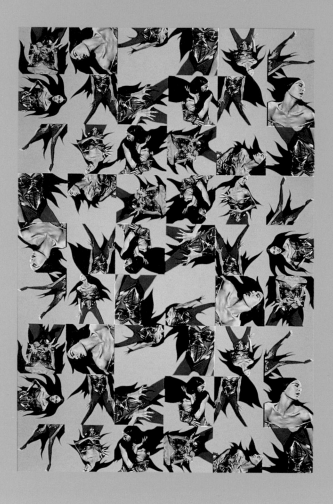

237 Stéphane Sednaoui
Tara, Paris 1989, 1989

decade produced subversive and knowing 'anti-fashion' pictures, as skilfully constructed and discomfiting as those of his fellow American in Paris, Man Ray, decades before. On the streets, Klein's models refused to jump across puddles, or smile pirouetting up on to the sidewalks. They stood resolutely still, holding mirrors up to the traffic like the urban installation of a performance artist. Klein, an accomplished film and documentary maker reserved much of his disdain for the fashion industry, in which he had never felt – or wanted at all to feel – at home for his satire *Qui-etes vous Polly Magoo?* In this bitter, quasi-comical and picaresque fantasy on the world of fashion, Klein neatly sent up the absurd reverence that the readers of fashion magazines a quarter of a century later would heap upon 'supermodels'. He commissioned a collection of constricting and uncomfortable clothes made out of aluminium, and invited real figures from the fashion world to its unveiling. He recorded their applause, much of it apparently genuine.

In 1975, a set of pictures for American *Vogue* by Deborah Turbeville, a fashion editor turned photographer, caused a storm of protest. She posed her models in a bath-house, languid and isolated, it appeared, in worlds of their own devising. With her characteristic grainy, Impressionistic colour photography she created a tense and hallucinatory *mise-en-scène*. She was accused of bringing to the magazine the whiff of the concentration camp; by their disembodied stasis, her models appeared to be in thrall to a drug-induced soporific. Liberman reminded readers that 'everything in life is not health and happiness'.[5] Such implications were unintended by Turbeville and her sense of unease and mystery was misinterpreted. She has however continued to subvert the fashion picture to great effect. For her book *Maquillage* (1975), she turned her attention to the qualities inherent in her prints.[6] By re-photographing them, distressing them, by collaging sequences and laying them out in unusual configurations, she fabricated, as she told critic Martin Harrison, 'a strange ghostlike magazine'. For Italian *Vogue* she tore up her contact sheets and started again, turning them into unattainable sequences and collages.

A common criticism levelled against fashion photography is that it is 'unreal', that it has no meaning or relevance for contemporary life outside the pages of magazines. The photographs of Juergen Teller and Wolfgang Tillmans have done much to bring a less abstruse slant to the genre. The work of both photographers is as powerful on the walls of the art gallery as it is in the pages of the fashion magazines. For Tillmans it appears that the

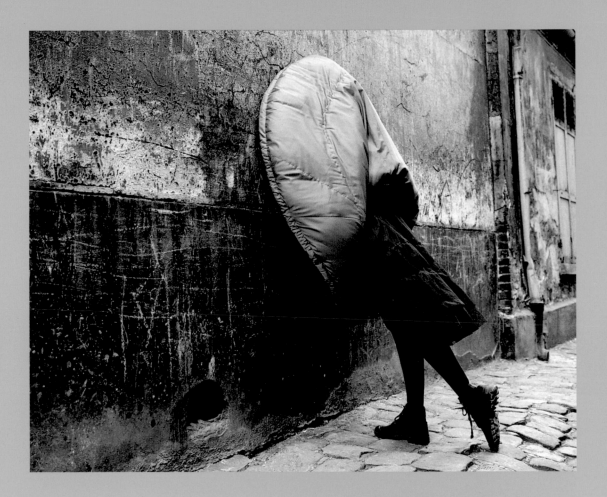

261 Juergen Teller
Six Magazine, Comme des Garçons,
Anna Pawlowski, April 1991

former is his preferred arena. Teller's snapshot aesthetic however has been embraced by the major fashion magazines and it is a testament to the impact of his photographs that there are so many prospective clients willing to share in his peculiar vision of the world. His early campaigns, especially those for the clothing company Jigsaw, are typified by a relaxed, fluid *verité* style. His models, too, refuse to pirouette on the sidewalks, but tell by gesture alone their own tales: they lie back distractedly in the grass, slump over tables, look bleary-eyed from grim train windows, poke around at the bottom of the glass for the piece of lemon. These mundane moments, reassuring in their familarity, are beautifully observed slices of what might be called 'real life'. Models do not pose as models ought. They twist and writhe and, as his celebrated pictures of Kristen McMenamy reveal in a classic documentary

style, they look bruised and defiant, vulnerable, ordinary and 'real'. Teller's vision threatens like the best of them to dispense with fashion altogether. 'I am not', he has said, 'interested in pieces of clothing'.

Pulling back the surface of the fashion picture to the skull beneath the skin – 'I like to scrape down the characters and tell a story' – Teller's off-kilter, idiosyncratic vision and his urban dramas, gritty and oblique, are emblematic of a 'new realism', explosive and subversive. Much in the same way as when we scrape down fashion photography's cast of characters over the last hundred years or so, disregarding the perfunctory and gloss over the superficial, we find it has much in common with the old one too. Fashion photography's subversives have found much to say to us in absorbing, disturbing, persuasive and irresistible ways.

Notes
1 Alexander Liberman (ed.), *The Art and Technique of Color Photography*, Simon & Schuster, New York, 1951.
2 'Blumenfeld' by Richard Martin, quoted in *The Idealizing Vision*, Aperture, New York, 1991.
3 Nancy Hall-Duncan, *The History of Fashion Photography*, Alpine Book Co., New York, 1991.
4 William Klein, *New York*, Editions de Seuil, Paris, 1956.
5 Liberman on Turbeville appears in 'Liberman's Choice', *American Photographer*, May 1980, p. 51.
6 Deborah Turbeville, *Maquillage*, Millrock Press, New York, 1975.

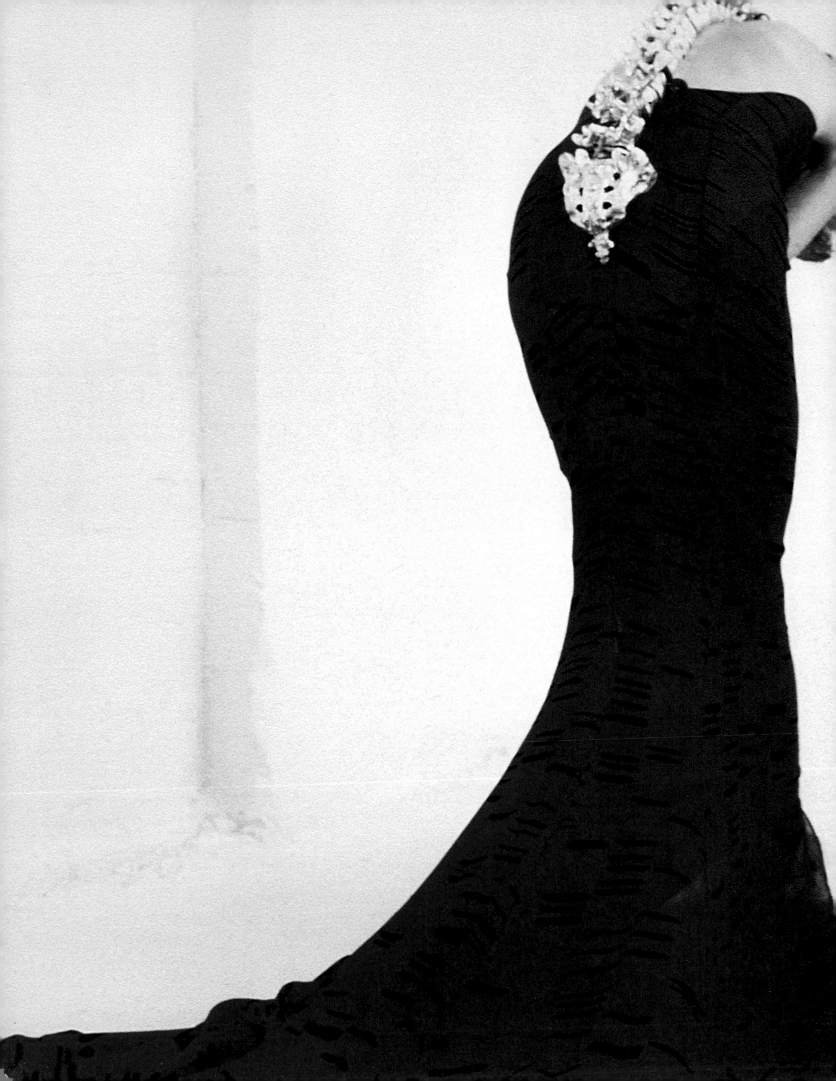

The Body Clothed
Joanne Entwistle and Elizabeth Wilson

The social world is a world of dressed or at least adorned bodies. Unadorned nakedness is almost always inappropriate, even in situations where the body, or most of it, is exposed. On the beach, in the swimming pool and in the bedroom, as much as in the street, bodies on display are likely to be adorned, if only with jewellery or scent; and when Marilyn Monroe was asked what she wore in bed she famously answered 'a few drops of Chanel No. 5' – for even without garments, the social body is always embellished and decorated to give it symbolic, social and/or erotic meanings. In Cranach the Younger's paintings of Venus, for example, the body of the goddess is unclad, but she invariably wears a hat, a scarf or transparent veil, and jewellery, and her hair is always elaborately arranged. Anthropological evidence, too, has shown that all cultures 'dress' the body in some way, by clothing, tattooing, scarifying, cosmetics, or other means.

In the West the practice of getting dressed is importantly framed by fashion. Fashion refers to a particular system for the production and consumption of dress, characterized by a cycle of changing styles. Contemporary research suggests that non-Western dress was and is also influenced by changing fashions in different ways,[1] but until recently costume historians associated the style cycle primarily with Western dress since the fourteenth century.

The fashion system sets the agenda for dress by producing and distributing clothing and by promoting, at any given period, a specific style aesthetic which becomes *à la mode*, in other words it becomes the popular, desirable style of dress. In the contemporary world, the ready-to-wear collections of haute couture designers play a significant role in promoting certain styles of dress, and today these reach the 'high street' faster than ever before through mass producers who interpret the collections and bring out cheaper versions. This has become such a well-established phenomenon that broadsheet newspapers such as *The Guardian* have regular 'cheat chic' columns informing readers of where to buy cheap copies of designer items.

Designers, as this example demonstrates, are only part of the picture. They depend on a whole array of other agents within the fashion system: not only mass manufacturers, but also fashion forecasters, fashion magazine editors, journalists, photographers and fashion buyers, all of whom play an important role in determining what styles of dress are promoted, and which styles will, as a result, be widely available to consumers. Fashion is therefore the product of a complex set of interactions between producers, retailers and

107 Marie-Ange Guilleminot
Dress on Wheels, 1992

consumers – between different bodies caught up within a system of ever-evolving dress.

Fashion as we have described it is one form of dress, which in turn is one form of bodily adornment, and the ubiquitous nature of adornment/dress suggests that it is one of the means by which bodies are made social and given meaning and identity. The individual and personal act of getting dressed is an act of preparing the body for the social world, making it appropriate, acceptable, indeed respectable, and possibly also desirable to others one might encounter in a social setting. Dress is one important means whereby individuals learn to live in their bodies and feel at home in them. Getting dressed is an ongoing practice of attending to the body, requiring knowledge, techniques and skills. It is simultaneously an intimate experience of the body and a public presentation of it. Operating on the boundaries between self and others, it is the interface between the individual and the social world, the meeting-place of the private and the public. It is a suit of armour or a shell, for, like the crab, the 'raw' human body is distinguished by its characteristic of being somehow unfinished, unpeeled, vulnerable and incomplete. But it is also a costume for a role, and for the dramatization of identity.

Because of the social and symbolic importance of dress and adornment, strict rules govern when and with whom we may appear undressed. In the public arena in particular, rules almost always require that the body be dressed, and the flaunting of flesh, or the inadvertent exposure of it in public, is experienced as disturbing, disruptive and potentially subversive. In the West, women who breastfeed in public places are often asked to remove themselves to somewhere 'private' and their activity is even sometimes described as disgusting or indecent; while to strip or 'streak' constitutes a disturbance of public order and is legally an offence – in 1995, a young man who ran naked across the cricket pitch at Old Trafford, Manchester, was summonsed to appear in court.

So potent is the naked body that when it is allowed to be seen, when, for example, it is represented in and as 'Art', it is still governed by social conventions. John Berger[2] has argued that, within art and media representations, there is a distinction between naked and nude, the latter referring to the way in which bodies, even without garments, are 'dressed' by social conventions and systems of representation; while according to Anne Hollander,[3] dress is so crucial to our understanding of the body, and our way of seeing the body is so determined by the fashions of the day, that representions of the

296 Stephen Willats
Multiple Clothing. Personal Display, 1992

109

naked body reproduce the shapes of those fashions and the conventions of dress of any given period. She demonstrates that depictions of the nude in art and sculpture correspond to the dominant fashions of the day at every period in Western art since the Renaissance, and argues that 'art proves that nakedness is not universally experienced and perceived any more than clothes are. At any time, the unadorned self has more kinship with its own usual *dressed* aspect than it has with any undressed human selves in other times and places'. In other words, the lines of Cranach's slender nude Venus mirrored the gothic robes of his time. Thus the nude is never naked, but is 'clothed' by contemporary conventions of dress – albeit invisible ones.

Dress is the form in which the body is made visible.[4] Bodies are potentially disruptive, and while fashion should not be rejected in the manner either of a stereotypical 'feminist',

Christian or Islamic moralist, it does act as a form of social control. Conventions of dress, furthermore, attempt to trasnform flesh into something recognizable and meaningful to a culture; a body that does not conform, that transgresses such cultural codes, is likely to cause offence and outrage and to be met with scorn or incredulity. One of the most important of these codes is gender, which is why the male transvestite or the female body-builder is likely to cause horror, derision or at least unease, although in recent years such 'deviantly' gendered bodies have become more acceptable.

Dress is a matter of morality as well as aesthetics. Dressed inappropriately, we are uncomfortable, we feel wrong, even guilty. According to Quentin Bell, it is so important to wear the right clothes that even those who are not interested in their appearance will dress

sufficiently well, or at least appropriately, to avoid social censure.[5] In this sense, he argues, we enter into the realm of feelings, having acquired a 'sartorial conscience' – even a fashion super-ego. He points out that dress is often discussed in moral terms, with the use of adjectives such as 'faultless', 'correct' and 'good'. In a reverse process, moral turpitude is often describe in terms that use metaphors from dress, as in 'shabby behaviour', 'down at heel' and 'slipshod'. Few are immune to the social pressure this implies, and most of us are embarrassed by certain mistakes of dress, such as finding one's flies undone or discovering a food stain on a jacket or dress. As Bell says, 'it is as though the fabric [of our clothes] were indeed a natural extension of the body, or even of the soul'. An extreme example of this is the Shirt of Nessus, in the Greek legend, which actually grew into the body of the wearer. In his painting,

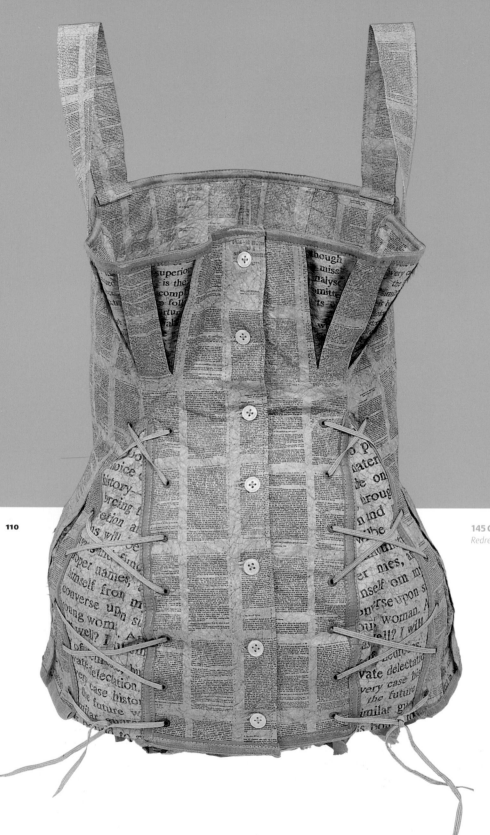

145 Christine LoFaso
Redress: Gestation Corset, 1992

René Magritte alludes to this sense of body and garment eerily melding into each other in images of shoes that are also feet, and veils that cover but also become the face.

So dress in everyday life cannot be separated from the living, breathing, moving body it covers. The importance of the body to dress is such that encounters with dress divorced from the body are strangely alienating. This can sometimes be strongly felt in the museum costume display, when the gallery may seem haunted by the individuals who once wore the gowns and coats that are now displayed with a dead stiffness, hinting at the sinister, threatening knowledge of the atrophy of the body and the evanescence of life.[6]

The gown or suit once cast off seems lifeless, inanimate and incomplete without the wearer. The sense of alienation from the body is the more profound when the garment or the shoes

still bear the marks of the body. Dress, the body and the self constitute a totality, and when dress and body are pulled apart, as in the costume museum, we grasp only a fragment, a partial snapshot of dress, our understanding limited. Of course, this is also true in a dress shop, except that in that situation we tend to visualise the garment as we would wear it, in addition to which the lively activity of the boutique or fashion department is usually very different from the hushed stillness of the museum, which transforms the garment into a fetish. Its displays cannot tell us how the garment moved when on a body, what it sounded like when it moved and how it felt to the wearer. When, as is often the practice, dress is displayed in museums as an art object, we lose something that art – painting, film – paradoxically returns to us: the sense of dress united with its body.

To say this is not to suggest that the display of garments is worthless or misguided. On the contrary, such displays are important for two reasons. They provide an opportunity to observe the beauty, construction and detail of garments, and thus remind us that they are, after all, art/craft objects in their own right as well as being constituent parts of the dress/body performance that constitutes identity. Secondly, they are important precisely because they reveal their incompleteness when withdrawn from the body. In *Le Plaisir du Texte*, Roland Barthes suggests that *jouissance* (a particular form of pleasure) arises at the point of a gap, and, while he is primarily discussing literature, he uses the example of the gap between waistband and jumper that reveals a glimpse of bare skin.[7] The exhibition of garments unworn suggests a different yet equally momentous and even mysterious gap; for by their very lifelessness, the gowns remind us of the life that they were destined to adorn.

Notes
1 Anna Jackson, 'Clothing Culture in Edo Period Japan' in Amy de la Haye and Elizabeth Wilson (eds), *Defining Dress*, Manchester University Press, Manchester, forthcoming 1999.
2 John Berger, *Ways of Seeing*, Penguin, Harmondsworth, 1972.
3 Anne Hollander, *Seeing Through Clothes*, Avon Books, New York, 1975.
4 Kaja Silverman, 'Fragments of a Fashionable Discourse' in Tania Modleski (ed.), *Studies in Entertainment: Critical Approaches to Mass Culture*, Indiana University Press, Bloomington, 1986, pp. 139-154.
5 Quentin Bell, *On Human Finery*, Hogarth Press, London, 1947.
6 Elizabeth Wilson, *Adorned in Dreams: Fashion and Modernity*, University of California Press, Berkeley, 1985.
7 Roland Barthes, 'Le Plaisir du Texte', *Oeuvres Complètes, volume 2, 1966-1973*, Éditions du Seuil, 1994, p. 1496.

List of Works

1 Vito Acconci
Jacket of Pockets, 1993
plastic and gold thread
63 x 171 cm
Private collection

2 Anon.
Poster advertising Paul Poiret's visit to Vienna,
November 1911
MAK, Austrian Museum of Applied Arts,
Vienna

3 John Armleder
346, 1988
Brooks Brothers suit
edition of 12
John Gibson Editions, New York
Cabinet des estampes (fonds
John M. Armleder), Geneva

4 Enrique Badalescu
Hat and Flower, London 1989
photograph
Courtesy Camilla Lowther, London

5 Léon Bakst
*Costume design for the blue sultan,
for the ballet Schéhérazade*, 1910
watercolour and graphite on (laid) paper
84 x 65.5 cm
The Harvard Theatre Collection,
The Houghton Library: Collection of
Howard D. Rothschild

6 Léon Bakst
*Costume design for the eunuch,
for the ballet Schéhérazade*, 1910
watercolour and graphite on (laid) paper
84 x 65.5 cm
The Harvard Theatre Collection,
The Houghton Library: Collection of
Howard D. Rothschild

7 Léon Bakst
*Costume design for the Sultan Zeman,
for the ballet Schéhérazade*, 1910
graphite, watercolour and gold paint
on laid paper
31.8 x 24.9 cm
The Fine Arts Museums of San Francisco,
Theater and Dance Collection,
Gift of Mrs. Adolph B. Spreckels

8 Léon Bakst
Costume for Schéhérazade, Almée, 1910
reconstruction
English National Ballet

9 Léon Bakst
Costume for Schéhérazade, The Golden Slave,
1910, reconstruction
English National Ballet

10 Léon Bakst
Costume for Schéhérazade, Zobéide, 1910,
reconstruction
English National Ballet

11 Balenciaga
Hat, 1962
black silk chiffon over horsehair
and wire frame
29 x 37 x 39 cm
Texas Fashion Collection at the
University of North Texas

12 Adrian Bannon
Thistledown Coat, 1998
cotton thread and thistledown on painted
MDF backboard with perspex cover
86.5 x 108 x 11.5 cm
© Adrian Bannon 1998
England & Co. Gallery, London
Photo: Miki Slingsby

13 Emily Bates
Depilator, 1994
spun and knitted human hair
260 x 75 x 20 cm
© Emily Bates 1998
Lent by the Contemporary Art Society,
London
Photo: Shirley Tipping

14 Tiziana Bendall-Brunello
Fragments, 1996
glass and ceramic
80 x 22 cm
© Tiziana Bendall-Brunello 1998
Collection the artist
Photo: Richard Heeps

15 François Berthoud
Geoffrey Beene for Visionnaire, 1997
monotype (oil on acetate)
c. 40 x 60 cm
© François Berthoud 1998
François Berthoud
Photo: Mike Fear

16 Joseph Beuys
Felt Suit, 1970
43 of an edition of 100
raw felt
170 x 100 cm
Ellen and Jerome Stern

17 Manolo Blahnik
Man Ray Style Shoes, Spring/Summer 1991
silver nappa
shoe size 37
Manolo Blahnik Collection

18 Erwin Blumenfeld
*Untitled Fashion Photograph for Dayton's
Oval Room*, 1959
silver gelatin vintage print
51 x 40 cm
© Estate of Erwin Blumenfeld, 1998
Courtesy Yorick Blumenfeld,
Estate of Erwin Blumenfeld
Photo: Mike Fear

19 Erwin Blumenfeld
Untitled Fashion Photograph for Dayton's Oval Room, 1962
silver gelatin vintage print
50.5 x 41 cm
© Estate of Erwin Blumenfeld, 1998
Courtesy Yorick Blumenfeld,
Estate of Erwin Blumenfeld
Photo: Mike Fear

20 Caroline Broadhead
Seams, 1989
nylon, cotton
130 x 500 cm
© Caroline Broadhead 1998
Courtesy Barratt Marsden Gallery, London
Photo: David Cripps

21 Caroline Broadhead
Wobbly Dress II, 1992
nylon
115 x 55 x 30 cm
© Caroline Broadhead 1998
Courtesy Barratt Marsden Gallery, London
Photo: Peter Mackertich

22 Tat'jana Bruni and Georgij Korsikov
Design for 'Young Ballet', Sporting Outfit, 1920
watercolour, gouache, indian ink and pencil
on paper
30 x 21 cm
Private collection, Germany

23 Tat'jana Bruni and Georgij Korsikov
Design for 'Young Ballet', Sporting Outfit, 1920
watercolour, gouache, indian ink and pencil
on paper
32.3 x 21 cm
Private collection, Germany

24 Roberto Capucci
Blades, 1985
black shantung taffeta, multicoloured lining
138 x 79 x 50 cm
Capucci Archive, Rome
Photo: Bardo Fabiani

25 Roberto Capucci
Boxes, 1987
multicoloured shot taffeta
155 x 75 x 65 cm
Capucci Archive, Rome

26 Pierre Cardin
Evening mini dress, 1968
iridescent sequin embroidered pink silk,
silver leather, pink perspex jewel
Martin Kamer Collection

27 Pierre Cardin
Men's shoes with toes, 1986
brown leather
11 x 24.5 x 29.4 cm
Courtesy of the Museum at The Fashion
Institute of Technology, New York, gift of
Richard Martin
Photo: Irving Solero

28 Hussein Chalayan
Mannequin with Mirrors, August 1998
fibreglass and mirror
c. 200 x 100 cm
made especially for *Addressing the Century*
at the Hayward Gallery
mannequin by Adel Rootstein

29 Christo
Jeanne-Claude's Wrapped Shoes, 1962
polyethylene, rope, plastic cord, stockings
and a pair of blue leather shoes
15.2 x 26 x 15.2 cm
Collection Christo and Jeanne-Claude,
New York

30 Christo
*Study for a Chapeau Empaquette and two
Empaquetages or La fille avec Empaquetages
for opening night Fashion Show, Museum
of Merchandise, The Art Council, Philadelphia,
12 April 1967*, 1967
collage, photo, pencil, crayon and
enamel paint
56.5 x 71.5 cm
Collection Christo and Jeanne-Claude,
New York

31 Christo
*Study for Evening Dress and Afternoon Suit
for opening night Fashion Show, Museum
of Merchandise, The Art Council, Philadelphia,
12 April 1967*, 1967
collage, photo, pencil, crayon and
enamel paint
56.5 x 71.5 cm
Collection Christo and Jeanne-Claude,
New York

32 Christo
*Study for Evening Dress-Suit and Evening Dress
for opening night Fashion Show, Museum
of Merchandise, The Art Council, Philadelphia,
12 April 1967*, 1967
collage, photo, pencil, crayon and
enamel paint
56.5 x 71.5 cm
Collection Christo and Jeanne-Claude,
New York

33 Christo
*Study for Wedding Dress and Evening Dress,
1967 for opening night Fashion Show, Museum
of Merchandise, The Art Council, Philadelphia,
12 April 1967*, 1967
collage, photo, pencil, crayon and
enamel paint
56.5 x 71.5 cm
Collection Christo and Jeanne-Claude,
New York

34 Christo
*Study for Wedding Dress for opening night
Fashion Show, Museum of Merchandise, The Art
Council, Philadelphia, 12 April 1967*, 1967
collage, photo, pencil, crayon and
enamel paint
56.5 x 71.5 cm
© Christo 1967
Collection Christo and Jeanne-Claude,
New York
Photo: Christian Baur

35 Christo
Wedding Dress, 1967
satin, silk, rope
c. 140 x 140 x 450 cm
© Christo 1967
Collection Christo and Jeanne-Claude,
New York

36 Jean Cocteau
Phoenix Hat, c. 1935
metal, canvas, gold thread
37 x 46 cm
Courtesy Judith Clark Costume, London

37 Clifford Coffin
Fashion photograph for American Vogue,
June 1949
photograph
29 x 22 cm
Courtesy Vogue, copyright © 1948 (renewed
1977) by The Condé Nast Publications Inc.

38 Mat Collishaw
*Image from Pampilion Catalogue: Dai Rees
Autumn/Winter Couture Collection*, 1998
photograph by Mat Collishaw
hat by Dai Rees
© Mat Collishaw 1998
Courtesy Judith Clark Costume

39 Comme des Garçons
Spring/Summer 1997
Comme des Garçons, Spring/Summer 1997
Collection

40 Comme des Garçons
Spring/Summer 1997
Collection Comme des Garçons

41 Comme des Garçons
Spring/Summer 1997
Collection Comme des Garçons

114

42 André Courrèges
'Dolly Bird' outfit, Spring/Summer 1973
white cotton, red PVC
Martin Kamer Collection

43 D'Ora
*Emilie Flöge in the fashion house
'Schwestern Flöge'*, 1910
photograph
Christian Branstätter, Vienna

44 D'Ora
*Emilie Flöge in the fashion house
'Schwestern Flöge'*, 1910
photograph
Christian Branstätter, Vienna

45 D'Ora
Pyjamas made from 'Pan' fabric, 1920
photograph
MAK, Austrian Museum of Applied Arts,
Vienna

46 Salvador Dalí
Aphrodisiac Dinner Jacket, 1936,
reconstruction
fabric and glass on hanger
69 x 56 x 10 cm
© Salvador Dalí/Foundation Gala-Salvador
Dalí/DACS 1998
Salvador Dalí Museum, St. Petersburg,
Florida, USA

47 Salvador Dalí
Heads of Gala, 1937-38
pencil on paper
43 x 52.5 cm
Salvador Dali Museum, St. Petersburg,
Florida, USA

48 Robert Delaunay
Portrait of Tristan Tzara, 1923
oil on board
104.5 x 75 cm
© L & M Services B.V., Amsterdam 980803
Museo Nacional Centro de Arte Reina Sofia,
Madrid

49 Robert Delaunay
The Runners, 1924-26
oil on canvas
24 x 33 cm
Staatsgalerie Stuttgart

50 Robert Delaunay
Portrait of Mme Heim, 1927
oil on canvas
130 x 97 cm
Musée national d'art moderne,
Centre Georges Pompidou, Paris

51 Sonia Delaunay
Fabric Sample, album 5, no. 36949
printed fabric
43 x 105 cm
Musée historique des tissus et des arts
décoratifs de Lyon

52 Sonia Delaunay
Fabric Sample, album 6, no. 36988 (4)
printed fabric
24.5 x 88 cm
Musée historique des tissus et des arts
décoratifs de Lyon

53 Sonia Delaunay
Fabric Sample, album 7, no. 36978 (3)
printed fabric
26.5 x 49 cm
Musée historique des tissus et des arts
décoratifs de Lyon

54 Sonia Delaunay
Fabric Samples
printed fabric
three samples: 20 x 49.5 cm, 26 x 41.5 cm,
21 x 30 cm
Musée historique des tissus et des arts
décoratifs de Lyon

55 Sonia Delaunay
Costume for Cleopatra, 1918
silk, sequins, beads
114.5 x 46.5 cm
Los Angeles County Museum of Art

56 Sonia Delaunay
Costumes for Cleopatra, 1918
4 watercolours
each 31 x 9.5 cm
© L & M Services B.V., Amsterdam 980803
Galerie Gmurzynska, Köln

57 Sonia Delaunay
*Maquette for the cover of the review
'Perfiles'*, 1918
La Bibliothèque nationale de France

58 Sonia Delaunay
Dress Poem 'forget the birds, the stars . . .', 1922
La Bibliothèque nationale de France

59 Sonia Delaunay
Fabric Design, album 2, no. 36988, 1924
watercolour on board
21 x 24 cm
Musée historique des tissus et des arts
décoratifs de Lyon

60 Sonia Delaunay
Fabric Design, album 2, no. 36993, 1925
watercolour on board
21 x 24 cm
Musée historique des tissus et des arts
décoratifs de Lyon

61 Sonia Delaunay
Fabric Design, album 1, no. 36978, 1926
watercolour on board
21 x 24 cm
Musée historique des tissus et des arts
décoratifs de Lyon

62 Sonia Delaunay
Three Drawings for Dresses, 1924-25
La Bibliothèque nationale de France

63 Sonia Delaunay
Coat, c. 1925
linen and cotton
100 x 45 cm
Musée de la mode et du textile, Palais du
Louvre, Paris. Collection de l'union française
des arts du costume

64 Sonia Delaunay
*Paintings, objects, simultaneous fabrics,
fashion*, 1925
book
c. 54 x 37 cm
Collection Peter Ascher, London/New York

65 Sonia Delaunay
Simultaneous Dresses (The Three Women),
1925
oil on canvas
146 x 114 cm
Fundación Colección Thyssen-Bornemisza,
Madrid

66 Sonia Delaunay
The Window of the 'Boutique Simultanée', 1925
pen and ink
19 x 18.5 cm
© L & M Services B.V., Amsterdam 980803
Galerie Gmurzynska, Köln
Photo: Sasa Fuis, Köln

67 Fortunato Depero
Template for Découpage
paper and tape
Collection Ugo Nespolo, Turin

68 Fortunato Depero
Marinetti's Futurist Waistcoat, 1923
coloured fabric and silk
59 x 54 cm
Collection Ugo Nespolo, Turin

69 Fortunato Depero
Hat, 1929
wool
diameter 28 cm
Collection Ugo Nespolo, Turin

70 Lesley Dill
Hinged Copper Poem Dress, 1997
copper and steel
162 x 54 x 20 cm (closed)
© Lesley Dill 1998
Private collection, Vancouver, B.C. Canada

71 Jim Dine
All in one lycra, 1965
shoes, textile, charcoal and paint on canvas
framed 152.3 x 122 cm
© Jim Dine 1998
Stedelijk Van Abbemuseum, Eindhoven,
Holland

72 Marcel Duchamp
*Surrealist mannequin 'A woman dressed as a
man'*, 1938, reconstruction 1981
mixed media
192 x 74 x 53 cm
© Succession Marcel Duchamp/DACS 1998
Musée de la mode et du textile, Palais du
Louvre, Paris. Collection de l'union française
des arts du costume
Photo: Man Ray

73 Raoul Dufy
Watercolour for Poiret, 1912-16
watercolour and ink on paper
32 x 25 cm
Private collection, France

74 Raoul Dufy
Watercolour for Poiret, 1912-16
watercolour and ink on paper
32 x 25 cm
Private collection, France

75 Raoul Dufy
Dresses for Summer 1920, 1953
gouache on paper
25 x 70 cm
Musée historique des tissus et des arts
décoratifs de Lyon

76 Raoul Dufy
Evening Dress, 1953
63 x 48 cm
Musée historique des tissus et des arts
décoratifs de Lyon

77 Aganetha Dyck
Wax Shoes – child's shoes, 1997
child's ankle boots, beeswax, pen
17 x 23 x 20 cm
Courtesy of the artist and Yorkshire
Sculpture Park

78 Aganetha Dyck
Wax Shoes – high heels, 1997
shoes, wax and paper, pen
13.5 x 9.5 x 26 cm and 13 x 9 x 26 cm
Courtesy of the artist and Yorkshire
Sculpture Park

79 Martin Fletcher
Speed Boots, 1997
fibreglass
37 x 28 x 85 cm
Courtesy Martin Fletcher

80 Sylvie Fleury
Twinkle, 1992
videoed performance
Courtesy the artist, Laure Genillard, London
and Bureau des Videos, Paris

81 Lucio Fontana for Bini-Telese
Dress, 1961
silver chinz cotton
90 x 48 cm
© Gentucca Bini 1998
Bini Collection

82 Lucio Fontana for Bini-Telese
Dress, 1961
yellow linen
92 x 48 cm
Bini Collection

83 Lucio Fontana for Bini-Telese
Cuts, 1961
silver paper
27 x 21 cm
Bini Collection

84 Lucio Fontana for Bini-Telese
Cuts, 1961
silver paper
27 x 21 cm
Bini Collection

85 Mariano Fortuny
Delphos dress, c. 1910
pleated ivory silk
Martin Kamer Collection

86 Mariano Fortuny
Tabard, c. 1910
silver printed silk velvet, glass beads
Martin Kamer Collection

87 Mariano Fortuny
Delphos dress, c. 1910
pleated aqua silk
Martin Kamer Collection

88 Illustration for the Gazette du Bon Ton, October 1912
'Lassitude', Paul Poiret Evening Dress
by Georges Lepape
24.5 x 19.5 cm
Martin Kamer Collection

89 Illustration for the Gazette du Bon Ton, October 1912
'Ribbons' by Georges Lepape
24.5 x 19.5 cm
Martin Kamer Collection

90 Illustration for the Gazette du Bon Ton, 1913
'The Gardens of Versailles', Paul Poiret Costume in the Style of Louis XIII
24.5 x 19.5 cm
Martin Kamer Collection

91 Illustration for the Gazette du Bon Ton, September 1913
'Which One?', Paul Poiret Evening Dress
by Georges Lepape
24.5 x 19.5 cm
Martin Kamer Collection

92 Illustration for the Gazette du Bon Ton, 1920
'Porcelain Hat', Fashion and Style of Torquate
24.5 x 19.5 cm
Martin Kamer Collection

93 Illustration for the Gazette du Bon Ton, 1920
'The Death of Love', Fashion and Style of Torquate
24.5 x 19.5 cm
Martin Kamer Collection

94 Rudi Gernreich
Mini dress, 1968
ivory wool knit and clear PVC
Martin Kamer Collection

95 Gilbert & George
Bend It, from *The World of Gilbert & George*, 1981
video projection
dimensions variable
Courtesy the artists and the Arts Council of England

96 Georgina Godley
Lump and Bump Collection, Winter 86, Padded Underwear, 1986, remade 1998
Georgina Godley

97 Georgina Godley
Lump and Bump Collection, Winter 86, Padded Underwear with Lycra Sheath, 1986, remade 1998
Georgina Godley

98 Nan Goldin for Matsuda
Nan Goldin meets Yokio Kobayaski: Naked New York, 1996
limited edition book
15 x 21 cm
Private collection

99 Natalia Goncharova
Dress design ('Borromées), c. 1922-25
gouache on paper
48.5 x 31.5 cm
Martin Kamer Collection

100 Natalia Goncharova
Dress design 'Glaneuse', c. 1922-25
gouache on paper
48.5 x 31.5 cm
Martin Kamer Collection

101 Natalia Goncharova
Template for White Cloak, c. 1923
watercolour and pencil on paper
118 x 107 cm
Private collection, courtesy of Julian Barran Ltd.

102 Harry Gordon
Paper Poster Dress (Bob Dylan), 1968
paper
82 x 32 cm
Courtesy of the Museum at The Fashion Institute of Technology, New York, gift of Estelle Ellis

103 Harry Gordon
Paper Poster Dress (Eye), 1968
paper
89 x 30.5 cm
Courtesy of the Museum at The Fashion Institute of Technology, New York, gift of Stephen de Petri
Photo: Irving Solero

104 Duncan Grant/Vanessa Bell
Painted Waistcoat, 1937
poster paint on linen
81 x 78 cm
The Charleston Trust

105 Fergus Greer
Leigh Bowery, 1991
photograph
55.5 x 45.2 cm
© Fergus Greer 1998
Courtesy Violette Editions, London

106 Madame Grès (Alix)
Short evening jacket, c. 1939
poppy silk velvet
Martin Kamer Collection

107 Marie-Ange Guilleminot
Dress on Wheels, 1992
tubular lycra, skateboard
© Marie-Ange Guilleminot 1998
Anne and William J. Hokin

108 F.C. Gundlach
James Blond Is Chasing The Beautiful Mask, 1966
silver gelatin print
36.9 x 30.5 cm
F.C. Gundlach

109 F.C. Gundlach
OP – Art Fashion, 1966
silver gelatin print
30 x 38 cm
F.C. Gundlach

110 Monika Hagenberg
Untitled, 1982
silk papier mâché
52 x 46 cm
W. Wittrock Kunsthandel Düsseldorf

111 Ann Hamilton
Untitled (haircollar), 1993
linen collar with hand-sewn horsehair alphabet, glass, birch
one of an edition of 12
collar approx. 51 cm diameter
56 x 56 x 18 cm
Courtesy Sean Kelly Gallery, New York

112 Ann Hamilton
The slaughter, 1997
silk organza, cotton thread, wood and glass display box
one of 10 versions
10 x 47 x 35 cm
Courtesy Sean Kelly Gallery, New York

113 Mona Hatoum
Hair Necklace, 1995
human hair, wood, leather
31 x 22 x 17 cm
© Mona Hatoum 1998
Collection the artist
Photo: Edward Woodman

114 Raoul Hausmann
Fiat Modes, 1920
photograph
24.5 x 19.6 cm
Londesmuseum für Moderne Kunst Photographie und Architektur, Berlin

115 Hannah Höch
Fashion Show, 1925-35
photomontage
27.5 x 23 cm
Private collection, Berlin

116 J. Hoffmann
Design for a Dress, 1911
MAK, Austrian Museum of Applied Arts, Vienna

117 Nicola Howard
Fish Bone, 1998
woven rubber, dip-dyed cherry pink and anthracite blue
c. dress size 10-12
Nicola Howard Textiles

118 Katerina Jebb
Organ Piece (Comme des Garçons), 1997
ink jet (nova jet) print
165 x 66 cm
Katerina Jebb

119 Stephen Jones
Colander Hat, 1982, reconstruction 1998
silk and steel
36 x 28 x 23 cm
Stephen Jones

120 Illustration for the Journal des Dames et des Modes, 1913
Dioné – drawing by Bakst realised by Paquin
22.2 x 14 cm
Martin Kamer Collection

121 Illustration for the Journal des Dames et des Modes, 1913
Little garden dress by Poiret
22.2 x 14 cm
Martin Kamer Collection

122 Illustration for the Journal des Dames et des Modes, 1914
Day dress in lemon duvetyn
22.2 x 14 cm
Martin Kamer Collection

123 Illustration for the Journal des Dames et des Modes, 1914
Harlequin
22.2 x 14 cm
Martin Kamer Collection

124 Mary Kelly
Extase from Interim, 1986
6 laminated photo positive screenprints and acrylic on perspex
each 122 x 90.5 cm
New Hall, University of Cambridge

125 Gustav Klimt
Portrait of Johanna Staude, 1917-18
oil on canvas
70 x 50 cm
Osterreichische Galerie Belvedere Wien
Photo: D. Otto 1997

126 Nick Knight
For Yohji Yamamoto (Art Director Marc Ascoli), 1986
photograph
59 x 49 cm
© Nick Knight 1998
Collection the artist

127 Nick Knight
For Yohji Yamamoto (Art Director Marc Ascoli), 1988/89
photograph
59 x 49 cm
Collection the artist

128 Nick Knight
Devon – For Visionnaire magazine (Art Director Alexander McQueen), 1996
photograph
59 x 49 cm
Collection the artist

129 Komar and Melamid
Sears Jacket, 1991
cloth
78.4 x 51.5 cm
© Komar and Melamid 1998
Komar and Melamid
Photo: D. James Dee

130 Krizia
Shell Hat, 1980
designed by Mariuccia Mandelli
lavender straw
17 x 31.8 x 29 cm
Courtesy of the Museum at The Fashion
Institute of Technology, New York,
Museum Purchase
Photo: Irving Solero

131 Yayoi Kusama
Shoes, 1963
shoes, sewn stuffed fabric, paint
Gallery HAM, Nagoya, Japan

132 Yayoi Kusama
Dress, 1976
dress, sewn stuffed fabric,
clothes hanger, paint
102 x 52 x 20 cm
© Yayoi Kusama 1976
Gallery HAM, Nagoya, Japan
Photo: Yoshihiro Kikuyama

**133 Student of Karl Lagerfeld
(participant: Competition PRIX
VALENTINO)**
Shoe drawing Nr 3255/1, 1982
ink on paper
29.7 x 21 cm
University of Applied Arts in Vienna,
Collection

134 Mark J. Lebon
Dress Toile 1996
photograph
24.5 x 19.5 cm
Mark J. Lebon

135 Fernand Léger
*Costume Design for 'Skating Rink'
(man in hat, green and brown)*,1922
watercolour
23 x 15 cm
Dansmuseet/The Dance Museum, Stockholm

136 Fernand Léger
*Costume Design for 'Skating Rink'
(man in hat, red, blue and brown)*, 1922
watercolour
23.5 x 15 cm
Dansmuseet/The Dance Museum, Stockholm

137 Fernand Léger
*Costume Design for 'Skating Rink'
(man in hat, yellow, brown and blue)*, 1922
watercolour
25 x 16 cm
Dansmuseet/The Dance Museum, Stockholm

138 Fernand Léger
*Costume Design for 'Skating Rink'
(man in horizontally striped jersey)*, 1922
watercolour
23 x 13 cm
Dansmuseet/The Dance Museum, Stockholm

139 Fernand Léger
*Costume Design for 'Skating Rink'
(woman in check skirt)*, 1922
watercolour
25 x 16 cm
Dansmuseet/The Dance Museum, Stockholm

140 Fernand Léger
*Costume Design for 'Skating Rink'
(woman in red and brown)*,1922
watercolour
24 x 16 cm
Dansmuseet/The Dance Museum, Stockholm

141 Fernand Léger
*Costume Design for 'Skating Rink'
(woman in red hat)*, 1922
watercolour
25 x 16 cm
Dansmuseet/The Dance Museum, Stockholm

142 Fernand Léger
*Costume Design for 'Skating Rink'
(woman with hat, yellow, red and
reddish yellow)*, 1922
watercolour
23 x 13 cm
Dansmuseet/The Dance Museum, Stockholm

143 Fernand Léger
Design for curtain for 'Skating Rink', 1922
watercolour
40.5 x 48 cm
© ADAGP, Paris and DACS, London 1998
Dansmuseet/The Dance Museum, Stockholm

144 Fernand Léger
Stage Model for 'Skating Rink' 1922
mixed media
40.5 x 61 x 45.3 cm
Dansmuseet/The Dance Museum, Stockholm

145 Christine LoFaso
Redress: Gestation Corset 1992
paper, stained with catnip, mink fur, buttons,
metal eyelets and lacing
59.7 x 40.6 x 33 cm
© Christine LoFaso 1992
Private collection

146 Man Ray
Meret Oppenheim
photograph
21 x 29.6 cm
Collection Lucien Treillard

147 Man Ray
Denise Poiret with a Brancusi, c. 1912
photograph
23.4 x 16.9 cm
Collection Lucien Treillard

148 Man Ray
Homage to Poiret, 1922
vintage photograph
12 x 9.2 cm
Collection Lucien Treillard

149 Man Ray
The Siégel Mannequins Series, 1925
6 photographs
each 29.5 x 21 cm
© Man Ray Trust/ADAGP, Paris and DACS,
London 1998
Collection Lucien Treillard
Photo: Mike Fear

150 Man Ray
Elsa Schiaparelli sitting, 1935
photograph
20.3 x 25.4 cm
© Man Ray Trust/ADAGP, Paris and DACS,
London 1998
Collection Lucien Treillard
Photo: Mike Fear

151 Man Ray
Dominguez's Wheelbarrow, 1937
photograph
30.5 x 23.9 cm
Collection Lucien Treillard

152 Man Ray
Surrealist mannequin 'Pipe with Bubbles', 1938,
reconstruction 1981
mixed media
192 x 73 x 53 cm
Musée de la mode et du textile, Palais du
Louvre, Paris. Collection de l'union française
des arts du costume

153 Man Ray
Elsa Schiaparelli solarised, 1953
photograph
30.5 x 23.8 cm
© Man Ray Trust/ADAGP, Paris and DACS,
London 1998
Collection Lucien Treillard
Photo: Mike Fear

154 Martin Margiela
Porcelain Waistcoat, 1989-90
porcelain, metal, wire, recycled materials
43 cm long
© Maison Martin Margiela 1989
Museum Boijmans Van Beuningen,
Rotterdam

155 Martin Margiela
Photo Dress, 1996
viscose, ink, recycled materials
French dress size 42
Museum Boijmans Van Beuningen,
Rotterdam

156 Martin Margiela
Drapery, 1997
textile, silk, elastic and corset tape
230 x 70 cm
Museum Boijmans Van Beuningen,
Rotterdam

157 Martin Margiela
Top in the form of a Stockman, 1997
textile, linen, cotton and metal
77 x 53 x 42 cm
Museum Boijmans Van Beuningen,
Rotterdam

**158 Mars of Ashville;
Wastebasket Boutique**
Paper Poster Dress (Yellow Pages), 1968
paper
95.5 x 34 cm
Courtesy of the Museum at The Fashion
Institute of Technology, New York,
Museum Purchase
Photo: Taishi Hirokawa

159 André Masson
Surrealist mannequin 'Head in a Cage', 1938,
reconstruction 1981
mixed media
183 x 68 x 55 cm
© ADAGP, Paris and DACS, London 1998
Musée de la mode et du textile, Palais du
Louvre, Paris. Collection de l'union française
des arts du costume

160 Henri Matisse
*Chamberlain's Costume for 'Le Chant du
Rossignol'*, 1920
130 x 182 cm
hand painted textile: silk, gold lamé
and cotton
The Israel Museum, Jerusalem. Gift of
Rena (Fisch) and Robert Lewin, London

161 Henri Matisse
*Mandarin's Costume for 'Le Chant du
Rossignol'*, 1920
140 x 176 cm
hand painted textile: silk, gold lamé
and cotton
© Succession H. Matisse/DACS 1998
The Israel Museum, Jerusalem. Gift of Rena
(Fisch) and Robert Lewin, London
Photo: Israel Museum

162 Henri Matisse
Drawing for' Le Chant du Rossignol', 1925
Case for the mechanical nightingale
27 x 21.6 cm
La Bibliothèque nationale de France

163 Henri Matisse
Drawing for' Le Chant du Rossignol', 1925
Lanterns, first idea for the nightingale's
costume, Death's costume,
mourners' costumes
25.5 x 25.5 cm
La Bibliothèque nationale de France

164 Lun*na Menoh
Spring and Summer Collection 1770-1998, 1998
© Lun*na Menoh 1998
Lun*na Menoh
Photo: Relah Eckstein

165 Deborah Milner
Plastic Bag Lace Dress, April 1997
plastic
140 x 50 x 5 cm
Deborah Milner, plastic bag lace made
by Janice Marr

166 Deborah Milner
Stainless Steel Dress, February 1998
100% woven stainless steel
140 x 100 x 50 cm
© Deborah Milner 1998
Deborah Milner, stainless steel fabric
provided by GKD

167 Antonio Miro
Surrealist mannequin 'Moustache', 1938,
reconstruction 1981
mixed media
183 x 60 x 55 cm
Musée de la mode et du textile, Palais du
Louvre, Paris. Collection de l'union française
des arts du costume
Photo: Man Ray

168 Issey Miyake
Flying Saucer, Spring/Summer 1994
© Issey Miyake 1998
Courtesy Issey Miyake Design Studio, Tokyo
Photo: Kazumi Kurigami

169 Issey Miyake
Minaret, Spring/Summer 1995
© Issey Miyake 1998
Courtesy Issey Miyake Design Studio, Tokyo
Photo: Yasuati Yoshinaga

170 Issey Miyake
Rattan Body, Spring/Summer 1982
rattan
42 x 60 x 31 cm
© Issey Miyake 1998
Courtesy Issey Miyake Design Studio, Tokyo
Photo: Daniel Jouanneau

171 Sarah Moon
Anatomie (Christian Lacroix for Frankfurter Allgemein Magazine), 1987
photograph
40 x 50 cm
Sarah Moon

172 Sarah Moon
Huenchan, 1987
photograph
Sarah Moon

173 Omega Workshops
Blouse, 1914-15
printed fabric
c. 52 x 60 cm
Collection of Robert Silbermann

174 Omega Workshops
Shoebag (Fabric 'Maud'), c. 1916
printed linen
The Charleston Trust

175 Omega Workshops
Shoebag (Fabric 'Pamela'), c. 1916
printed linen
46 x 26 cm
The Charleston Trust

176 Omega Workshops
Shoebag (Fabric 'Pamela'), c. 1916
printed linen
44.3 x 25 cm
The Charleston Trust

177 Omega Workshops
Dressing gown in Amenophis VI design, 1918
printed linen
141 x 150 cm
South Australian Government Grant 1984,
Collection – Art Gallery of South Australia,
Adelaide

178 Omega Workshops
Nina Hamnett and Winifred Gill modelling dresses at Omega, 1918
photograph
24.5 x 19.6cm
Private collection

179 Omega Workshops
Pair of Pyjamas in Mechtilde III design, 1918
designer of garment: Vanessa Bell; designers of fabric: Frederick Etchells and Roger Fry
printed linen
186 x 168 cm
© Estate of Vanessa Bell 1961, courtesy Henrietta Garnett
South Australian Government Grant 1984,
Collection – Art Gallery of South Australia,
Adelaide

180 Meret Oppenheim
Design for Title Page of Annabelle
gouache
c. 26 x 19 cm
Private collection, Switzerland

181 Meret Oppenheim
Buttons for an Evening Jacket, 1942-45
gouache on felt paper
16.7 x 28.9 cm
Private collection, Switzerland

182 Meret Oppenheim
Designs for Cape, Hat and Variety-Show Lingerie, c. 1942-45, 1960
pencil and coloured pencil on paper
c. 27 x 21 cm
Private collection, Switzerland

183 Meret Oppenheim
Project for Parkett No. 4, 1985
goat suede with silk screen, hand-stiched
one of an edition of 50
h. 20 cm
© DACS 1998
Private collection, Matthias Beltz,
Frankfürt am Main, Germany

184 Lucy Orta
Refuge Wear, Collective Survival Sac 2 persons, 1994
microporous polyester, PU coated polyamide, silkscreen print, zips
200 x 200 cm
© Lucy Orta 1998
Photo: John Akehurst

185 Dagobert Peche
'Falte' fabric design
block print on paper
MAK, Austrian Museum of Applied Arts,
Vienna

186 Dagobert Peche
'Falte' fabric sample
printed fabric
MAK, Austrian Museum of Applied Arts,
Vienna

187 Dagobert Peche
'Pan' fabric sample
printed fabric
MAK, Austrian Museum of Applied Arts,
Vienna

188 Dagobert Peche
Dress in 'Wicken' Fabric
printed fabric
120.5 x 48 cm
© MAK, Austrian Museum of Applied Arts,
Vienna 1998
MAK, Austrian Museum of Applied Arts,
Vienna

189 Dagobert Peche
'Wicken' fabric sample
printed fabric
MAK, Austrian Museum of Applied Arts,
Vienna

190 Dagobert Peche
Dress in 'Falte' (Pleats) Fabric, 1923
printed fabric
90 x 74 cm
MAK, Austrian Museum of Applied Arts,
Vienna

191 Irving Penn
Two Guedras, Morocco, 1971
gelatin silver print
33 x 33 cm
Irving Penn courtesy PaceWildensteinMacGill

192 Irving Penn
Issey Miyake Fashion: Face Covered with Hair (B), New York, 1991
gelatin silver print
36.7 x 36.7 cm
Irving Penn courtesy PaceWildensteinMacGill

193 Paul Poiret
La Perse, 1911
printed velvet with fur collar and cuffs, fabric designed by Raoul Dufy
149 x 130 cm
Private collection
Photo: Mike Fear

194 Paul Poiret
La Pomone, 1920s
woven textile, fabric designed by Raoul Dufy
128 x 95 cm
Private collection

195 Paul Poiret
Sesostris, evening coat, Autumn/Winter 1923
silk velvet with crêpe satin binding
220 x 124 cm
Musée de la mode et du costume, Paris

196 After a design by Ljubov Popova
One piece trouser suit, 1922, reconstruction c. 1979
blue linen, with a red patent leather belt with a red clasp
Galerie Gmurzynska, Köln
Photo: Sasa Fuis, Köln

197 Ljubov Popova
Costume design for 'The World in Turmoil', 1923
watercolour, indian ink and pencil on paper
34.5 x 25.5 cm
Private collection, Germany

198 Ljubov Popova
Costume design for 'The World in Turmoil' (The Army Commander), 1923
watercolour, indian ink and pencil on paper
25.5 x 17.4 cm
Private collection, Germany

199 Ljubov Popova
Clothes Design (Leto), 1924
collage and gouache
37 x 23.5 cm
Galerie Gmurzynska, Köln
Photo: Sasa Fuis, Köln

200 Mary Quant for Ginger Group
Dress, c. 1963
wool jersey
Royal Pavilion, Art Gallery and Museums,
Brighton

201 Mary Quant
Dress, c. 1966
cream wool jersey with blue sleeves and red front pocket
The Museum of Costume, Bath

202 Paco Rabanne
Metal Dress, c. 1968
aluminium plaques
76 x 39 cm
Musée de la mode et du textile, Palais du Louvre, Paris. Collection de l'union française des arts du costume

203 Paco Rabanne
Mini evening dress, Spring/Summer 1970
Martin Kamer Collection

204 Paco Rabanne
Leather Polygon Jacket, 1979
white leather
69 x 42 cm
Musée de la mode et du textile, Palais du Louvre, Paris. Collection de l'union française des arts du costume

205 Paco Rabanne
Hat, Collection Calandre, Spring/Summer 1993
recycled found objects
Musée de la mode et du textile, Palais du Louvre, Paris. Collection de l'union française des arts du costume

206 Dai Rees
Hat, 1998
pheasant quills, duck feathers, human hair, styrofoam, collar felt
56 x 67 x 17 cm
Pampillion III © Dai Rees 1998
Courtesy Judith Clark Costume

207 Dai Rees
Hat, 1998
buckram, peacock coq, turkey quills, black viscose flock, aluminium
49 x 34 x 34 cm
Pampillion VII © Dai Rees 1998
Courtesy Judith Clark Costume

208 Dai Rees
Mask, 1998
sheep's pelvis, czech crystal, swarovski crystal, silver
95 x 21 x 22 cm
Pampillion XII © Dai Rees 1998
Courtesy Judith Clark Costume

209 Herb Ritts
Wrapped Torso, Los Angeles, 1989
platinum photograph, Ed. 25
39 x 49 cm
Courtesy Vernon Jolly, New York

210 After a design by Alexander Rodchenko
Man's working suit and boots, 1922, reconstruction c. 1979
jacket, trousers, black leather belt and boots in grey with black leather
© DACS 1998
Galerie Gmurzynska, Köln
Photo: Sasa Fuis, Köln

211 Alexander Rodchenko
Design for a dress, 1924
collage and ink
29.2 x 11.6 cm
© DACS 1998
Galerie Gmurzynska, Köln
Photo: Karl Arendt, AFD, Köln

212 James Rosenquist
Paper Suit, 1998
paper, scissors, original box
Ellen and Jerome Stern

213 Paolo Roversi
London, 1985
photograph
Courtesy Marion de Beaupré, New York

214 Elsa Schiaparelli
Sweater, 1923-25
black and white knit wool
54 x 125 cm
Philadelphia Museum of Art: Given by
Mrs S.S. White III

215 Elsa Schiaparelli
Drawing for Drawer Coat, Winter 1936
gouache and ink on paper
38 x 32 cm
Musée de la mode et du textile, Palais du
Louvre, Paris. Collection de l'union française
des arts du costume

216 Elsa Schiaparelli
Drawing for Lamb Chop Hat, Winter 1937
gouache and ink on paper
38 x 32 cm
Musée de la mode et du textile, Palais du
Louvre, Paris. Collection de l'union française
des arts du costume

217 Elsa Schiaparelli
Drawing for Shoe Hat, Winter 1937
gouache and ink on paper
38 x 32 cm
Musée de la mode et du textile, Palais du
Louvre, Paris. Collection de l'union française
des arts du costume

218 Elsa Schiaparelli
Long evening dress, c. 1933
gold lamé
Martin Kamer Collection

219 Elsa Schiaparelli
Monkey Fur Shoes, 1938
black suede and black monkey hair
Philadelphia Museum of Art: Given by
Mme Elsa Schiaparelli
Photo: Graydon Wood, 1994

220 Elsa Schiaparelli
Pair of Gloves, c. 1938
black suede, red snakeskin, cording
Philadelphia Museum of Art: Given by
Mme Elsa Schiaparelli
Photo: Lynn Rosenthal, 1998

221 Elsa Schiaparelli
Sweater, c. 1938
black and white knit wool
54 x 125 cm
Philadelphia Museum of Art: Given by
Mme Elsa Schiaparelli

222 Elsa Schiaparelli
Veil, c. 1938
white net, blue bugle beads
length 98 cm
Philadelphia Museum of Art: Given by
Mme Elsa Schiaparelli

223 Elsa Schiaparelli
Jacket from a design by Leonor Fini, c. 1940
37 x 36 cm
Steinberg and Tolkien, London

224 Elsa Schiaparelli
Jacket, 1941
black crepe with magenta plasterion front,
completely embroidered in vegetable
design, matching vegetable buttons
48 x 34 cm
Philadelphia Museum of Art: Given by
Mme Elsa Schiaparelli

225 Oskar Schlemmer
*Golden Sphere – Figurine from 'The Triadic
Ballet', Black Series*, 1922, reconstruction
1967/93
(Goldkuge Das Triadische Ballett Schwarze
Reihe Figurine mit Maske)
papier mâché, wood, fabric, laquer and
goldbronze on stainless steel figurine
© The Oskar Schlemmer Theatre Estate 1998,
I-28824 Oggebbio
Collection C. Raman Schlemmer
Photo: Christian Baur

226 Oskar Schlemmer
*Spiral – Figurine with Spiral Hat and Cuffs from
'The Triadic Ballet', Black Series*, 1922,
reconstruction 1994
(Spirale Das Triadische Ballett Schwarze Reihe
Figurine mit Spiralhut und Manschetten)
skirt, head gear and cuffs: laminated with
metal foil and transparent celluloid, rubber
tube, wood, laquer and leather straps; tricot
of black velvet with metallic buttons,
on stainless steel figurine
© The Oskar Schlemmer Theatre Estate 1998,
I-28824 Oggebbio
Collection C. Raman Schlemmer
Photo: Christian Baur

227 Oskar Schlemmer
*The Abstract – Figurine from 'The Triadic Ballet',
Black Series*, 1922, reconstruction 1967/85
(Der Abstrakte Das Triadische Ballette
Schwarze Reihe Figurine mit Maske)
papier mâché, wood, fabric and laquer
on stainless steel figurine
© The Oskar Schlemmer Theatre Estate 1998,
I-28824 Oggebbio
Collection C. Raman Schlemmer
Photo: Christian Baur

228 Oskar Schlemmer
*Wire Figure – Figurine from 'The Triadic Ballet',
Black Series*, 1922, reconstruction 1985
(Drahtkostüm Das Triadische Ballett
Schwarze Reihe Figurine mit Kopfputz)
stainless steel wire on stainless steel figurine
© The Oskar Schlemmer Theatre Estate 1998,
I-28824 Oggebbio
Collection C. Raman Schlemmer
Photo: Christian Baur

229 Oskar Schlemmer
*Wire Figure – Technical Drawing for Skirt from
'The Triadic Ballet', Black Series*, 1923
(Drahtfigur Das Triadische Ballett Schwarze
Reihe Technische Zeichnung für Rock)
red and black ink on paper
30 x 31 cm
© The Oskar Schlemmer Theatre Estate 1998,
I-28824 Oggebbio
Oskar Schlemmer Theatre Estate,
Theatre Collection, UJS

230 Oskar Schlemmer
Examples of Costume Forms, 1926
(Darstellung von Kostümbildungen)
watercolour over pencil on watercolour
paper, mounted on board
43.4 x 58.1 cm
© The Oskar Schlemmer Theatre Estate 1998,
I-28824 Oggebbio
Oskar Schlemmer Theatre Estate,
Theatre Collection, UJS

231 Oskar Schlemmer
Figure Types and Types of Coat Costumes, 1926
(Typenfiguren und Matelkostümtypen)
pen and watercolour over pencil on
watercolour paper, mounted on board
43.7 x 58.1 cm
© The Oskar Schlemmer Theatre Estate 1998,
I-28824 Oggebbio
Oskar Schlemmer Theatre Estate,
Theatre Collection, UJS

232 Oskar Schlemmer
Figurine with Bronzed Discs, 1926
(Figurine mit Bronzierten Scheiben)
coloured inks and collage of bronze metallic
paper on light board
58 x 44.5 cm
© The Oskar Schlemmer Theatre Estate 1998,
I-28824 Oggebbio
Oskar Schlemmer Theatre Estate,
Theatre Collection, UJS

233 Oskar Schlemmer
Figurine with Hanging Threads, 1926
(Figurine mit Fadengehänge)
gouache and collage on black light board
57.5 x 44.5 cm
© The Oskar Schlemmer Theatre Estate 1998,
I-28824 Oggebbio
Oskar Schlemmer Theatre Estate,
Theatre Collection, UJS

234 Oskar Schlemmer
Mask Variations, 1926
(Maskenvariationen)
watercolour over pencil on watercolour
paper, mounted on board
45.6 x 61.2 cm
© The Oskar Schlemmer Theatre Estate 1998,
I-28824 Oggebbio
Oskar Schlemmer Theatre Estate,
Theatre Collection, UJS

235 Oskar Schlemmer
*Three Figurines for 'The White Party'
at Bauhaus Dessau*, 1926
(Drei Figurinen für 'Das Weisse Fest' am
Bauhaus Dessau)
pencil and coloured ink on paper
32 x 49.7 cm
© The Oskar Schlemmer Theatre Estate 1998,
I-28824 Oggebbio
Oskar Schlemmer Theatre Estate,
Theatre Collection, UJS

236 Kurt Schwitters
9, 1930
collage on card mount
40 x 35 cm
Collection Timothy Baum, New York

237 Stéphane Sednaoui
Tara, Paris 1989, 1989
4 colour repro print
53 x 28.5 cm
© Stéphane Sednaoui 1989
Collection the artist
Photo: Mike Fear

**238 Cindy Sherman for Comme des
Garçons**
Invitation cards, Spring/Summer 1994
photographs
Collection Comme des Garçons

239 Jeanloup Sieff
*Pierre-André Boutang tearing a fashion
photograph*, 1966
gelatin silver print
30 x 40 cm
Jeanloup Sieff/Maconochie Photography

240 Wiebke Siem
Hat, 1987
foam rubber, woolen fabric, jersey, ribbon
50 x 35 x 32 cm
Courtesy Johnen & Schöttle, Cologne

241 Mimi Smith
Recycle Coat, 1965, remade 1993
plastic bags, plastic, bottle caps,
metal hanger
122.5 x 83 cm
© Mimi Smith 1998
Courtesy of the artist and Anna Kustera
Gallery, NY
Photo: Oren Slor

242 Mimi Smith
Maternity Dress, 1966
plastic, vinyl, zipper, screws, wood hanger
110 x 49 x 22 cm
© Mimi Smith 1998
Courtesy of the artist and Anna Kustera
Gallery, NY
Photo: Oren Slor

243 Max Snischek
Drawing for an Evening Dress, 1918
pencil on paper
MAK, Austrian Museum of Applied Arts,
Vienna

244 Max Snischek
Drawing of a dress, 'Falte, by D. Peche', 1927-28
MAK, Austrian Museum of Applied Arts,
Vienna

245 After a design by Varvara Stepanova
Three piece trouser suit, 1922, reconstruction
c. 1979
trousers, top and bolero-jacket in red
and white linen
© DACS 1998
Galerie Gmurzynska, Köln
Photo: Sasa Fuis, Köln

246 Varvara Stepanova
*Costume Design for 'The Death of Tarelkin'
(Doctor)*, 1922
ink and coloured pencil on paper
35.8 x 22 cm
© DACS 1998
Galerie Gmurzynska, Köln
Photo: Karl Arendt, AFD, Köln

247 Varvara Stepanova
*Costume Design for 'The Death of Tarelkin'
(Tarelkin)*, 1922
pencil on paper
37 x 23 cm
© DACS 1998
Private collection, Germany

248 Helen Storey
Primitive Streak Collection: Anaphase Bodice Dress, 1997
high spun viscose with plastic mirror
130 x 39 cm
© Helen Storey 1998
Collection the artist
Photo: Justine
Model: Korinna at Models 1
Textile origination and printing by Belford Print Ltd
Primitive Streak is supported in 1998 by Pfizer Ltd and was initiated by the Wellcome Trust Sci/Art Project in 1997

249 Helen Storey
Primitive Streak Collection: Heart Hat, 1997
nylon tubing and straw
66 x 61 cm
© Helen Storey 1998
Collection the artist
Hat made by Philip Treacy
Photo: Justine
Model: Korinna at Models 1
Primitive Streak is supported in 1998 by Pfizer Ltd and was initiated by the Wellcome Trust Sci/Art Project in 1997

250 Helen Storey
Primitive Streak Collection: Implantation Dress, 1997
red silk jersey and silk chiffon
137 x 39 cm
© Helen Storey 1998
Collection the artist
Photo: Jason Lowe
Model: Korinna at Models 1
Embroidery by Becky Jones from the London College of Fashion
Primitive Streak is supported in 1998 by Pfizer Ltd and was initiated by the Wellcome Trust Sci/Art Project in 1997

251 Helen Storey
Primitive Streak Collection: Spinal Column Dress, 1997
printed silk with resin, aluminium foil and fibre optics
260 x 100 cm
© Helen Storey 1998
Collection the artist
Photo: Justine
Model: Korinna at Models 1
Resin cast, aluminium spine by Articular
DNA sequence cloth printed by Coats Viyella plc
Fibre optic work by Sarah Taylor from The Scottish College of Textiles
Fibres by Mitsubishi UK Ltd
Primitive Streak is supported in 1998 by Pfizer Ltd and was initiated by the Wellcome Trust Sci/Art Project in 1997

252 Atsuko Tanaka
Untitled (Study for Green Dress), 1956
ink on paper
25 x 36 cm
Gallery HAM, Nagoya, Japan

253 Atsuko Tanaka
Filmed Performances with 'Electric Dress' and 'Green Dress', 1957
video
Ashiya City Museum of Art & History

254 Atsuko Tanaka
Green Dress, 1956
cloth
100 x 110 x 52 cm
Gallery HAM, Nagoya, Japan

255 Atsuko Tanaka
Untitled (Study for Electric Dress), 1956
ink on paper
77 x 55 cm
Gallery HAM, Nagoya, Japan

256 Atsuko Tanaka
Untitled (Study for Electric Dress), 1956
ink on paper
77 x 55 cm
Gallery HAM, Nagoya, Japan

257 Atsuko Tanaka
Untitled (Study for Electric Dress), 1956
ink and crayon on paper
109 x 77 cm
Gallery HAM, Nagoya, Japan

258 Atsuko Tanaka
Untitled (Study for Electric Dress), 1956
ink, crayon and watercolour on paper
109 x 77 cm
© Atsuko Tanaka 1956
Gallery HAM, Nagoya, Japan
Photo: Gallery HAM

259 Ilja Tchaschnik
Design for a Dress, 1924
watercolour and pencil
16.5 x 20 cm
Galerie Gmurzynska, Köln
Photo: Karl Arendt, AFD, Köln

260 Ilja Tchaschnik
Design for a Dress, 1924
watercolour and pencil
16.6 x 20 cm
Galerie Gmurzynska, Köln
Photo: Karl Arendt, AFD, Köln

261 Juergen Teller
Six Magazine, Comme des Garçons, Anna Pawlowski, April 1991
photograph
91.5 x 91.5 cm
© Juergen Teller
Exhibition Print, The Artist's Collection

262 Juergen Teller
Per Lui Magazine, Istanbul, 1989
photograph
91.5 x 45.7 cm
Exhibition Print, The Artist's Collection

263 Thayaht
Drawing for Madeleine Vionnet
27.5 x 21.5 cm
Musée de la mode et du textile, Palais du Louvre, Paris. Collection de l'union française des arts du costume

264 Thayaht
Invitation Card for Madeleine Vionnet
printed paper
16.2 x 10.5 cm
Musée de la mode et du textile, Palais du Louvre, Paris. Collection de l'union française des arts du costume

265 Thayaht
Receipt for Madeleine Vionnet, 1936
printed paper
26.7 x 19.3 cm
Musée de la mode et du textile, Palais du Louvre, Paris. Collection de l'union française des arts du costume

266 Thayaht
Tuta, 1919, reconstructed 1997
cotton toile
Musée de la mode et du costume, Paris

267 Thayaht
Tuta, 1919, reconstructed 1997
cotton toile
Musée de la mode et du costume, Paris

268 Isabel Toledo
Packing Dress, Spring/Summer 1988
Baseball Collection
raw silk imported from India
© Isabel Toledo 1988
Courtesy Isabel Toledo

269 Philip Treacy
17th Century French Sailing Ship, Finale Hat, Spring/Summer 1995
satin and feather bones
Courtesy Philip Treacy

270 Philip Treacy
Black criss-cross Straw Hat, Autumn/Winter 1998
straw and fabric
Courtesy Philip Treacy

271 Philip Treacy
Pink Satin Hat, Autumn/Winter 1998
Courtesy Philip Treacy

272 Deborah Turbeville
Charles Jourdan publicity/Wolf form factory collage, June 1974
collage from 'Wallflower'
silver gelatin print
93 x 90.5 cm
Deborah Turbeville

273 Deborah Turbeville
Mary Martz and friends trying on shoes, June 1974
from Charles Jourdan publicity/Wolf form factory
silver gelatin print
57.5 x 49 cm
© Deborah Turbeville 1974
Deborah Turbeville
Photo: Deborah Turbeville

274 Deborah Turbeville
Pin cushion dolls, June 1974
from Charles Jourdan publicity/Wolf form factory
silver gelatin print
45 x 30.6 cm
Deborah Turbeville

275 Deborah Turbeville
Seated figure with shoe boxes, June 1974
from Charles Jourdan publicity/Wolf form factory
silver gelatin print
25 x 35.5 cm
Deborah Turbeville

276 Deborah Turbeville
Heel of shoe, March 1976
Andrew Geller shoes for *Vogue*
silver gelatin print
25.5 x 35.5 cm
Deborah Turbeville

277 Deborah Turbeville
Figures of women with shoes in factory, August 1976
publicity for Andrew Geller shoes, designed by Calvin Klein
silver gelatin print
25 x 68.5 cm
Deborah Turbeville

278 Deborah Turbeville
Women lying on table with shoe, August 1976
publicity for Andrew Geller shoes, designed by Calvin Klein
silver gelatin print
25 x 35.5 cm
Deborah Turbeville

279 Madeleine Vionnet
Black Dress, 1918-19
black silk crêpe de chine
120 x 136 cm
Musée de la mode et du textile, Palais du Louvre, Paris. Collection de l'union française des arts du costume

280 Madeleine Vionnet
Afternoon Dress, 1922
black silk
Martin Kamer Collection

281 Miguel Cisterna and Myriam Teissier
Drawing of cut for Vionnet Model 675, 1994
Musée de la mode et du textile, Palais du Louvre, Paris. Collection de l'union française des arts du costume

282 Constantin Vjalov
Costume design for Sten'ka Razin (Harem), 1923-24
watercolour and indian ink on paper
29 x 40.5 cm
Private collection, Germany

283 Constantin Vjalov
Costume design for Sten'ka Razin (Popi), 1923-24
watercolour, indian ink and pencil on paper
26.5 x 17.7 cm
Private collection, Germany

284 Constantin Vjalov
Costume design for Sten'ka Razin (Voivoda), 1923-24
gouache, indian ink, gold, silver and pencil on paper
32.3 x 24.8 cm
Private collection, Germany

285 Friedrich Walker
Emile Flöge by the Attersee, 1913
autochrome
18 x 9 cm
Christian Brandstätter, Vienna

286 Friedrich Walker
Emilie Flöge by the Attersee in a Chinese housedress, 1913
autochrome
Christian Brandstätter, Vienna

287 Andy Warhol
Andrew Geller Shoe Ad, 1950s
ballpoint pen and collage on paper
35.4 x 46 cm
The Andy Warhol Museum, Pittsburgh
Founding Collection, Contribution The Andy Warhol Foundation for the Visual Arts, Inc.

288 Andy Warhol
Shoes, 1950s
ink on paper
27.9 x 21.6 cm
The Andy Warhol Museum, Pittsburgh
Founding Collection, Contribution The Andy Warhol Foundation for the Visual Arts, Inc.

289 Andy Warhol
Shoes, 1950s
ink and dye on paper
57.5 x 72.7 cm
The Andy Warhol Museum, Pittsburgh
Founding Collection, Contribution The Andy
Warhol Foundation for the Visual Arts, Inc.

290 Wiener Werkstätte
Gustav Klimt with Emilie Flöge, 1909
photograph in hammered silver frame
by Josef Hoffmann
17.5 x 10 cm
University of Applied Arts in Vienna,
Collection

291 Wiener Werkstätte
Blouse (for Johanna Staude), 1910-15
printed silk
53 x 54 cm
Christine Kugler, Vienna

292 Vivienne Westwood
Poiret, 1995
shoes
Private collection

293 Stephen Willats
Variable Sheets, 1965
PVC and mixed media
dress top + 8 panels
exhibition copy made by Christine Smith
1998
Stephen Willats

294 Stephen Willats
Multiple Clothing Kinetic Modules,
November 1991
64 x 42 cm
ink, crayon, poster paint, letraset text
on paper
Stephen Willats

295 Stephen Willats
Multiple Clothing. Free Expression, 1992
PVC and mixed media
dress & jacket top + 16 panels
and connecting elements
1 from an edition of 10, example made
by Brigette Wellmann
Stephen Willats

296 Stephen Willats
Multiple Clothing. Personal Display, 1992
rubber cloth, text cards & mixed media
1 from an edition of 10
© Stephen Willats 1992
Stephen Willats

297 Stephen Willats
Multiple Clothing. Positive Feedback, 1991
rubber cloth and mixed media
1 from an edition of 10
Stephen Willats

298 Stephen Willats
Multiple Clothing. Creative Noise, October 1991
posterpaint, ink, letraset text on paper
64 x 52.5 cm
Stephen Willats

299 Stephen Willats
Multiple Clothing. New Directions, October
1997
pencil, ink, poster paint, Letraset text
on paper
64 x 52 cm
Reinhard Hauff

300 Stephen Willats
Multiple Clothing. Going Forward, 1998
25 x 17 x 19 cm
rubber cloth and mixed media
example made by Brigette Wellmann
Stephen Willats

301 Millie Wilson
Mistress, 1993
stylized synthetic wigs/chrome
70 x 21 x 12
Collection of Ruth and Jake Bloom

302 E.J. Wimmer Wisgrill
Design for a Dress 1912
MAK Austrian Museum of Applied Arts,
Vienna

303 E.J. Wimmer Wisgrill
Fashion Drawing, 'Franziska' 1913
pencil and watercolour on paper
MAK Austrian Museum of Applied Arts,
Vienna

304 E.J. Wimmer Wisgrill
Fashion drawing, 'Tango', 1913
pencil and watercolour on paper
MAK Austrian Museum of Applied Arts,
Vienna

305 E.J. Wimmer Wisgrill
Design for an Outfit 1914
pencil and watercolour on paper
MAK Austrian Museum of Applied Arts,
Vienna